ITALIAN PAINTINGS
FROM BURGHLEY HOUSE

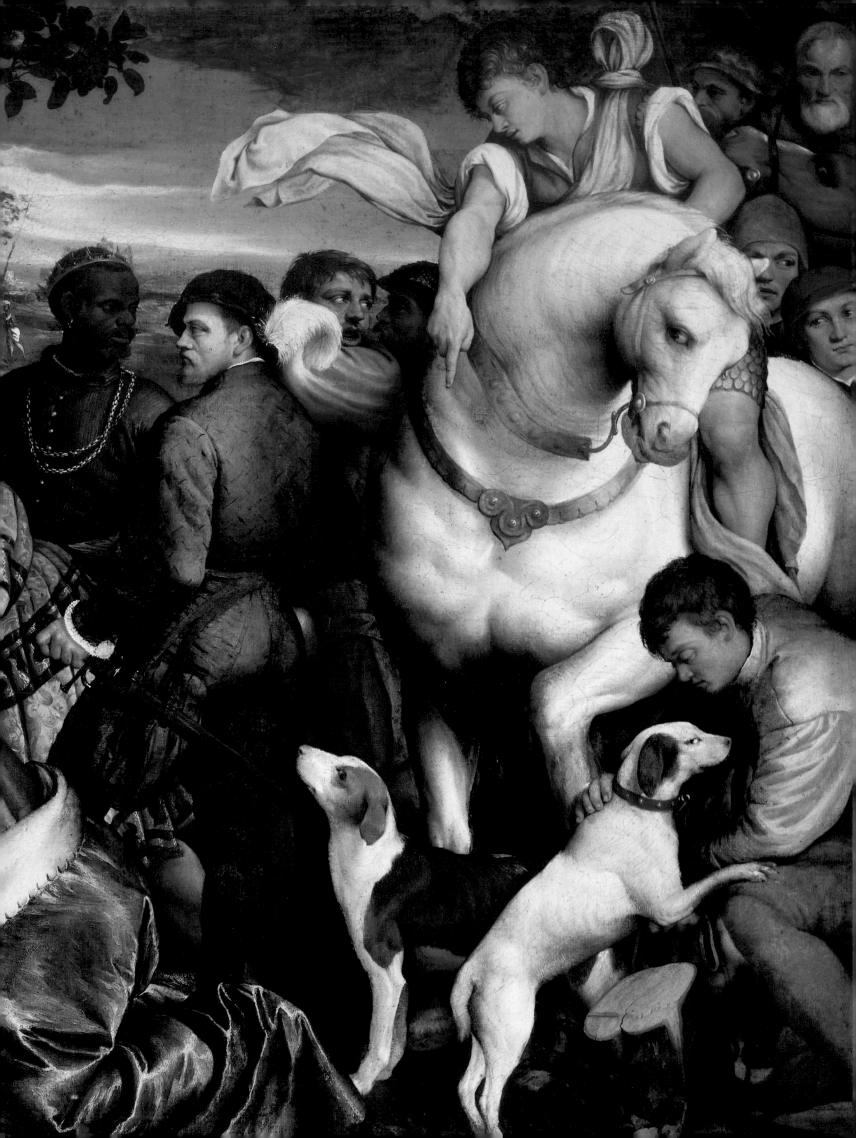

ITALIAN PAINTINGS
FROM BURGHLEY HOUSE

HUGH BRIGSTOCKE
JOHN SOMERVILLE

with a foreword by

LADY VICTORIA LEATHAM

ART SERVICES INTERNATIONAL
ALEXANDRIA, VIRGINIA
1995

PARTICIPATING MUSEUMS

The Frick Art Museum
Pittsburgh, Pennsylvania

Indianapolis Museum of Art
Indianapolis, Indiana

Fresno Metropolitan Museum
Fresno, California

Phoenix Art Museum
Phoenix, Arizona

Mississippi Museum of Art
Jackson, Mississippi

National Gallery of Scotland
Edinburgh, Scotland

Library of Congress Cataloging-in-Publication Data

Brigstocke, Hugh.
 Italian paintings from Burghley House / Hugh Brigstocke, John
Somerville; with a foreword by Lady Victoria Leatham.
 p. cm.
 Catalog of an exhibition organized and circulated by Art Services
International, Alexandria, Va; participating museums, the Frick Art
Museum, Pittsburgh, Pa. and others.
 Includes bibliographical references.
 ISBN 0-88397-114-3
 1. Painting, Italian—Exhibitions. 2. Painting—16th century—
Italy—Exhibitions. 3. Painting, Modern—17th-18th centuries—
Italy—Exhibitions. 4. Devonshire, Dukes of—Art collections—
Exhibitions. 5. Painting—Private collections—England—Stamford—
Exhibitions. 6. Burghley House (Stamford, England)—Exhibitions.
I. Somerville, John, 1950- . II. Art Services International.
III. Frick Art Museum (Pittsburgh, Pa.) IV. Title.
ND615.B74 1995
759.5'074—dc20 94-36386
 CIP

Editor: Nancy Eickel
Designer: Oser Design
Printer: Balding + Mansell, Peterborough

Cover: Detail of *Venus Dissuading Adonis from the Chase* by Giovanni Battista Gaulli (cat. no. 18)
Frontispiece: Detail of *The Adoration of the Kings* by Jacopo Bassano (cat. no. 2)

ISBN 0-88397-114-3

Printed and bound in Great Britain

Table of Contents

Acknowledgements 7

Foreword 11
 Lady Victoria Leatham

Burghley: The House and the Cecil Family, A History 15
 John Somerville

John Cecil, the 5th Earl of Exeter: An English Traveller, Patron and Collector in Italy 29
 Hugh Brigstocke

Authors' Note 38

Notes to the Catalogue 39

Catalogue of Works 40

The Cecils of Burghley: A Family Tree 156

An Annotated Listing of Pictures Mentioned in the 1688 Inventory 159

Select Bibliography 172

Acknowledgements

Burghley House is outstanding among the great estates erected during the era of Queen Elizabeth I, and for more than 450 years, as today, it has been home to the Cecil family. Each generation has left its mark on Burghley by adding to its diverse collections, purchasing new furnishings and modifying the landscape of the vast estate. The exceptional taste and voracious collecting habits of two of the family's members - John Cecil and Brownlow Cecil, the 5th and 9th Earls of Exeter - are responsible for Burghley's amazing holdings of Italian paintings from the sixteenth, seventeenth and eighteenth centuries. This exhibition celebrates their eye and the glory of Italian painting. On their lengthy tours of Italy both Earls acquired scores of paintings from then-contemporary artists working throughout that country. Equally astounding is that these magnificent pictures have remained at Burghley House, withstanding both the whims and the financial tribulations of these centuries. It is with great pride and extreme pleasure that Art Services International, in keeping with its mission to present the finest works of art to viewers worldwide, introduces these sixty paintings to audiences in the United States and Scotland.

Lady Victoria Leatham, who is of the seventeenth generation of Cecils to inhabit the House, continues the Cecil family tradition of caring for the treasures of Burghley. Together with her husband Simon Leatham, Lady Victoria has dedicated herself to preserving and documenting the great house and the outstanding collections it contains. It is our honour to join Lady Victoria in bringing the history of Burghley and its holdings to a wider audience, and we are indebted to her for entrusting us with travelling these examples of her family's prized artistic heritage. In addition, we consider the opportunity to know her and to share in her enthusiasm for Burghley House to be a lasting treasure of the exhibition.

Joining us in the celebration of the Italian paintings at Burghley House are two authorities on art of the baroque era: Hugh Brigstocke, Director and Senior Expert in the Department of Old Master Paintings at Sotheby's, London, and guest curator of this exhibition; and John Somerville, Honorary Keeper of the Burghley House Picture Collection. Their extensive knowledge of Italian art of the sixteenth, seventeenth and eighteenth centuries and their keen interest in Burghley's painting collection have led to the impressive selection of paintings included in this tour and the scholarly essays and entries found in this catalogue.

We thank them for their time, expertise and eagerness to participate in this important international endeavour.

The willingness of His Excellency Sir Robin Renwick, Ambassador of Great Britain, and His Excellency Boris Biancheri, Ambassador of Italy, to serve as Honorary Patrons of *Italian Paintings from Burghley House* is respectfully acknowledged. Their interest in this international presentation of art is gratifying. It is also our pleasure to thank David J. Evans, Cultural Counsellor at the British Embassy, and Roberto Spinelli, Cultural Counsellor at the Italian Embassy, for their assistance.

This far-reaching project benefitted from the generous support of the Samuel H. Kress Foundation in New York and we send our thanks for this assistance in particular to Lisa M. Ackerman, its Chief Administrative Officer. We are further indebted to Sotheby's, London, for the on-going support it has given this project, particularly providing extensive photography for the catalogue, and we extend our personal thanks to the Directors of Sotheby's for this endorsement. It is our great pleasure to recognize the crucial involvement of the Federal Council on the Arts and the Humanities, and specifically Alice Whelihan, for supporting this tour with an indemnity. Each has earned our respect and deepest gratitude and it is our pleasure to acknowledge their assistance.

Key to the ultimate success of this project has been the assistance provided by Jon Culverhouse, House Manager of Burghley. His saintly patience, unflagging attention to detail and eagerness to help were matched only by that exhibited by Sarah Culverhouse and Nicholas Humphrey. Charles Pugh provided valuable information on the paintings by researching inventories, account books, letters and notes kept at Burghley House. We fondly recognize Sue Bond of Sue Bond Public Relations in London for her personal attention to this project and are grateful for this opportunity to collaborate with her again. We extend our thanks as well to the staff of Sotheby's, London, for their repeated and good-natured assistance. We have benefitted from the keen dedication to Burghley which each has exhibited and we extend them our warmest regards.

International endeavours such as *Italian Paintings from Burghley House* would be impossible without the enthusiastic support of our colleagues at the museums which are hosting the exhibition's tour. With heartfelt thanks and professional pride we would like to acknowledge the following key individuals: DeCourcy E. McIntosh, Executive Director of The Frick Art Museum in Pittsburgh; Bret Waller, Director, and Ronda Kasl, Associate Curator of Painting and Sculpture before 1800, of the Indianapolis Museum of Art; Edwin J.C. Sobey, Executive Director, and Kaywin Feldman, Director of Exhibitions, of the Fresno Metropolitan Museum; James K. Ballinger, Director, and Michael Komanecky, Curator of European Art, of the Phoenix Art Museum; Linda Sullivan, Executive Director, and Rene Paul Barilleaux, Chief Curator, of the

Mississippi Museum of Art in Jackson; and Timothy Clifford, Director, and Michael Clarke, Keeper, of the National Gallery of Scotland in Edinburgh. Their enthusiasm for sharing these works with their local audiences underscores the significance of this project. We appreciate their endorsement and look forward to future opportunities for collaboration.

Combining their creative talents once again are Nancy Eickel and Judy Oser, editor and designer of this significant catalogue. Working in conjunction with Balding + Mansell, their efforts have produced a book which will endure as a seminal record of the Italian paintings at Burghley.

It is our pleasure to recognize Marcia Early Brocklebank, ASI's representative in the United Kingdom, for her unflagging efforts on our behalf. Our congratulations are further extended to the staff of Art Services International - Ana Maria Lim, Douglas Shawn, Anne Breckenridge, Kirsten Simmons, Betty Kahler, Patti Bruch and Sally Thomas - who worked to ensure the success of this endeavour. We applaud these dedicated individuals and send them our personal thanks.

Lynn K. Rogerson Joseph W. Saunders
Director Chief Executive Officer
 Art Services International

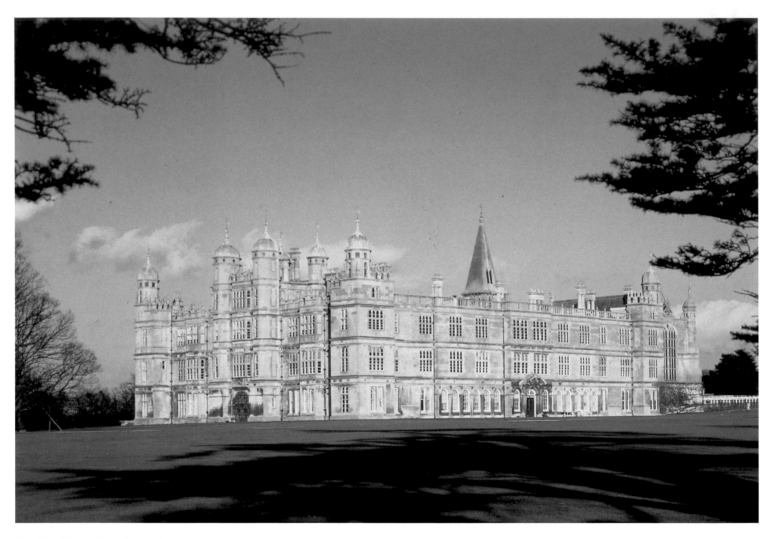

Burghley House from the southwest

Foreword

The first Lord Burghley has been regarded throughout history as one of the great statesmen of the Elizabethan era. He was, it also appears, one of the most enthusiastic builders of great mansions!

In many ways I can identify much more easily with his sixteen-century megalomaniac architectural schemes than with the single-minded personal indulgences of his descendant, the 3rd Marquess of Exeter. At the end of the nineteenth century he possessed no less than six yachts, the purchasing and fitting out of which very nearly led to the demise of Burghley. A three-day sale of items from the house took place in London in 1888. The vagaries of artistic taste luckily spared the Italian pictures but the catalogues of items successfully sold to pay his debts make sombre reading.

One field of research that has been most invigorating since my family and I moved into Burghley House in 1982 has been the on-going investigation into the buying taste of the Cecil family in the seventeenth and eighteenth centuries. Room furnishings and decorations are well described in both the 1688 inventory and in the day books and inventories kept by the 9th Earl in the eighteenth century. Referring to these has allowed us to re-discover items within the house which were previously written off as lost or sold. The Japanese porcelain makes a good example. For many years, collectors and enthusiasts in Japanese art had not realized that here at Burghley lies one of the country's, and indeed the western world's, earliest inventoried collections of Imari and Kakiemon wares in existence, all described in minute detail in the 5th Earl's inventory of 1688.

It also surprised us to find that Burghley houses the best preserved collection of seventeenth-century *objets de vertu* in private hands, a fine selection of sixteenth- and seventeenth-century portrait miniatures, splendid eighteenth- and nineteenth-century scientific instruments, superb tapestries, furniture, silver and vermeil, and many other fascinating and high-quality treasures. Even more outstanding is that many of these objects still have their original bills of sale or are documented in detail.

Of course, great buildings such as Burghley House are expected to be furnished in a glamorous fashion, but it surprised me that successive generations took their responsibilities towards the house so seriously. Although the end of the nineteenth century was a time of debts and sales at Burghley, there were far longer periods in the history of the house when people were collecting fine

objects, patronizing artists and craftsmen, adapting the building to better advantage and generally enriching the house and estate. Both the seventeenth and eighteenth centuries saw extensive purchases of works of art, a large number of which remain here today.

Within this scenario we should not forget the horrendous struggles that have occurred to keep the house and the estate solvent and more or less intact in times of financial austerity. When I was a child growing up here, almost every conversation turned on whether or not such and such an area could be sold off to pay death duties. Huge acreages of farmland went, as well as the village properties, the pubs, the little shops and the homes of many good loyal farm workers. This was an agonizing time of decision for my father, who was passionate about his inheritance and who felt himself cast in the role of a betrayer of his heritage and of those who made their livings from his estate.

At a tax rate of 80 percent of all assets, death duties in England after the Second World War rang a death knell for many great houses. No cottage on the estate was equipped with inside plumbing, and no electricity supplied the main house other than that to power my grandfather's razor! I could scarcely have blamed my father if he had sent the entire contents of the house to the nearest auction rooms and moved to the south of France to live out his days in comfort. To his everlasting credit it never occurred to him to do that, although in those vastly depressing early days in the house, I daresay it may have crossed the mind of my long-suffering mother. I recently found her diary for 1957, the year after they moved into Burghley and the first year in which they opened the house to the public. Every evening she writes the same, "Went to bed exhausted."

When my mother took over Burghley House, it was still redolent of the Victorian age. No lighting or heating worked, gas leaked from every lamp, carpets were rotted beyond repair and curtains hung in shreds. She writes in the diary on the first day of the house's public opening, "We had lunch early in the unlikely event of anyone coming to see round the house, at ten minutes to opening time we looked out of the dining room window and to our wondering gaze saw the whole park full of visitors in buses, cars and on their feet. We seem to be well and truly open!" By that time, just short months after taking over such an unpromising beginning, my mother had turned the house into a gracious home with colour and warmth and style. She had also moved most of the furniture into the state rooms herself, to the lasting detriment of her spine!

When Simon and I and our children moved into Burghley House in 1982, following the deaths of my parents within seven months of one another, we did so at the request of the family trust that had been set up by my father to avoid repeat of the tax problems that had bedevilled him and also to ensure that the collections were not sold or divided. This has meant that we have considerable flexibility when approaching the problem of raising funds to support the estate. It is infinitely easier for me to request corporate sponsorship "for the house" than it would be if I in any way owned a part of it. We are the first house to seek corporate donations on an international level and we have received generous grants from companies in the United States and Japan towards the huge restoration of the contents of Burghley and on occasion have arranged tandem

exhibitions. The building itself has benefitted from grants for structural repairs, but no funds have been made available for mending furniture and porcelain, or for restoring paintings or the renowned painted rooms decorated by Antonio Verrio in the seventeenth century which are in a perilous state.

Living in a house as large as this has its drawbacks. You can never find people when you want them – although short-wave radio is useful – and the cleaning and everyday attentions are time consuming and physically demanding. (You have to be fit to carry a vacuum cleaner up eighty-three stairs!) Putting the entire collection and all the house's contents onto a computer database has been an extraordinary marathon. Now that they are safely recorded, however, it is proving to be a godsend. Information about each piece is at our fingertips and it is surprising how often in a week's work we need to access it. Research on Burghley House is constant, yet it is one of the parts of the job that I enjoy most. I have learned some rather surprising facts about my ancestors, but I always have been left with the impression that they were all, with the possible exception of perhaps four of them, extremely proud of this house and what it contained.

We all hope that you enjoy this handsome presentation of the Italian paintings at Burghley House. We very much hope that at some time in the future you may find an opportunity to visit the house and see the other treasures in the rooms that were designed to hold them.

My thanks and those of my family go to John Somerville and Hugh Brigstocke for their tireless work. To have two close friends and colleagues working on the picture collection has been a delight. Our best wishes are extended to Jon and Sarah Culverhouse at Burghley, and to Charles Pugh and Nicholas Humphrey whose input has been invaluable. Our grateful thanks are also offered to the staff and directors of Art Services International, without whom none of this would have happened. Thank you for turning a dream into a reality.

Lady Victoria Leatham

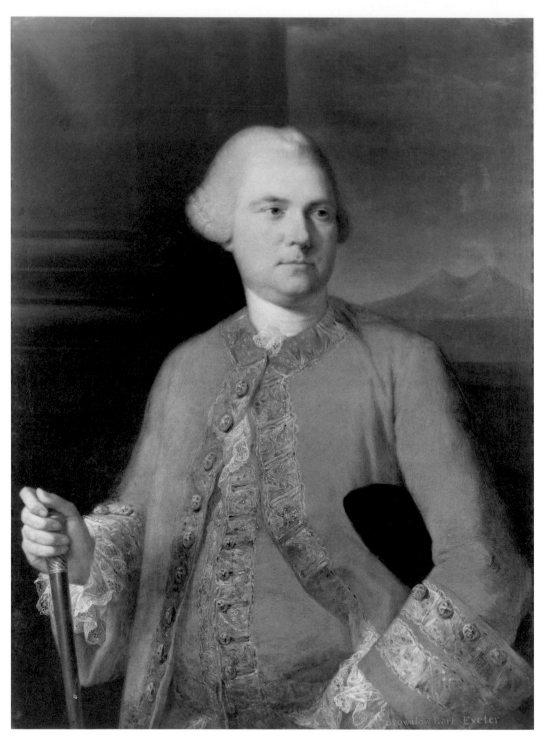

Figure 1
Angelica Kauffmann
Brownlow Cecil, 9th Earl of Exeter
Private collection
Photo, courtesy of Sotheby's

Burghley: The House and the
Cecil Family, A History

John Somerville

Burghley is the largest, grandest and most impressive of the great houses still occupied from the Elizabethan era. It was built between 1555 and 1587 by Elizabeth I's Chief Minister, William Cecil (1520–1598), who was described by that monarch's suitor, Lord Essex, as "the greatest, gravest and most esteemed Councillor . . ." (fig. 2). As the Queen's Principal Secretary and then as Lord High Treasurer, Lord Burghley (as Cecil became in 1571) was, through immense influence and power, able to acquire considerable property and riches, mostly from grants on crown land which had originally been confiscated by his first royal master, Henry VIII, from the church at the time of the Dissolution of the Monasteries. These lands were mostly in and around Stamford in the county of Lincolnshire, though his parents had acquired the site on which the house now stands and his mother had land at nearby Bourne. (Concurrent with the work at Burghley, the Treasurer was also erecting another huge house at Theobalds in Middlesex.) Although later inventories tell us much about what was in Burghley in the seventeenth, eighteenth and nineteenth centuries, very little is known about the contents of the house in the time of its builder. In addition to much furniture, there doubtless would have been tapestries to decorate the walls and reduce draughts, but as for pictures we can only imagine family portraits. Paintings were seldom hung in any quantity in country houses until the latter part of the seventeenth century, and indeed it was not until the next century that the practice became widespread. Serious paintings were reserved for royal palaces and the London houses of great noblemen and courtiers.

Few changes to the fabric or interior of the house took place following the death of Treasurer Burghley in 1598. His son Thomas, the 1st Earl of Exeter, was a career soldier and an old man by the time he inherited. His unmarried son was a remarkably unremarkable man. He was succeeded by a nephew who was Earl for barely three years and was followed, just as the country was being plunged into civil war, by a boy of fifteen. During the Civil War and ensuing Commonwealth, the family laid low, endeavouring not to take sides, though through no fault of their own, the estate having been commandeered by the royalist Lord Camden, Burghley House was besieged and subsequently occu-

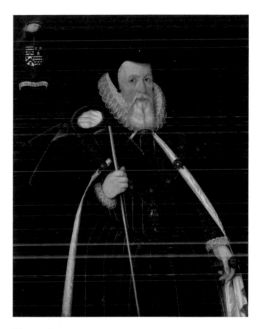

Figure 2
Marcus Gheeraerts
William Cecil, Lord Burghley, K.G.
Burghley House

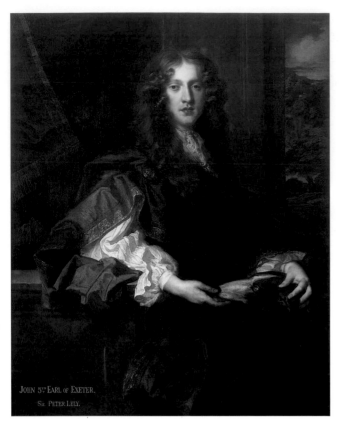

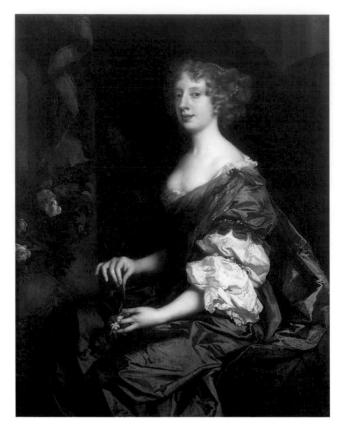

Figures 3, 4
Sir Peter Lely
John Cecil, 5th Earl of Exeter and *Anne Cavendish, Countess of Exeter*
Burghley House

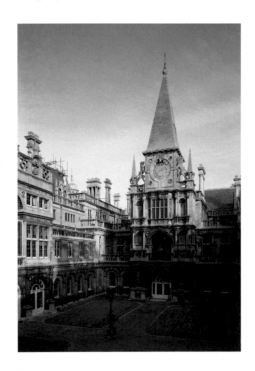

Figure 5
Inner Courtyard and Clock Tower

pied by Cromwellian troops. Fines and austerity were the order of the day, but with the restoration of Charles II in 1660, a new age began in which the arts and sciences flowered. The scene was set for the emergence of the 5th Earl, under whose aegis Burghley was to enter a golden and indeed its most glorious age.

On the death of his father in 1678, John Cecil, Lord Burghley (1648–1700), became the 5th Earl of Exeter (fig. 3). At that time the great Tudor mansion which his great-great-great-grandfather had built would have seemed positively old fashioned, incredibly uncomfortable and impractical (fig. 5). When Charles II returned to England in 1660, having spent part of his exile at the rich and highly sophisticated court of his cousin, the young Louis XIV, the English monarch had come to admire French ways and ideas, and he keenly set about transforming the old Tudor Palace at Hampton Court. Similarly, the 5th Earl, within a year of succeeding to the title and the huge Burghley estates, instigated sweeping changes to the layout of his great house. The long galleries so favoured by the Tudors and early Stuarts were divided into state rooms on the first floor (fig. 6), where the grandest rooms formed a set of five on the south front, one room leading to the other with a long enfilade on all sides. The Tudor Great Hall, rising up three floors, was retained however, on the east front. On the ground floor were the private apartments, where suites of chambers for the use of the Earl and his Countess were created on either side of the west (then the principal) entrance and beneath the earlier Tudor vaulting. These massive and extremely radical alterations naturally required new furnishings, and in 1679 the 5th Earl of Exeter set off with his wife, son and large entourage on the first of his European tours.

Over the next twenty years the Earl and Countess of Exeter spent incredible sums on lavish decorations and on superb and untold quantities of paintings, furniture, statuary, tapestries, silver, ceramics and all manner of works of art. Whilst the tapestries came from England as well as France, the vast majority of the paintings were acquired in Italy. This was the first time that paintings had been ordered on such a scale for an English country house. Equally remarkable was that for the greater part, all the paintings were by living or near contemporary artists in Italy. Such pictures were largely unknown in England. In his travels there was almost no major artistic centre in Italy – from Venice, Genoa and Bologna, to Florence, Rome and Naples – that the 5th Earl did not visit. In this great "shopping spree" Lord Exeter was fully supported by his wife, Lady Anne Cavendish (c. 1650–1703), sister of the 1st Duke of Devonshire of Chatsworth, an heiress in her own right, and a wealthy widow from her first marriage to Lord Rich (fig. 4). Between them they all but exhausted the very considerable Exeter fortune, leaving enormous debts from which the estate took many decades to recover. The almost royal patronage of painters abroad was not entirely at the expense of painters and craftsmen working in England. Portraitists William Wissing and Sir Godfrey Kneller and the carver Grinling Gibbons all worked at Burghley, as did Jean Tijou the ironworker, the artists Benedetto Gennari (cat. no. 19) and Jean-Baptiste Monnoyer and above all Antonio Verrio (c. 1639–1707).

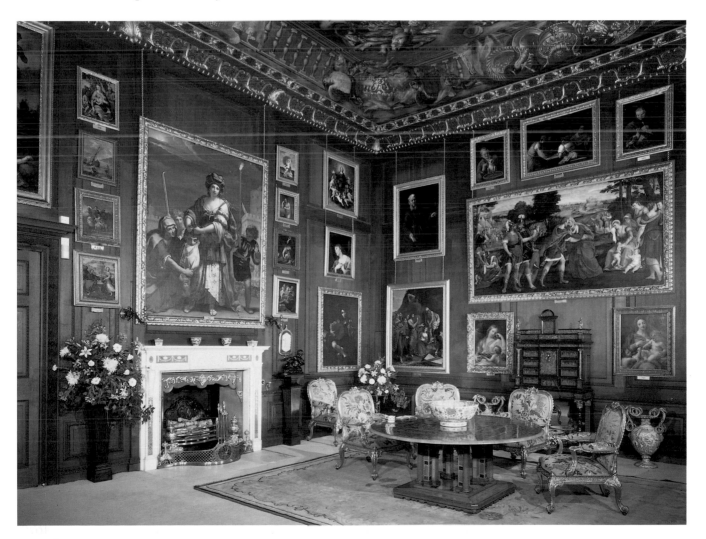

Figure 6
Fourth George Room

Verrio, whom it must be admitted wisely left Italy where he would have been overshadowed by the greater ability of so many of his fellow countrymen, far surpassed, however, native English decorators. Since the destruction of his work at Hampton Court in the early nineteenth century, Verrio's paintings on the ceilings and walls at Burghley remain his largest and finest extant decorative scheme (fig. 7).

In his seminal work *Patrons and Painters* (New Haven, 1965), Francis Haskell poses the pertinent question as to whether the 5th Earl was a serious connoisseur or simply a magpie collector. That the very different art of Carlo Dolci (cat. no. 14) and Luca Giordano (cat. nos. 24, 25) appealed to the Earl simultaneously does not necessarily imply he was inconsistent; nor does the sheer number of pictures he acquired suggest he was indiscriminate. There is little doubt, however, that the considerable amount of naked flesh seen at Burghley House – in Verrio's ceiling and wall decoration, as well as in the hundreds of Italian paintings, both religious and secular, that the Earl collected – suggests that Lord Exeter delighted in the female form. We know from the 1688 inventory of Burghley House that in his most intimate chambers the Earl had pictures almost entirely of pagan subject matter of a kind which invariably gave the artist full excuse to depict the female nude: the rape of the Sabines, Salmacis and Hermaphroditus, the judgement of Paris, Galatea, and Hero and

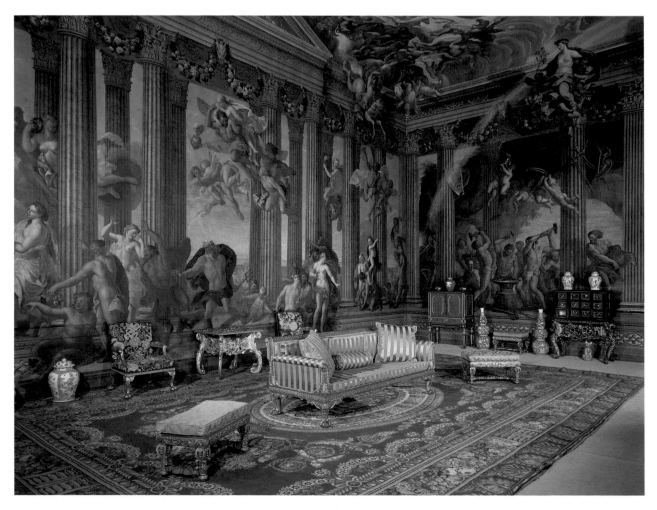

Figure 7
Heaven Room
Antonio Verrio

18

Leander.[1] At the same time he clearly enjoyed surrounding himself with decorative pieces and still life paintings of fish, fruit and flowers. We are fortunate indeed that he was so inclined, for still at Burghley are the two greatest Neapolitan still life paintings in the country, those being the large-scale canvases by Giuseppe Recco (cat. nos. 42, 43). Lady Exeter, on the other hand, would seem to have been a woman of religious conviction, for in her most private rooms we find Pasinelli's *Penitent Magdalen* (B.II. No. 418), Luca Giordano's *Woman Taken in Adultery* (B.H. No. 152), an alabaster relief of the Entombment, and perhaps most interesting of all, six devotional works by Carlo Dolci.

The 5th Earl and his wife avoided court life and appointments (his position of Lord High Almoner was an hereditary and honourary one), and they were frequently out of the country. The great inventory of 1688 was drawn up in the watershed year that marked both the long-awaited arrival of William of Orange and the crumbling authority of James II. It was some five years before the Exeters set off again for Italy, preferring perhaps to be on hand rather than risk being absent and in no position to counter any accusations levelled against them.[2] Whatever religious convictions the 5th Earl of Exeter and his wife may have held, between them they were responsible for assembling the finest and most comprehensive collection of seventeenth-century Italian paintings and for creating an ensemble of late seventeenth-century taste without parallel in England.

In 1700, whilst on his way back to England from the fourth Italian excursion, Lord Exeter was taken ill at Issy, near Paris (from a surfeit of fruit, it is said), and died. He and his wife had already sat to Pierre-Etienne Monnot (1657–1733), a French sculptor working in Rome, for bust portraits. After the Countess's death in 1703, the great tomb commissioned earlier from Monnot was erected in 1704 in the family chapel in the Church of St Martin in Stamford. (Other pieces by Monnot are still at Burghley, but the great *Andromeda and the Sea Monster* is now in the Metropolitan Museum of Art.) Details of how the 5th Earl's body was returned to Burghley House are not known, but his superb tomb is, in both its scale and quality, an appropriate and fitting monument to this unique man and collector. How his collection remains almost entirely intact some three hundred years later is a result of both luck and judgement. The activities of succeeding generations will explain and reveal how this was so.

With the 5th Earl's death the estate was plunged into colossal debt, and his widow died three years later with almost equal debts of her own. Though saddled with these encumbrances, and the great state rooms on the south front were left unfinished, there is no evidence that the family and estate were so impoverished that they were obliged to sell paintings and works of art. Admittedly, some pictures mentioned in the 1688 inventory are not readily identifiable in the ensuing one which was drawn up in 1738. Artists' names are easily forgotten and subject matter mistaken by succeeding generations. As pictures and effects must have continued to arrive from the Continent for some time after the 5th Earl's unexpected demise, and with the decision taken not to complete the state rooms on the first floor where a considerable number of paintings

both could (and were intended to) be hung, it is not inconceivable that some pieces were disposed of. Despite these reduced circumstances, the 6th Earl was able to acquire some extremely important and expensive silver, including a spectacular wine cooler.[3] Family portraits were of course still sat for, and the Dutch artist Frans van der Mijn was at Burghley in the 1730s and executed a number of paintings for the 8th Earl. It was his son Brownlow, however, on his inheriting the title in 1754, who was to become the second great collector in the family's history.

Brownlow, 9th Earl of Exeter (1725–1793) (fig. 8), was aged twenty-five when his father died. He had married Laetitia Townsend, an heiress from Norfolk, in 1749, but within seven years she was dead, which enhanced her husband's already considerable wealth. In 1763, like his great-grandfather before him, the 9th Earl set off on his first journey to Italy, where, in keeping with his contemporaries, the intention was to acquire works by the Old Masters, the great Italian painters of the sixteenth and early seventeenth century. There was little need for him to consider Italian art of the seventeenth century; more than enough paintings from that era already adorned the walls at Burghley. Fortunately, the 9th Earl's heart evidently lay in the sixteenth century. He settled initially in Naples where, through the British Minister Sir William Hamilton, he met Angelica Kauffmann (1741–1807), who had arrived from Rome that year. Angelica was able to introduce him to the artistic milieu of the city, and one senses that Lord Exeter, like so many other men, was captivated by this bright and beautiful creature. Instead of waiting to sit for Pompeo Batoni in Rome, which could have been expected of such a grandee, Angelica painted his portrait with the Bay of Naples and Vesuvius in the background (fig. 1). The childless Earl left this portrait to his sister, Lady Elizabeth Chaplin, and sadly no likeness of comparable quality remains in the collection at Burghley. Angelica shared the 9th Earl's interest in the sixteenth century, copying Old Masters for him and providing him with numerous other works, including a portrait of David Garrick (B.H. No. 176) and a large group of her small mythological subjects, mostly of celebrated lovers. Angelica's own portrait by Nathaniel Dance, another of her admirers, today still hangs at Burghley (B.H. No. 180), and from the fact that that picture was acquired, one imagines the friendship was more than just a meeting of like minds. Yet patronage of Angelica Kauffmann was not merely because of a personal relationship, for the 9th Earl commissioned works from other contemporary artists: gouaches from Jacob Philip Hackert, views in and around Naples from Pietro Fabris (cat. nos. 15, 16), a painting of Hebe by Gavin Hamilton (B.H. No. 366), drawings by William Hogarth and a landscape by Zuccarelli (B.H. No. 242).

Lord Exeter was also a great book collector, amassing a typical Grand Tour library with volumes of engravings after Old Masters, designs by James "Athenian" Stuart, prints by Piranesi and other topographical views. There are volumes of engravings recording the extensive excavations of the classical sites both in Rome and at Pompeii and Herculaneum as well as views of Switzerland through which the 9th Earl travelled. Acquiring sixteenth-century masters remained, however, the 9th Earl's primary goal. For even more paintings to be

Figure 8
Thomas Hudson
Brownlow Cecil, 9th Earl of Exeter
Burghley House

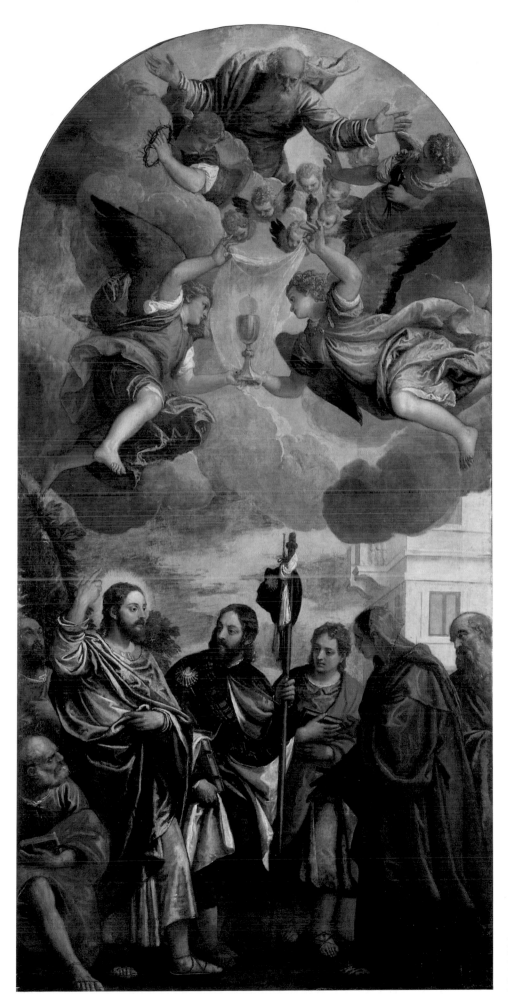

Figure 9
Paolo Veronese
The Wife of Zebedee Petitioning Our Lord
Burghley House

21

absorbed into an already crowded hang of pictures at Burghley, it was necessary to complete the state rooms which had been left unfinished in 1700. The extraordinary Verrio ceilings were in place, as were the cornices, doors, overdoors and door jambs. Into this Baroque splendour the 9th Earl incorporated new dado panelling, fireplaces and furniture – much of it classically inspired but not so severe that any of it jarred with the original decorations begun almost a hundred years earlier. Alterations were made to some of the private rooms on the ground floor, principally to create a new main entrance on the north side and to provide for two libraries to contain the ever-increasing collection of books. The private suites of the 5th Earl and his Countess remained virtually unaltered, whilst the chapel, which seems to have been a relatively insignificant place in the late seventeenth century, was re-created in late eighteenth-century style. As its focal point was the full-size altarpiece of *The Wife of Zebedee Petitioning Our Lord* by Paolo Veronese (B.H. No. 610) (fig. 9). Matching frames were made for the series of enormous canvases by Carl Loth (B.H. Nos. 71, 368), Antonio Zanchi (cat. no. 60), and Pietro Liberi (B.H. Nos. 70, 74) which decorate the upper walls (see cat. nos. 32, 60). Two other works by Veronese – superb images of standing male saints, which may have originally been the shutter-doors of an organ (cat. nos. 58, 59) – came from the same church as the altar-piece, San Giacomo in Murano. It was another Venetian work, however, which was to be the 9th Earl's finest purchase and which is today the crowning glory of the Burghley collection: Jacopo Bassano's *Adoration of the Kings* (cat. no. 2). Together with paintings by Bassano of the same subject at Edinburgh and Hampton Court, the Burghley *Adoration of the Kings* is amongst the supreme masterpieces of that most individual Venetian master, inside or outside of Italy. Poussin's *Assumption of the Virgin* was purchased in 1764 from the Soderini collection in Rome, along with a pair of landscapes which were bought as Claudes (cat. nos. 11, 12) and can claim to be indeed by that artist, who has remained enduringly popular with the British collector.

At the same time, however as he was collecting these superb Old Masters, the 9th Earl was, no doubt inadvertently (and quite inexplicably), buying what can only be described as "real duds". Like the 5th Earl, he had to rely on agents as he could not be forever in Italy, but the dangers of using agents when seeking works by deceased painters were great. The 5th Earl was more concerned with being overcharged by the artists themselves and not his being sold fakes (see cat. nos. 24, 25). The 9th Earl inevitably found himself in the clutches of the notorious William Byres and Thomas Jenkins. Whilst the latter secured works from, among others, Jacob Philip Hackert, it fell to Byres, the less scrupulous of the two, to obtain for the 9th Earl his longed-for Raphael (B.H. No. 404). Despite much explanation in correspondence of how difficult it had been to by-pass (or bribe) the Vatican authorities, the painting is in fact nothing more than a copy of Raphael's *Madonna del Passeggio* (on loan to the National Gallery of Scotland, from the Ellesmere collection). Almost as much fuss was made about a tiny *Virgin and Child* said to be by Correggio, but which is not and is a total wreck (B.H. No. 270). What the 9th Earl mistakenly believed to be a *Virgin and Child* by Leonardo was in reality a painting by Joos van Cleve (B.H.

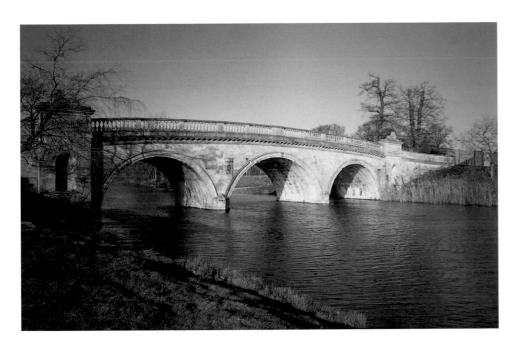

Figure 10
Lion Bridge
Lancelot "Capability" Brown

No. 350). It is hard to imagine today, when concepts of connoisseurship have so changed, to what extent the 9th Earl realized the differences between good and poor works of art. If he appreciated the wonder of his Bassano *Adoration*, how could he have believed his Correggio to be genuine? This notwithstanding, the 9th Earl's achievements at Burghley are outstanding. A lesser man might well have put away many of the late seventeenth-century Italian paintings which were then less fashionable in order to create larger areas for displaying his Old Masters. Instead Brownlow Exeter completed rooms so that all the pictures could be hung. He had wonderful frames carved for them, Carlo Dolci's *Christ Consecrating the Elements* (cat. no. 14) being just one of many.

Like the 5th Earl, whose plans for constructing formal gardens in the French style were cut short by his death, the 9th Earl also turned his attentions out of doors. He commissioned Lancelot "Capability" Brown to create a large and truly wonderful park and landscape around the great house (fig. 10). Brown's extensive plan covered more than a thousand acres with a lake, a bridge, a temple and an orangery, and new stables within the vicinity of the house.

With the death of the childless 9th Earl in 1793, the title passed to his nephew Henry (1754–1804), who though elevated to the marquessate in 1801, only enjoyed his Burghley inheritance for just over ten years. His most notable contribution to the collection was his commissioning Thomas Lawrence to paint a portrait of him, his wife Sarah (known from her humble origins as "The Cottage Countess") and their daughter Sophia (fig. 11). Painted just before the Countess's untimely death (she died in 1797 before Henry became a marquess), its combination of grandeur and tenderness places it amongst the artist's master-pieces. Following his marriage to Elizabeth, Dowager Duchess of Hamilton, the 1st Marquess commissioned another portrait from Lawrence, this one of his new wife reclining in a shady landscape with a small dog. Portraits continued to be

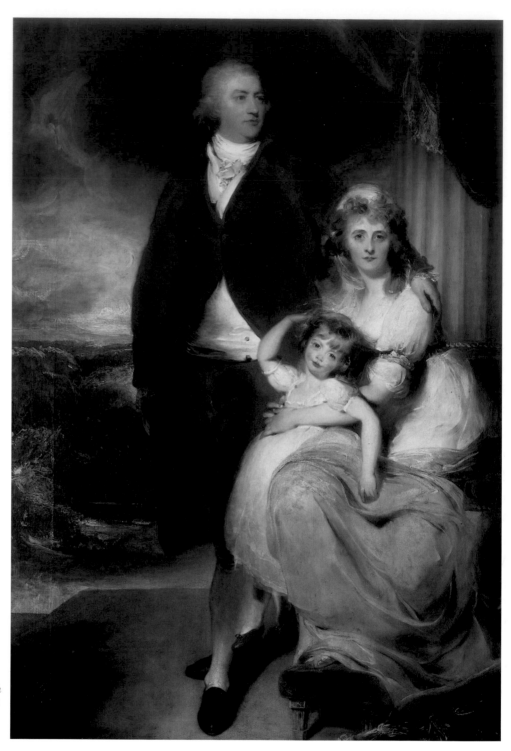

Figure 11
Sir Thomas Lawrence
Henry Cecil, 10th Earl and
1st Marquess of Exeter, with
his wife Sarah Hoggins and
his daughter Sophia
Burghley House

added to the Burghley collection by succeeding generations throughout the nine-teenth century. With the exception of a pair of portraits by Thomas Gainsborough of her forebears, which were brought to Burghley by the wife of the 4th Marquess, these portraits by Lawrence can claim to be the last of any significance to enter the house.

The 2nd Marquess (1795–1867), named Brownlow after his great-uncle, was a minor when his father died, and during his sixty-three years as Marquess he did little other than spend considerable sums of money on horses and yachts. Admittedly he did employ the architect J.P. Gandy to fill in the cloisters around the courtyard, which much improved the comfort and function of both the family apartments on the ground floor and the state rooms above. An unpopular and

extravagant man, the 2nd Marquess far outspent even his considerable income. Three royal visits, in 1835, 1842 and 1844, necessitated lavish expenditure, and at the end of his life the estate was in such debt that tens of thousands of acres had to sold. Debts were again run up by the 3rd Marquess (1825–1895). Due to the law of entail being relaxed under the Settled Land Act of 1882, the 3rd Marquess was able to raise money by selling pictures, silver and oriental ceramics from the Burghley collection. The auction held at Christie's in June 1888 was not the disaster it could have been. Only thirty paintings went under the hammer, but because those collected by the 5th Earl were then considered inferior to the Old Masters acquired by the 9th Earl, it was largely works then ascribed to the great names of Rubens, Dürer, Van Eyck, Velásquez, Leonardo and Titian that were sold. Few if any of these attributions, however, have stood the test of time. The vagaries of fashionable taste and connoisseurship saved the paintings and yet satisfied the debts.

Only three years after the death of the 3rd Marquess in 1895 his only son, the 4th Marquess, died and so began the fifty-eight-year tenure of William, the 5th Marquess (1876–1956). He was everything his nineteenth-century forebears were not: conscientious and dutiful, hard-working, dependable, paternalistic and acutely aware of his great responsibilities. In all this he was ably supported by his wife Myra Orde-Powlett (1879–1973) and as a result they were held in high regard and with great affection. After the First World War, when Burghley had been used as a hospital for wounded soldiers, life was never quite the same. The 5th Marquess and Marchioness, who being essentially Victorians, valiantly coped with the enormous changes that the war wrought upon the social order and way of life in a great house. With the Second World War the house again became a hospital, and the paintings and most of the principal treasures were packed up and hidden, especially as it was known that the German Field Marshal, Hermann Goering, had earmarked Burghley for himself.

Lady Exeter was the first person since the "list making and annotating" 9th Earl to pay any serious attention to the picture collection, sorting and noting a great deal of the archival material. Until she published her privately printed catalogue in 1954, only inventories and lists compiled in the nineteenth century documented the pictures. Though the present handlist of Burghley paintings (1st edition, 1987) is brought up to date annually and corrected with regard to attributions, and the collection is "on computer", Myra Exeter's catalogue is still indispensable when studying the picture collection.

During the years of post-war austerity, David, 6th Marquess (1905–1981) inherited the Burghley estate. He shared his mother's interest in the picture collection, and in 1969 he set up the Charitable Burghley House Preservation Trust, which ensures that the house and its magnificent contents can never be broken up. The 6th Marquess, however, is justifiably best known for his considerable athletic prowess. That the scion of a great noble family should excell in competitive athletics captured the public imagination, and in his youth he was hailed as a national hero. Lord Exeter crowned his many sporting triumphs with a gold medal for hurdling at the 1928 Olympics, and to

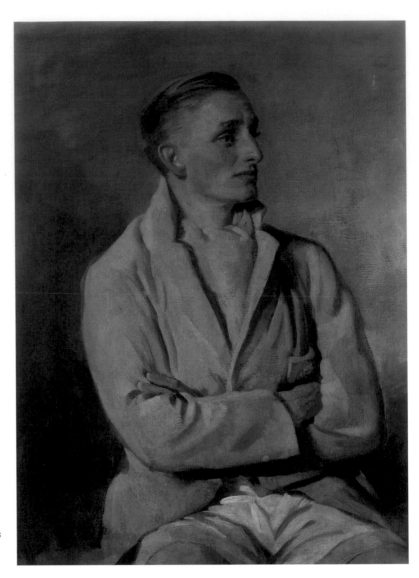

Figure 12
Sir Oswald Birley
*David, 6th Marquess
of Exeter, wearing his
"Cambridge blues"*
Burghley House

this day he is the only man to have run around the Great Court at Trinity College Cambridge within the time of the clock striking twelve (fig. 12). (In an unforgivable distortion of the truth, the honour was given to his friend Harold Abrahams in the film *Chariots of Fire*.)

His achievement of holding Burghley together at a time when the fate of such places was very much in the balance was not done without sacrifices. Death duties, escalating costs of maintenance and repairs to acres of roof, along with ever-diminishing returns from agricultural land, resulted in the sale of some treasures from the collection. Poussin's *Assumption*, Benjamin West's *Agrippina at Brindisium*, and Monnot's sculpture of *Andromeda and the Sea Monster* all entered collections across the Atlantic. In 1952 the 6th Marquess did augment the collection by buying in its entirety one of the largest (more than three hundred pieces) and finest collections of Chinese snuff bottles, including nine eighteenth-century Imperial ivory examples.

In 1982, following the deaths of her father, the 6th Marquess, and her mother, the Trustees of the Private Charitable Fund invited Lady Victoria and her husband Simon Leatham to occupy and manage the house on behalf of the family. Lady Victoria's boundless energy, indefatigable enthusiasm, and sound commercial and common sense, combined with her abiding love for her ances-

tral home and the achievements of her forebears, have brought about a *renaissance* at Burghley. The entire picture collection has been re-hung; an ongoing restoration scheme has been set in motion, and ultraviolet excluders have been placed on all the windows to minimize fading of furniture, paintings and fabrics. Rotting beams above the Verrio ceilings have been replaced and the entire roof repaired. Every year a new exhibition addressing some aspect of the many different collections is mounted at the house. The outstanding collection of Japanese porcelain which was amassed by the 5th Earl and his wife and which was "lost" for several generations has been exhibited in both America and Japan. The entire contents of the house, running to thousands of items, has been properly inventoried, and specialists are consulted on all aspects of the collections. An ongoing programme of restoration is also in place. On this front Burghley is the only house to have secured corporate sponsorship for the restoration of works of art and paintings. Though the rooms of the private apartments are larger and grander than the state rooms of most English country houses, Burghley is far from intimidating or museum-like. It is very much a family home, with a wonderfully welcoming atmosphere, but where the past is honoured and respected.

For the 1985 exhibition *Treasure Houses of Britain*, more items were lent from Burghley than from almost anywhere else. Burghley can fairly claim to be *the* treasure house of Britain, as almost every field of art is represented there and all of the finest quality. Losses to the collection over three hundred years are infinitesimal by comparison to those of other great houses. The exhibition and catalogue *Italian Paintings from Burghley House* include less than 10 percent of the paintings that hang there. In his *Antiquarian Annals of Stamford* (1727), Peck wrote, "As Burghley, therefore, is so abundantly stocked, with original pictures, nice furniture of all sorts, and such a variety of other curiosities, in every kind, that is rich and costly; and those also so numerous, that, if they were parcelled out, among twenty other great houses, there would be enough in each to make them all worth going to see; . . .". This too was written a quarter century *before* the 9th Earl's very considerable additions to the collection.

> *No wonder then, if Burghley unsurveyed,*
> *Strangers think not the Tour of Britain made.*
> — 1797 inventory, p. 203

1. Celia Fiennes, travelling through England at this time, records a long description of Burghley:
" . . . and very fine paint in pictures, but they were all Without Garments, or very little, that was the only fault, the immodesty of ye Pictures Especially in my Lords appartment."

2. Lord Exeter not only refused to take the two oaths of allegiance to William and Mary (one of which was a denial of the Catholic faith) but he also declined to fulfill his role of Lord High Almoner at their coronation in 1689. When William, during his progress of 1696, visited Burghley, though hospitality was laid on, Lord Exeter absented himself by leaving for London (see Macauley, *History of England*, vol. 2 [1899], p. 537).
We do know, however, that the Exeters stayed in a Huguenot house whilst travelling through France to Italy and that after his death Lord Exeter was referred to as "heretico Inglese" by Conte Orazio D'Elce (died 1701) in his *Vite de Cardinale* (see Francesco Valesio, *Diario di Roma, 1700–1742*). Perhaps to shield his heirs from recriminations or to divert attention, the long and laudatory inscription on his tomb included the claim "Ecclesiae Anglianae, fortis semper Propugnator".

3. The size and magnificence of the wine cooler caused a stir when it was shown in 1985 at the National Gallery of Art in Washington, D.C., as part of the exhibition *Treasure Houses of Britain* (no. 120).

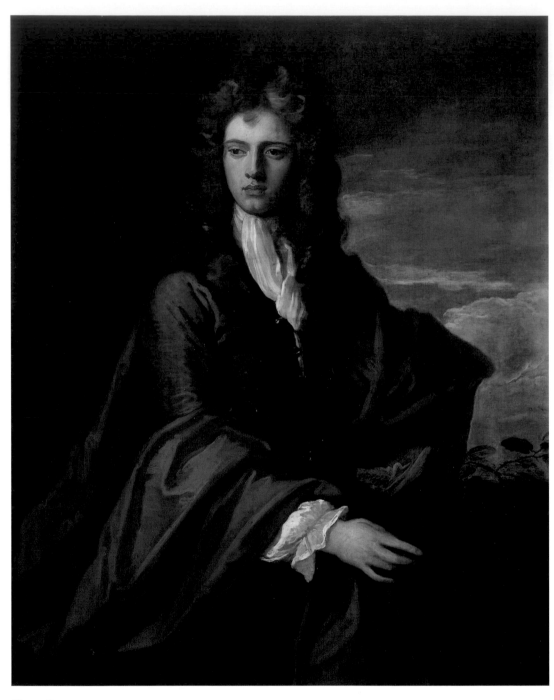

Figure 1
Sir Godfrey Kneller
John Cecil, 5th Earl of Exeter
Burghley House

John Cecil, the 5th Earl of Exeter: An English Traveller, Patron and Collector in Italy

Hugh Brigstocke

F rom the moment of his succession as 5th Earl of Exeter in 1678, John Cecil (1648–1700, fig. 1) set about the development of Burghley House, originally built between 1557 and 1587, on an extraordinarily ambitious, indeed palatial scale. Dr Eric Till, whose unrivalled knowledge of the Cecil family archives is based on a lifetime's research, has observed that the 5th Earl employed the best available skilled craftsmen, including "a surveyor (architect) and the small band of elite London tradesmen who worked in the Royal Palaces, great country houses and towards the end of the century, in the rebuilding of St Paul's Cathedral – joiners, carpenters, masons, plasterers, woodcarvers, ironworkers and decorative painters".[1] Their task was to reconstruct and redecorate all the major rooms.

> The two long galleries on the first and second floors of the west front were divided into rooms, seven to each floor and the ground floor developed as an appartement in the French fashion: four rooms (anteroom, dressing room, bedchamber and closet) on each side of a central hall, the Earl's suite to the north, the Countess's to the south. The whole of the south front on the first floor was to be altered to a suite of five state rooms (The George Rooms) for the entertainment of royalty. In addition, all the other major rooms were to be brought up to date and suitably furnished.[2]

Much of the money, as well as of the initiative, for all these projects was brought to Burghley by the 5th Earl's wife Anne, daughter of William Cavendish, 3rd Earl of Devonshire, whom he had married in 1670. As Till has further observed, "She ordered furnishings and commissioned work as she saw fit, reflected in the fact that at the Earl's death in 1700, his immediate personal debts of £8,000 were nearly equalled by those of his wife".[3]

At home in England their patronage of painters was directed above all to Antonio Verrio (c. 1639–1707), who after working in Naples and Toulouse had been brought to England by Ralph, 1st Duke of Montagu in 1672 and had then worked for the Royal family at Windsor between 1675 and 1684. Verrio came to Burghley in 1696 and remained until 1697, during which period he decorated

the ceilings of all four George Rooms, as well as the Heaven Room and the Hell Staircase. Sir Godfrey Kneller painted the portraits of both Lord and Lady Exeter.

The 5th Earl does not appear to have had any appetite either for court life or for political intrigue – he refused to sign the oath of allegiance to William III – and preferred to spend much of his time out of the country, on extensive recreational tours of the Continent. The physical disruption and the building works at Burghley House may well have provided a further incentive to travel. Lord Exeter went abroad on at least four occasions, from 1679 to 1681, from 1683 to 1684, in 1693 and from 1699 to 1700. There is some scant evidence from bank accounts at Child's and from passport applications that the Earl was also abroad in 1689.

The "passe" or passport granted for the 1679 departure was for John, Earl of Exeter and Anne, his wife; his son John, Lord Burghley, then aged five; John Willoughby and John James Gaeles who may have been young army officers acting as bodyguards; Edward Child, his chaplain; five women and fourteen men-servants; and thirty horses. They appear to have set off by private yacht, ludicrously over-equipped with carriages, a huge tent, kitchen equipment and unsuitable heavy woollen clothing. After crossing the Channel they then travelled south via Paris, where they may have spent the winter and where they bought furniture and tapestries; Tours, where they are recorded on 13 May 1680 "in the house of a considerable merchant and Huguenote"; Lyon, where they are recorded on 14 October 1680 "demeurant a la pomme de Pin, En Belle Cour, a Lion . . ."; Turin, where Lord Exeter had arrived (or was due to arrive) on 22 October 1680; Genoa, where they are recorded in November 1680 "au Logis del Sig. Carlo Ricca Bang . . le."; and Venice, where John Hobson, the British consul, was awaiting their arrival on 20 December 1680. It is not clear from the surviving records if they had travelled over the Alps from France or if they took a boat from some port on the French Riviera.

Their subsequent itinerary within Italy included Lucca, Padua, Florence and Rome. Their precise movements, however, are sometimes difficult to chart, since the party often split up, with the steward Culpepper Tanner, whose correspondence provides many essential clues, often going on ahead to make the necessary arrangements. Certainly Tanner was at Lucca by February 1681, and Lord Exeter was at Padua by 29 March, when he left behind a coach horse. After this they probably moved on to Venice but had already left again by 12 April. At this juncture the indispensable Mr Tanner became ill, and after a disagreeable day's travel from Padua, during which the Exeters invited him to travel in their carriage, he retired to bed for ten days at Bologna. Lord Exeter meanwhile went on to Florence and then travelled south to Rome on the Monday in Easter week. After this, there is no useful documentation until 17 August 1681, when Tanner, who was now back in France, at Tours, wrote to Mr Balle and Mr Mann, two Italian agents or picture dealers based, respectively, at Genoa and Florence, that his Lordship was expected on a ship departing from Leghorn.

Although this initial tour of Italy by the Exeters did not result in the purchase of major paintings, the letter from Tanner of 17 August 1681, described

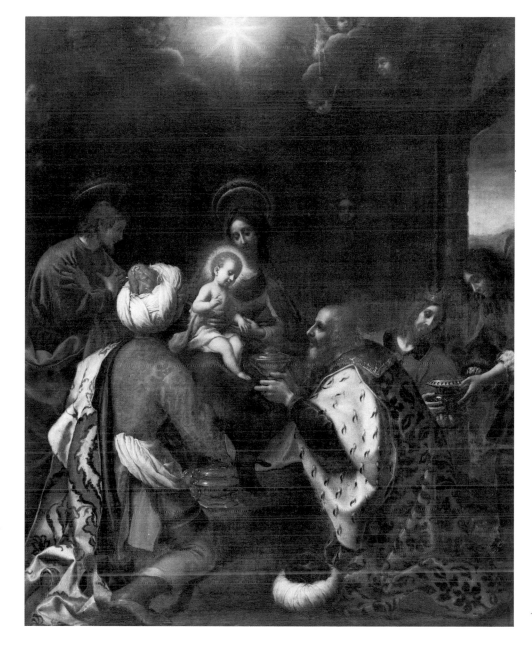

Figure 2
Carlo Dolci
Adoration of the Magi
Burghley House

above, refers to two paintings by contemporary artists active in Florence which had been acquired by or on behalf of Lord Exeter: a picture by "Sigr. Livio Maous" (i.e., Mehus) and a copy of a Carlo Dolci. "Mr Laurenzini told my Lord of a Coppie of the adoration done by Carlo Dulce which if itt Cannot be done by the time his Lordsp desires may be done and Sentt after by some opportunity". This almost certainly is a reference to Carlo Dolci's *Adoration of the Magi* (fig. 2), which is still at Burghley House (B.H. No. 456). This painting is not in fact a copy but an autograph variant of a picture at Blenheim Palace which had originally been painted for Leopold de Medici.[4]

The second Italian tour of 1683–1684 is far more extensively documented, due to the survival of two bundles of accounts which record day-to-day disbursements made by Culpepper Tanner. Although the record is far from complete there is sufficient evidence of both sightseeing and picture buying vividly to convey the spirit and character of the expedition. On this occasion the party which set out around 17 September 1683 comprised Lord Exeter (but apparently not his wife and son), together with two military gentlemen to serve

as companions and bodyguards, Captain Hyde and Captain Charles Fitzwilliam; Edward Child, the chaplain; Culpepper Tanner, the steward; and four servants. They wintered at Florence and were quickly absorbed into the court circle of Cosimo Grand Duke of Tuscany. This was just after Luca Giordano had visited Florence from Naples to decorate the Corsini family chapel in the church of the Carmine and had made *modelli* for the decoration of the gallery of the Palazzo Riccardi, a project he would complete when he returned to the city in 1685. Lord Exeter took the opportunity to acquire two vast Giordano paintings, which the artist had only recently completed and then left behind – *The Rape of Europa* and *The Death of Seneca* (cat. nos. 24, 25). They were bought through the agency of Mr Balle from Genoa, who himself elected to proceed anonymously through an intermediary. Lord Exeter went on to commission or purchase a further thirteen pictures by Giordano, which are listed in the 1688 inventory and most of which remain *in situ* at Burghley House.

To judge from Balle's letter, dated December 1683 and now in the Burghley archives, there is some suggestion that Lord and Lady Exeter had already visited Genoa and had commissioned pictures there from Domenico Piola and Giovanni Andrea Carlone.

> Piola is now finishing ye designes promised, and I hope in [. . .] or two shall have them, Carlone hath bin with mee, and desires may doe somewhatt for ye honor, and I beleeve would doe itt well, and moderate, being seemes very ambitious you should have some of his worke sue you may please lett me knowe ye pleasure, and I shall act accordingely.

The Piolas can no longer be identified at Burghley and may have been disposed of after the 5th Earl's death. However, pictures by Piola are recorded in the 1688 Burghley House inventory, on page 7 as "1 Satyr and Boyes", on page 13 as "the Child Achilles delivered to a Centaur" and on page. 23 as "2 pieces of Boyes". On the other hand Carlone's bid for work may have been unsuccessful since pictures by him do not appear in the 1688 inventory.

Lord Exeter's most significant expression of artistic taste in Florence at the Grand Duke's court was his predilection for the work of Carlo Dolci. Already on his earlier journey he had commissioned a version of *The Adoration of the Magi*. He went on to acquire eight more pictures by the artist, including above all *Christ Consecrating the Elements* (cat. no. 14), and *The Flight into Egypt* (fig. 3), which he only received after 1688 as a gift from Andrea del Rosso, one of the artist's principal patrons.[5] The 5th Earl's preference for Dolci was shared by other Englishmen, most notably Sir John Finch, a British resident in Florence, and Sir Thomas Baines, who studied medicine in Padua. Both Finch and Baines sat to Dolci for their portraits during the period 1665–1670.

Towards the end of the winter of 1683–1684, Lord Exeter's party moved on to Rome, and from there they made a twelve-day sightseeing excursion to Naples, for which they hired a light open carriage (a calash). The trip back to Rome took them to Gaeta, Fondi, Terracina, Priverno and Velletri, and the expenses were meticulously recorded by Tanner. Apart from the cost of the horses, saddlery and a whip, he also enters such gastronomic necessities as wine

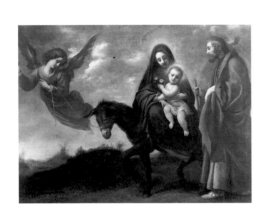

Figure 3
Carlo Dolci
The Flight into Egypt
Burghley House

and ice, cherries and sweets. It was almost certainly during the Neapolitan excursion that Lord Exeter first encountered the work of Giuseppe Recco and commissioned two large decorative flower pieces (cat. nos. 42, 43), although it was not until the following May that the British consul, George Davies, paid the artist sixty-six ducats as the first installment of the agreed price of four hundred ducats. Another commission to the artist for paintings of fish and game followed in 1685, long after Lord Exeter had returned home. The two magnificent still life paintings ascribed to Giovanni Battista Ruoppolo (cat. nos. 45, 46) and Mattia Preti's *The Triumph of Time* (cat. no. 41) may also have been acquired or commissioned by the 5th Earl during his stay in Naples in 1684. More puzzling are the frequent references in the 1688 Burghley House inventory to works by Francesco di Maria on a variety of themes, including Susannah and the Elders, Herodias, Argus and Io, Diana, Orpheus, and Prometheus. None of these works can now be identified, and they were probably sold after the 5th Earl's death.

Back in Rome the tempo of Lord Exeter's picture buying increased. Tanner's accounts record a very substantial payment of six hundred crowns to Carlo Maratta, an amount that was probably sufficient to account for *The Penitent Magdalen with an Angel* (cat. no. 34), *Christ and the Woman of Samaria at the Well* (cat. no. 33) as well as the series of four small pictures of

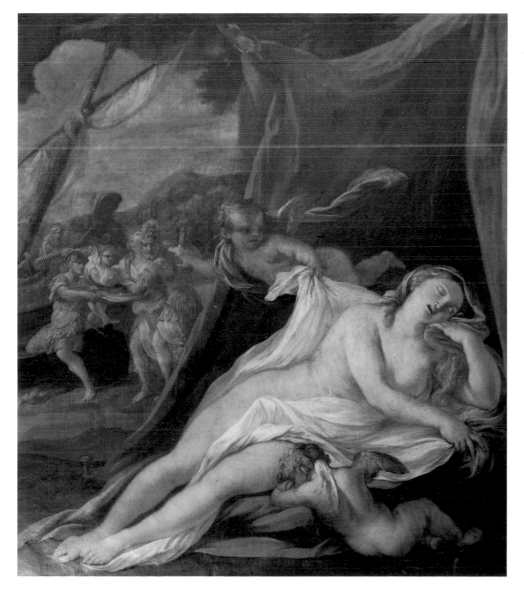

Figure 4
Agostino Scilla
Ariadne Abandoned by Theseus
Burghley House

Leda and the Swan, Ixion Embracing the Cloud, Jupiter and Semele, and *Danae and the Shower of Gold* (cat. nos. 35–38). Lord Exeter was by no means the first travelling Englishman to commission work from Maratta. He was preceded by the 4th Earl of Roscommon, by Sir Thomas Isham of Lamport Hall, and by John Herbert, Master of the Bench of the Inner Temple, all of whom had commissioned portraits from the artist. Surprisingly, there is no known portrait by Maratta of the 5th Earl of Exeter, although Bellori, in his life of the artist, refers to one.

Sir Thomas Isham had been in Rome from 1677 to 1678 and, apart from Maratta, had also patronized Giacinto Brandi, David de Koninck, Ludovico Gimignani and Filippo Lauri, as well as ordering copies after early sixteenth- and seventeenth-century masters by Giovanni Remigio.[6] The names of all these artists recur in Lord Exeter's accounts in Rome in 1684. Exeter and Isham even used the services of the same agent, Sr Talbot, a priest at the Vatican, who sold Lord Exeter a pair of pictures by Giacinto Gimignani and Turchi. Exeter's payment to Lauri of one hundred crowns was probably for four pictures on copper of *St Stephen* and *St Laurence*, and of *Apollo* and *Midas*, which are all still at Burghley House. He also paid seventy-four crowns to Agostino Scilla for *Ariadne Abandoned by Theseus* (fig. 4), which remains at Burghley, on its original support, in the Black and Yellow Bedroom; 104 crowns to Ludovico Gimignani for pictures which are not listed under the artist's name in the 1688 Burghley House inventory and cannot now be identified; 125 crowns to David de Koninck whose name appears several times in the 1688 inventory and many of whose pictures from this moment remain at Burghley (B.H. Nos. 116, 120, 479); sixty crowns to Daniel Seiter for a pair of pictures of *Venus, Cupid, Ceres and Bacchus* (cat. no. 51) and *Sleeping Venus* (B.H. No. 300), which remain at Burghley; twenty crowns to Giacomo Brandi for *Elijah and the Widow* (B.H. No. 107, fig. 5); and twenty crowns to Giacinto Calandrucci for *Venus and Adonis* (cat. no. 4). The frequent references to Remigio in the 1688 inventory might suggest that the 5th Earl was buying copies of Old Masters as well as original works from his contemporaries, although most of the Old Master copies still at Burghley traditionally have been associated with the 9th Earl's collecting activities in the eighteenth century.

From Rome, Lord Exeter's party travelled north, along a route which included Monterosi, Montefiascone, Bolsena, Acquapendente, Radicofani, Torrenieri, Siena, Poggibonsi and Bologna, which they reached on 24 February 1684. Tanner's accounts contain no further references to picture buying. For this we have to turn instead to a second bundle of accounts, beginning on 25 May, by which time the travellers were again based at Florence. Their destination was Milan which they reached by way of Firenzuola, Loiano, Bologna (whence they departed on 30 May), Modena, Reggio, Parma, Piacenza and Lodi. Three boxes of pictures were dispatched by Tanner from Bologna to Leghorn. It seems likely that their contents included pictures by Bolognese artists listed in the 1688 inventory, such as the signed *Magdalen* by Lorenzo Pasinelli (B.H. No. 418, fig. 6), although it is not mentioned specifically in the accounts. From Milan the journey continued to Ferrara, Rovigo, Padua, Fusina, Venice, Vicenza

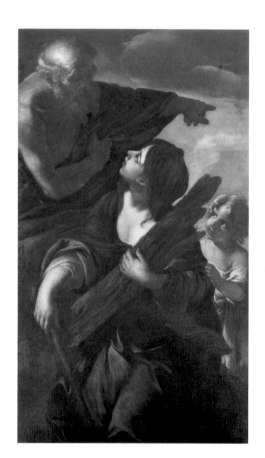

Figure 5
Giacomo Brandi
Elijah and the Widow
Burghley House

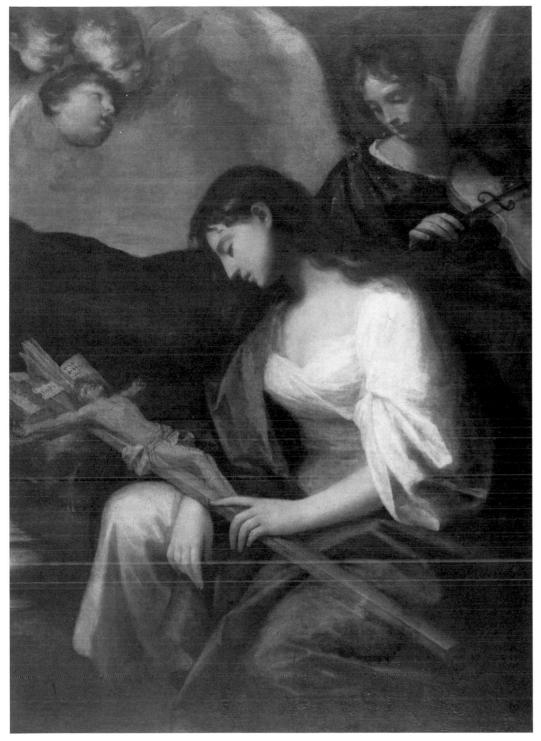

Figure 6
Lorenzo Pasinelli
Magdalen
Burghley House

Figure 7
Jacopo di Castello
Beasts and Birds
Burghley House

and then back to Padua, Verona, Brescia and Bergamo. Pictures acquired in Padua or Venice by 2 June 1684, with the help of Mr Thomas Hobson, the British consul, included "3 peices of beasts and birds" by Jacopo di Castello (B.H. Nos. 145 [fig. 7], 513, 525) and a *Magdalen* by Pietro Liberi. This picture by Liberi is one of six paintings apparently bought directly from the artist by the 5th Earl (see cat. no. 30), although some, especially *The 6th Earl of Exeter when a Child, Pulling Fortune by the Hair*, may well date from the earlier tour of 1679–1681.

No references are made in the accounts to other major Venetian pictures acquired by the 5th Earl before 1688, including two works by Antonio Zanchi – *Jephtha's Vow* (cat. no. 60) and *Saul and the Witch of Endor* – and two works by

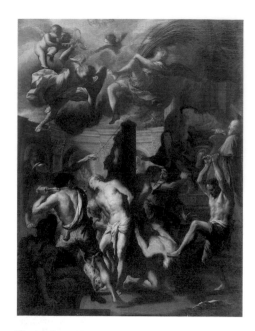

Figure 8
Francesco Trevisani
The Martyrdom of the Four Crowned Saints
Burghley House

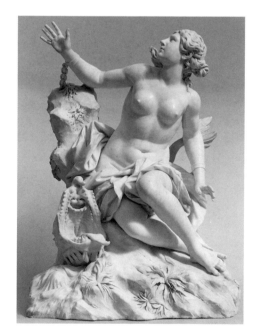

Figure 9
Pierre-Etienne Monnot
Andromeda and the Sea Monster
The Metropolitan Museum of Art, Purchase,
1967. Josephine Bay Paul and C. Michael Paul
Foundation, Inc. and Charles Ulrick and
Josephine Bay Foundation, Inc.

Johann Carl Loth – *The Idolatry of Solomon* and *The Finding of Moses* (cat. no. 32).

Finally comes evidence that Lord Exeter was back in Genoa in the autumn of 1684. A list in the Calendar of Treasury Books VII (pp. 1250–1251) under 14 October records forty-six pictures held by the customs there, but released on payment after Lord Exeter had confirmed that "they were all bought by his Lordship himself for his own house at Burghley". The Genoese artists named include Piola, Jockino (i.e., Assereto), Antonio Vassallo, Tempesta, Mullo (Vincent Malo?), "Antonio Mallino", Gregatto (i.e., Castiglione), Antonio da Sestri (i.e., Travi), Badarucco, Raggio (i.e., Pietro Paolo Raggi), Pagniolo Minitto, Ferrari and Valerio Castello. Few works by these artists can now be identified at Burghley, although it is reasonable to suppose Valerio Castello's *Joseph and Potiphar's Wife* (cat. no. 7) was part of this consignment, together with some of the large group of paintings by Tempesta which are still at Burghley. As Sir Ellis Waterhouse observed, however, it is "further remarkable evidence of Lord Exeter's patronage of contemporary painters".[7] Most of the artists were praised by Soprani in his *Vite de' pittori scultori et architetti Genovesi 1674*, which Lord Exeter had bought in Rome earlier in the year.

Lord Exeter's last tour of Italy began in September 1699. On this occasion he was joined by his wife and his three children. They were accompanied by Captain Richard Creed, a half-pay officer from the Earl of Denbigh's regiment, who probably acted as a bodyguard and whose travel journal has survived.[8] This provides evidence, not available in the Burghley archives, of the itinerary of Lord Exeter's party from 30 September 1699, when they embarked at Dover for Calais, to 23 December, when they reached Rome. The route was through Moncenesio, Susa, Vigliana, Turin (18–24 November), Vercelli and Castiliana, but to judge from Creed's account little serious sightseeing took place. In Rome, however, Lord Exeter appears to have lost little time before catching up with recent artistic developments in the city. In particular he admired Trevisani's impressive work in the Crucifixion chapel in S. Silvestro, which was only completed in 1696, and he commissioned or bought from the artist autograph copies of *The Mocking of Christ* (cat. no. 54) and *The Flagellation*. He also acquired a sketch after Trevisani's altarpiece of *The Martyrdom of the Four Crowned Saints* in Siena Cathedral, dating from 1688 (fig. 8). Above all he bought the outstanding *Noli Me Tangere* (cat. no. 55) which provides an important landmark in Trevisani's stylistic development prior to 1700. Lord Exeter also turned to Maratta's principal pupil, Giuseppe Chiari, acquiring his *Virgin and Mary Magdalen Mourning over the Dead Christ* (cat. no. 10), perhaps after admiring an earlier version of the same design in the collection of the Accademia di San Luca, Rome. Other paintings by Chiari – *Venturia and Volumnia Imploring Coriolanus not to Take up Arms against Rome* (cat. no. 9) and *Tullia Driving her Chariot over the Body of her Father Servius Tullius* (cat. no. 8) – had originally been painted for Jacopo Montinioni, treasurer to Pope Innocent XII, who died in 1687. Presumably they had come back on to the market, but the circumstances surrounding this acquisition are not recorded.

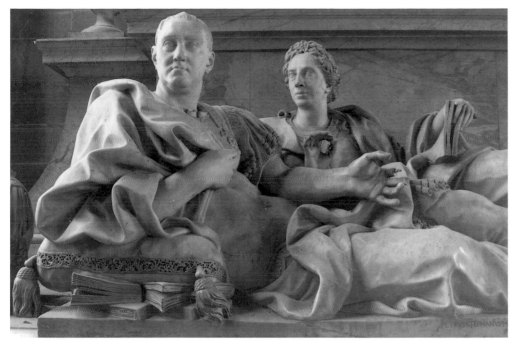

Figure 10
Pierre-Etienne Monnot
The 5th Earl and Countess of Exeter
St Martin's Church, Stamford

Lord and Lady Exeter also used their time in Rome to commission a group of sculptures from the French artist Pierre-Etienne Monnot (1657–1733). The most ambitious project, based on Ovid's *Metamorphoses*, represents *Andromeda and the Sea Monster* (fig. 9). This was flanked by two *Infant Triton* fountains that remain at Burghley. In one, the young man may be identified as Narcissus, while the older man in the other fountain has been identified as Phineus. These works were conceived and designed in 1699 but not completed until 1704. Monnot was also commissioned to design a funerary monument of the 5th Earl and his wife for the church of St Martin, Stamford. It shows the Exeters dressed in Roman attire, on an inscribed sarcophagus flanked by figures of Victory and the Arts (fig. 10). Sadly this remarkable monument was called into use rather sooner than the patrons may have anticipated. The 5th Earl died at Issy, near Paris, on the way home from Italy on 29 August 1700. Anne, his wife, died in 1703. The monument, as well as the Andromeda statue, was completed in 1704.

By the time of the 5th Earl's death only the First George Room at Burghley House had been completed. Many of the pictures bought in Italy had still not been displayed. Debts exceeded £38,000 and it took an Act of Parliament and fourteen years for the executors to clear the estate. It is likely that many of the pictures in the 1688 inventory which can no longer be identified were disposed of during this period. As Eric Till dryly observed, "Collecting and patronage on such a scale carries a price."[9]

1. Till 1988, pp. 2–3.
2. Till 1988, 3.
3. Till 1988, 3.
4. F. Russell, *Treasure Houses of Britain*, p. 335.
5. This is recorded by Baldinucci in his biographical note on Dolci. See Baldinucci 1845, p. 500.
6. For Isham see Burdon 1960, pp. 15–16.
7. Waterhouse 1960, p. 57.
8. For Creed see J. Black, "Savoy – Piedmont in 1699", *Studi Piemontesi*, vol. 15 (March 1986), pp. 189–193.
9. Till 1990, p. 2.

Authors' Note

The authors of this catalogue could never have brought this project to fruition without the help of art historical colleagues throughout the world, and we would especially like to thank the following: Ilaria Bignamini, Edgar Peters Bowron, Rosemary Dewell, Oreste Ferrari, Roger Griffiths, Ann Sutherland Harris, Francis Haskell, Mary Howarth, Michael Jaffe, Michael Kitson, Helen Langdon, Denis Mahon, Uschi Niggemann, Marcel Röthlisberger, Cristiana Romalli, Pierre Rosenberg, Stella Rudolph, Erich and Mary Schleier, David Scrase, John Spike, Eric Till and Nicholas Turner. Other scholars are acknowledged in individual catalogue entries.

We would both like to thank the staff at Burghley House, above all Jon and Sarah Culverhouse, Charles Pugh and Nicholas Humphrey, and our colleagues at Sotheby's in the Old Master Paintings and Drawings Department, especially Tim Llewellyn and Julien Stock who generously supported the project in its early days. Our thanks also to Michael Cowell, who has cleaned, restored and prepared many of the paintings for this exhibition and for his help with technical information. Last but by no means least, we mention the help of our volunteer researchers, Alberto Chiesa, who helped initiate the project, Florence Broberg, Cecilia Treves and above all Xavier Bray, who worked intensively on the catalogue in the final year of its preparation.

We are very grateful to Lynn K. Rogerson, Director, and Joseph Saunders, Chief Executive Officer, of Art Services International for the invitation to make this exhibition. We wish to thank all the staff at ASI and in particular Marcia Brocklebank, their representative in England, and Nancy Eickel, their editor, for their help in completing this project.

Finally, we would like to express our warmest gratitude to Simon and Victoria Leatham for all their encouragement, forbearance and generous hospitality. This above all ensured that our work on this exhibition was not only a privilege but a constant source of pleasure.

Hugh Brigstocke John Somerville

Notes to the Catalogue

Individual entries were written by Hugh Brigstocke, Director and Senior Expert in the Department of Old Master Paintings, Sotheby's, London, and John Somerville, Honorary Keeper of the Burghley House Painting Collection. John Somerville wrote entries 5, 27, 28, 29, 31, 32 and 51; Hugh Brigstocke contributed the remaining entries. Works are arranged in alphabetical order in accordance with the artist's name. Dimensions are given in both centimetres and inches, height preceding width. All paintings are property of the Burghley House Preservation Trust, and the Burghley House inventory number (indicated as B.H. No.) is provided for each work.

Information given on the provenance of each work is based largely on early inventories taken at Burghley House and now housed in the Burghley archives, as well as on subsequent publications. Original spelling in the inventories has been retained. Individual inventories and publications are referenced by date, as follows:

1688 "An Inventory of the Goods in Burghley House belonging to the Right Honble. John Earl of Exeter and Ann Countesse of Exeter. Taken August 21st 1688". Manuscript.

1738 "A Description of Burghley House, August the 14th 1738". Manuscript.

1797 *A History or Description General and Circumstantial of Burghley House, The Seat of The Right Honourable The Earl of Exeter.* Shrewsbury, J. & W. Eddowes.

1815 *A Guide to Burghley House . . . Containing A Catalogue of all the Paintings, Antiquities & c. . . .* Stamford, John Drakard.

1847 Rev. W.H. Charlton. *Burghley . . . A Description of Burghley House, with a Complete and Accurate Guide to the Several Paintings, Tapestries, Antiquities, etc.* Stamford, W. Langley.

1878 Rev. W.H. Charlton. *History of Burghley . . . with a Description of Burghley House, Forming a Complete and Accurate Guide to the Several Paintings, Tapestries, Antiquities, etc.* Stamford, Henry Johnson.

1882 *Guide to Burghley House, Stamford, The Seat of the Most Honourable The Marquis of Exeter, etc., etc.* Stamford, John H. Howard (revised edition 1888).

1954 Myra Exeter. *Catalogue of Pictures at Burghley House Northamptonshire.* Privately printed.

In the literature section of the entries, as in the entries themselves, references to other books, exhibition catalogues and articles have been shortened following an author/date system. Full citations are given in the bibliography.

Catalogue of Works

1.

MICHELANGELO ANSELMI
Lucca 1491 – 1554 Parma

Christ and the Woman of Samaria

Oil on canvas
47.5 by 39 cm; 18¾ by 15½ in.
B.H. No. 420

Provenance:
Bought by the 9th Earl; said to have belonged
to Cardinal Mazzarin (inscription on reverse is
in the 9th Earl's hand; the same information is
repeated in his annotated copy of Orlandi,
Abecedario Pittorico, 1704, p. 313, as follows:
"Christ and the Woman of Samaria by Giulio
Romano formerly in Cardinal Mazzerenis col-
lection is now at Burghley". First recorded at
Burghley in a list made out in the 9th Earl's
hand, *Extracts from an old catalogue of ye fur-
niture at Burghley*, as "Christ and ye Samaritan
Woman by Julio Romano once belong'd to
Card'. Mazarine"; also in 1815, p. 115; 1847, p.
251, no. 411; 1878, p. 52, no. 420; 1954, no.
420, all as by Giulio Romano.

Acquired as by Giulio Romano, *Christ
and the Woman of Samaria* was still list-
ed under this attribution in the invento-
ries of 1815 (p. 115) and 1847 (p. 251).
The attribution to Michelangelo Anselmi
was first suggested by Philip Pouncey
(oral communication, 1983). Anselmi,
who was active primarily in Parma,
played a major role in the revival of
painting in that city, working like
Parmigianino before him in an eclectic
but highly individual mannerist style.
The prominent landscape in the present
painting may reflect the influence of
Beccafumi and Sodoma, under whom
Anselmi is traditionally said to have
trained in Siena.

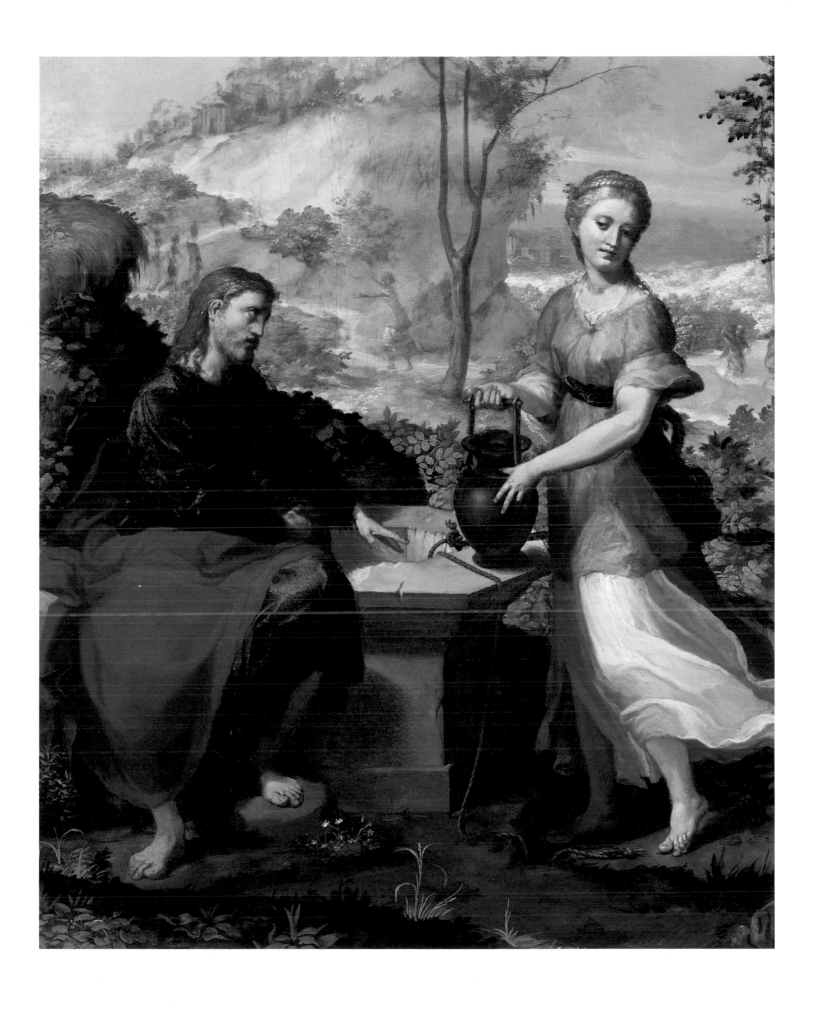

2.

JACOPO BASSANO (JACOPO DA PONTE)
Bassano 1510/1518 – 1592 Bassano

The Adoration of the Kings

Oil on canvas
149 by 224 cm; 58¾ by 88¼ in.
B.H. No. 375

Provenance:
Probably the picture of this subject commissioned in 1537 by Giovanni Simon Zorzi for the chapel of the Palazzo del Podestà in Bassano del Grappa, recorded in the artist's *Libro Secondo* (see Muraro 1992). Perhaps taken by Zorzi to Venice when he left Bassano in November 1538; perhaps at Casa Widmann, Venice, soon after 1586 when Giovanni Widmann, a noted collector, came to Venice; and in any case by 1648 (see Ridolfi); bought by the 9th Earl from Sigr. Vitturi in Venice ("in his Gondola at night", according to a note in the Burghley archives), and recorded in a list made in the 9th Earl's hand, *Extracts from an old catalogue of ye furniture at Burghley,* as follows: "*Adoration of the Magi* by Bassan painted for the Vidimana [*sic*] family, from them it came to Sigr. Vitturi, a Venetian Senator, of him Lord E. bought it"; also recorded at Burghley in 1797, p. 25, as in the South Dining Room, and again in 1815, p. 106; 1847, p. 242, no. 371; 1878, p. 48, no. 375; 1954, no. 375, all as by Bassano.

Literature:
Ridolfi 1648, vol. 1, p. 400; Waagen 1854, p. 404, as by Pordenone; Gerola 1909, pp. 32–36; Crowe and Cavalcaselle 1912, vol. 3, p. 182; Longhi 1948, p. 44, fig. 55; Zampetti 1957, pp. XXIV–XXV, fig. 2; Berenson 1957, vol. 1, p. 17; Rearick 1958, vol. 12, pp. 197–200, fig. 218, and illustrating the Chantilly drawing, fig. 217; Arslan 1960, vol. 1, p. 165; Brigstocke 1993, pp. 26–27, under no. 100; Muraro 1992, fol. 95v–96r; Rearick 1993, pp. 54–55, fig. 16.

Acquired in Venice by the 9th Earl as a work by Jacopo Bassano. This attribution is accepted by all modern scholars. In the nineteenth century, however, it was attributed to Pordenone (Waagen 1854). Rearick has suggested that the Burghley House picture may be identifiable as *The Adoration of the Magi* recorded in Bassano's diary/account book, the *Libro Secondo* (fol. 95v–96r), as commissioned in 1537 by the Podestà Giovanni Simon Zorzi for the chapel of the Palazzo del Podestà in Bassano del Grappa. In this case the prominent Venetian senator in the centre of the picture may be a portrait of Giovanni Simon Zorzi. This identification of the Burghley House picture is entirely consistent with the dates of circa 1537–1540 which have been proposed for the picture on the basis of its style.

The Burghley House *Adoration* reflects the moment when Bassano's early debt to Bonifazio Veronese is combined with fresh stylistic influences derived from Pordenone, but before he had absorbed the mannerist influence of Parmigianino, which strongly affected his later work in the 1540s. Clear compositional links are found between the present painting and Pordenone's picture of the same subject, dating from 1521, in the Cappella Malchiostro of Treviso Cathedral. The Madonna and the overpowering horse and rider at the right (based on a Pordenone drawing in the Musée Condé, Chantilly; see Rearick 1958, fig. 217 and Rearick 1993, p. 54, n. 36) provide clear evidence of Bassano's debt to Pordenone. Rearick (1993, p. 54), however, has observed that the Burghley House picture is quite independent of Pordenone's influence in its chromatic emphasis and its strong local colours: "Quite unlike Pordenone's tonality, Jacopo's emphasis on lustrous white, pale rose, apple green and rust here assumes a personal character distinct from that of his sources".

Another *Adoration of the Magi* by Jacopo Bassano, now in the National Gallery of Scotland and formerly in the Balbi collection, Genoa, repeats many elements from the Burghley House picture. It is less dependent on Pordenone, however, and may date from slightly later. Here too the artist expresses his individuality through a brilliant juxtaposition of intense local colour, enhanced by a subtle sense of light and shade.

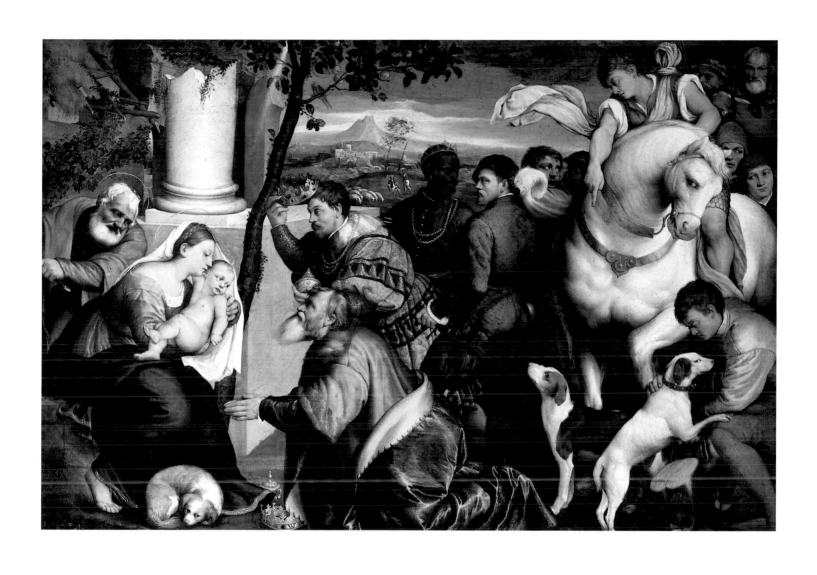

3.

ANDREA DEL BRESCIANINO
Active in Siena 1506 – 1524 and in Florence 1525

The Holy Family, with the Archangel Michael, St Jerome and the Infant St John the Baptist

Oil on panel
71 by 54.5 cm; 28 by 21½ in.
B.H. No. 425

Provenance:
Probably acquired by the 9th Earl, and first
recorded at Burghley House in a manuscript
inventory of 1793, partly in the hand of the
9th Earl, as "a holy family by Ghirlandaio"; also
recorded in the 9th Earl's annotated copy of
Orlandi, *Abecedario Pittorico*, 1704, p. 445, as
by Ridolfo Ghirlandaio; recorded in 1815, p.
115, and 1847, p. 251, no. 412, both as by R.
Ghirlandaio; 1878, p. 53, no. 425, and 1954,
no. 425, both as by Francesco Francia.

Literature:
Berenson 1968, vol. 1, p. 65.

This work was acquired as a painting by
Ridolfo Ghirlandaio. The attribution to
Andrea del Brescianino was first pro-
posed by Bernard Berenson. The figure
style reflects the influence of Domenico
Beccafumi, but the composition is
indebted to Raphael and other
Florentine sources.

47

4.

GIACINTO CALANDRUCCI
Palermo 1646 – 1707 Palermo

Venus and Adonis

Figure 1
Giacinto Calandrucci
Venus and Adonis
Musée du Louvre, Paris

Oil on canvas
183 by 143.5 cm; 72 by 56½ in.
B.H. No. 174

Provenance:
Bought by the 5th Earl in Rome in the winter of 1683–1684 for twenty crowns, as by Callandrucci [*sic*], as recorded in *An Account of wt I have expended since Naples*, drawn up by his steward Culpepper Tanner under the heading "The account of ye charge of pictures at Rome". Recorded in the 9th Earl's annotated copy of Orlandi, *Abecedario Pittorico*, 1704, p. 230, as Venus and Adonis by Chiari; also recorded in 1815, p. 61, and 1847, p. 206, no. 187, both as by Chiari; 1878, p. 21, no. 174, as by Chiari; 1954, no. 174, as by Chiari.

Literature:
Kerber 1968, p. 79, fig. 8, as by Chiari; Graf 1986, p. 23 and p. 494, fig. A.25, as by Calandrucci.

This painting of the mythological characters Venus and Adonis, acquired by the 5th Earl as by Calandrucci, was then recorded as by Chiari in all subsequent Burghley House inventories of the eighteenth, nineteenth, and twentieth centuries. The attribution to Chiari received further support from Kerber as recently as 1968. However, Graf convincingly proposed a reattribution to Calandrucci, largely on the evidence of a preparatory drawing by that artist in the Louvre (Graf 1986, p. 494, fig. A.26, illus.) (fig. 1). The composition of the drawing differs in many respects from the finished painting, with Adonis placed in the immediate foreground with his back to the viewer.

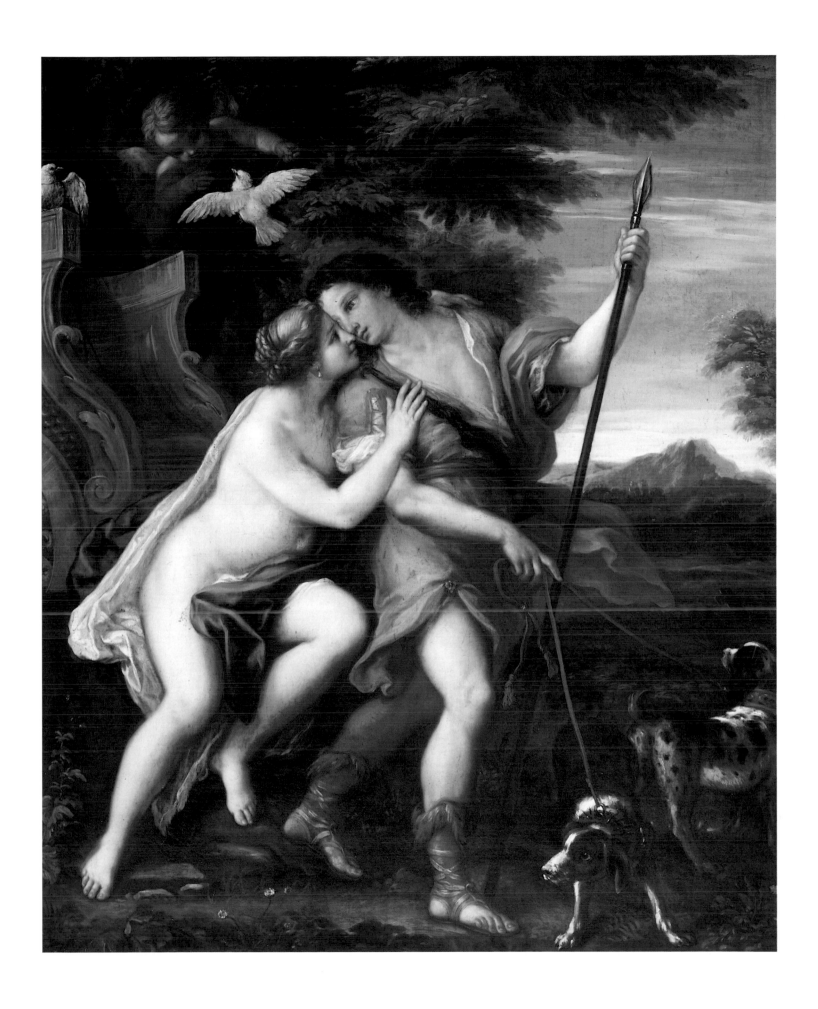

5.

DENYS CALVAERT
Antwerp 1540 – 1619 Bologna

The Annunciation

Oil on copper
37.5 x 27.6 cm.; 14¾ x 10⅞ in.
Signed lower right on the base of the prieu
dieu: DIONISI CALVA. FIAMENGO
B.H. No. 279

Provenance:
The Abbé Fiori, Bologna, according to an
inscription on the reverse in the hand of the
9th Earl, by whom acquired and recorded in a
manuscript list; 1815, p. 77; 1847, p. 218, no.
275; 1878, p. 30, no. 279; 1882, p. 38, no.
279; 1954, no. 279, all as by Calvaert.

Literature:
Waagen 1854, p. 405, "A picture painted in a
very warm tone and blended like an enamel,
with the artist's name".

Denys Calvaert interrupted his appren-
ticeship in Antwerp sometime after 1556
and travelled to Italy, where he settled in
Bologna under the patronage of the
Bolognini family. By 1575 he had
returned to Bologna after a period in
Rome, during which time he had evi-
dently studied Correggio's work in
Emilia. As a result his mature style is a
mixture of mannerism from the Bologna

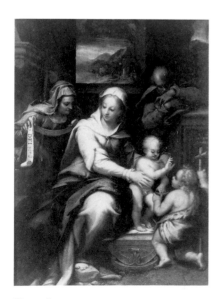

Figure 1
Denys Calvaert
*The Holy Family with St Elizabeth and the
Infant Baptist*

tradition of Prospero Fontana and
Lorenzo Samachini, combined with
strong Tuscan, Roman and Emilian
influences. Through his studio in
Bologna, with its emphasis on anatomy,
perspective and the study of prints and
sculpture, passed Albani, Domenichino
and Guido Reni.

According to Malvasia (vol. 1, pp.
195–208), Calvaert's somewhat volatile
and covetous personality resulted in a
mass exit of his pupils to the rival and
more progressive Carracci academy in
1582. The Burghley painting would
seem to date from this period as it
reveals strong similarities with *The Holy
Family with St Elizabeth and the Infant
Baptist*, which was sold at Sotheby's,
London on 29 November 1961, lot 90.
That picture, also painted on copper and
on a similar scale, is almost identically
signed but is dated *1586/DIONISIO/FIA-
MENGO* (fig. 1). Another work from the
same period is *The Flight into Egypt* in
the art collection of the University of
Minnesota (Inv. D73. x 8). Yet another
of these small works on copper from the
same period, namely *Presentation of the
Infant Christ in the Temple*, which was
last recorded at Sotheby's, London on 8
July 1992, lot 26, is itself a version of an
almost identical composition in the
National Museum at Warsaw (no.
231090).

Calvaert explored the subject of the
Annunciation on many occasions, most
notably in the painting dated 1582 in
Santa Maria dei Bulgari, and most spec-
tacularly in the full-size altarpiece in the
church of San Domenico, also in
Bologna (fig. 2). In that painting a
dazed, almost swooning Virgin is
addressed by a beautiful Archangel
Gabriel in shining white drapery. The
Burghley picture is, of course, the com-
plete opposite in scale, being an intimate

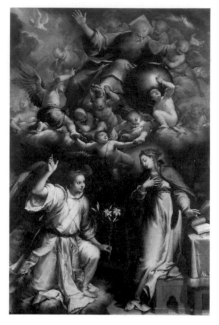

Figure 2
Denys Calvaert
Annunciation
Church of San Domenico, Bologna

private devotional object whose chief
glory is the wonderful rainbow colours
of Gabriel's wings and golden robes.
The immediacy of the moment is cap-
tured in the way the Archangel seems to
have landed slightly off balance and is
attempting to rectify the situation as he
delivers his Divine message. Unlike the
fully Italian Virgin of the San Domenico
altarpiece, Mary is a demure, round-
faced northern girl caught at prayer.
The needlework she has laid aside and
the white lily in its urn form an enchant-
ing and delightfully observed still life.

Like so many of the paintings at
Burghley that for centuries have hung
not only in the same room but in the
same place, this jewel-like panel has
been in the first George Room since at
least 1815. Unfortunately, the identity
of Abbé Fiori, from whom the 9th Earl
purchased this picture, and the paint-
ing's earlier history are as yet unknown.

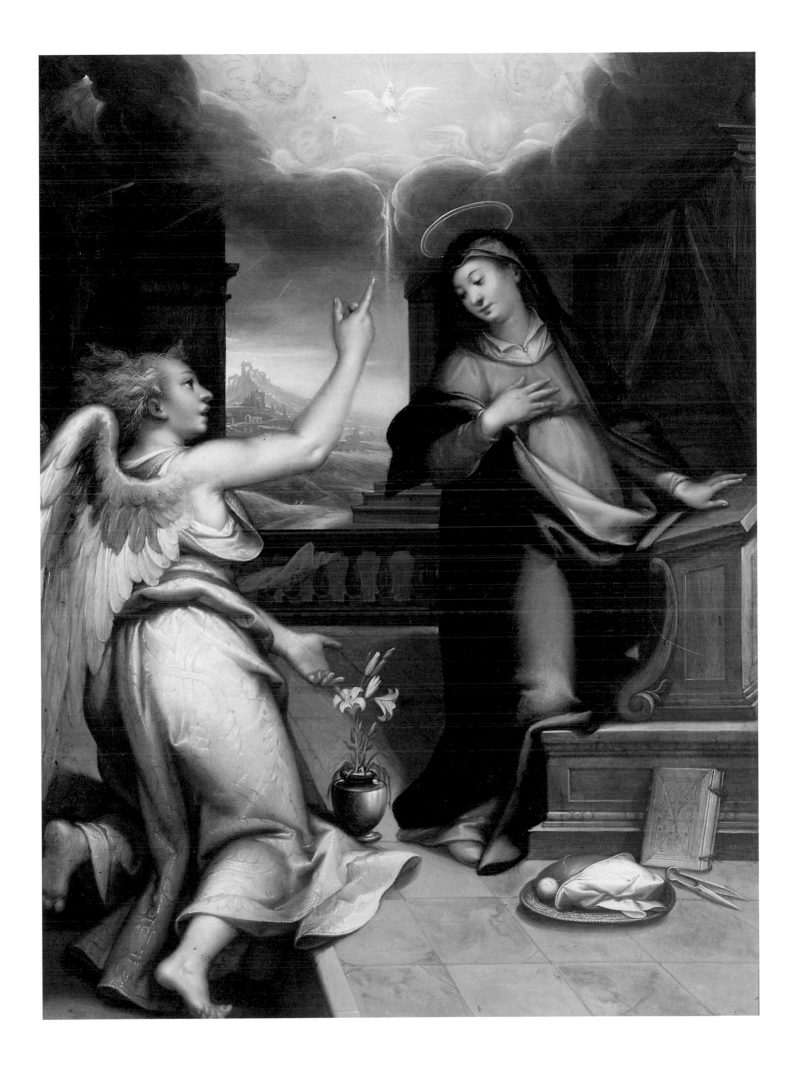

6.

SIMONE CANTARINI

Pesaro 1612 – 1648 Verona

The Rest on the Flight into Egypt

Oil on copper
19 by 26 cm; 7½ by 10¼ in.
B.H. No. 253

Provenance:
Bought by the 9th Earl from Mons. Scarselli at
Bologna (information from a list in the 9th
Earl's hand, *Extracts from an old catalogue of
ye furniture at Burghley*); also recorded in the
9th Earl's annotated copy of Orlandi,
Abecedario Pittorico, 1704, p. 460, as "*Virgin,
Infant, St Joseph*, by Sin. Cant: da Pesaro at
Burghley, a small picture"; also recorded in
1815, p. 75; 1847, p. 219, no. 290; 1878, p. 27,
no. 253, all as by Passeri; 1954, no. 253, as by
Simone da Pesaro (i.e. Cantarini).

Literature:
Mancigotti 1975, p. 121, fig. 60.

The design is based on Cantarini's own
etching (*The illustrated Bartsch 42*,
1981, p. 72, no. 6 [126]). The print is in
the same sense (direction) as the picture
and therefore probably precedes it. (If
the print had been made after the pic-
ture the image would have been
reversed.) Another painting in the
Louvre (oil on canvas; 104 by 145 cm.,
41 by 57 in.) also relates to the print but
here the image is reversed (Mancigotti
1975, p. 117, fig. 55). Further variants
of the Louvre picture that are also paint-
ed on canvas are recorded by Mancigotti
in the Ugolini collection, Rome, and the
Matozzi collection, Florence (Mancigotti
1975, p. 121, figs. 58, 59).

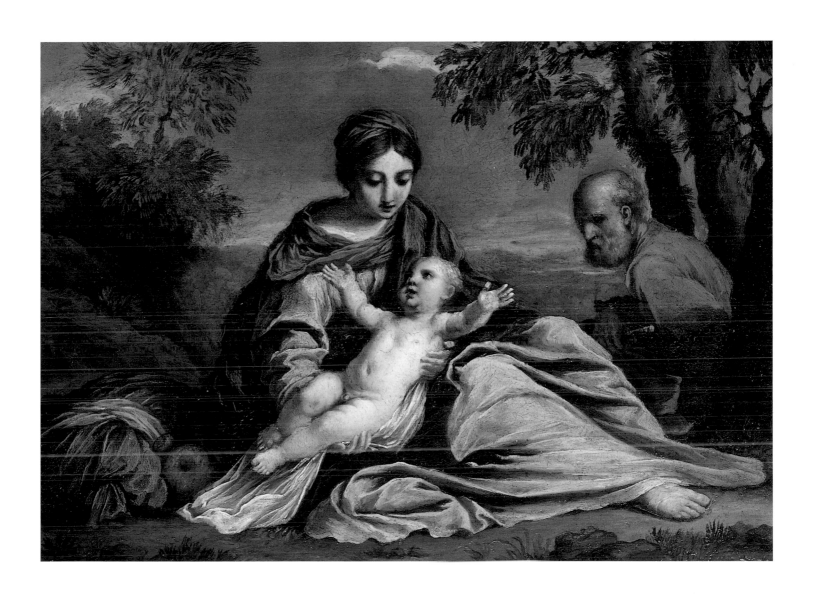

7.

VALERIO CASTELLO
Genoa 1624 – 1659 Genoa

Joseph and Potiphar's Wife

Oil on canvas
94.5 by 131 cm; 37¼ by 51½ in.
B.H. No. 232

Provenance:
Probably bought by the 5th Earl in Italy before October 1684, when a picture by Castello is listed among forty-six paintings held by customs but released on payment (Calendar of Treasury Books VII, pp. 1350–1351). Perhaps also identifiable as the picture recorded in the 1688 inventory, p. 14, as in "The Plaster Dineing Room & Clossett" as "1 peice of Joseph and potifer's wife by . . ." without the artist's name. Not identifiable in the 1738 inventory, but recorded in the 9th Earl's annotated copy of Orlandi, *Abecedario Pittorico*, 1704, p. 477, as "Joseph and Potiphers wife by Val° Castelli at Burghley." Recorded in 1815, p. 68, and 1847, p. 213, no. 241; 1878, p. 25, no. 232; 1954, no. 232, all as by Valerio Castelli [sic].

Literature:
Waterhouse 1960A, p. 57; Newcome 1978, p. 323, fig. 1.

Mary Newcome has suggested that this painting may date from circa 1650, thus making it more or less contemporary with the artist's painting *Sampson and Delilah* at Oberlin College in Ohio (see Manzitti 1972, no. 38). She further observes that "it is one of the few examples of Valerio's vast *oeuvre* to consist of two half-length figures set against a solid background". In its monumentality the picture is reminiscent of the work of Strozzi, who had died a few years earlier, in 1644.

The story is from Genesis 39:7–20. The wife of Potiphar, captain of the pharaoh's guard, attempted to seduce Joseph, their household steward, whom Potiphar had bought from the Ishmaelites.

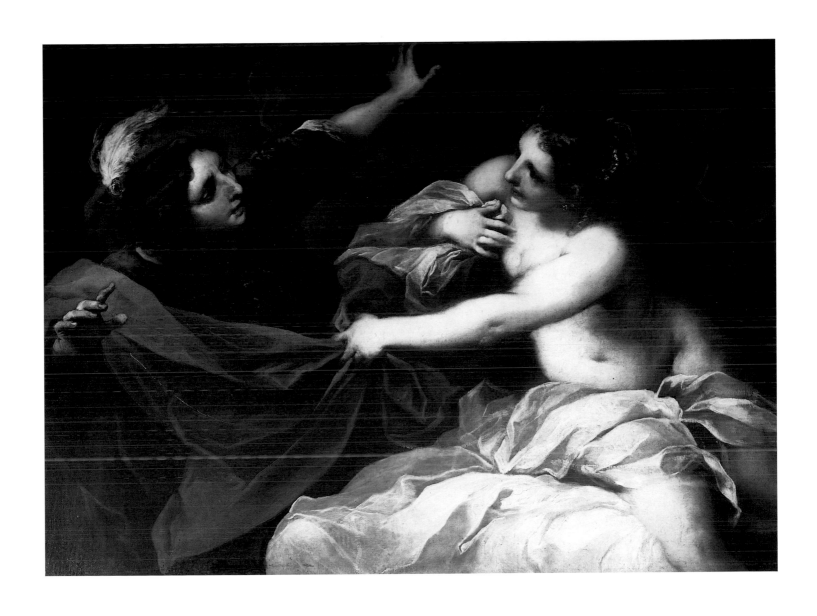

8, 9.

GIUSEPPE BARTOLOMEO CHIARI
Rome 1654 – 1727 Rome

Tullia Driving her Chariot over the Body of her Father Servius Tullius, who Murdered Tarquinius, her Husband

Venturia and Volumnia Imploring Coriolanus not to Take up Arms against Rome

A pair
Oil on canvas
Each 165 by 221 cm; 65 by 87 in.
B.H. Nos. 398, 402

Provenance:
Painted for Jacopo Montinioni (died 1687 in Rome). Bought by the 5th Earl, probably in Rome in 1699, but first recorded at Burghley House in the 1738 inventory, pp. 72–73, as in the North Dressing Room, without attribution; also recorded in the 9th Earl's annotated copy of Orlandi, *Abecedario Pittorico*, 1704, p. 230, as by Chiari; and in 1815, p. 48, and 1847, pp. 193–194, nos. 86, 90; 1878, p. 51, nos. 398, 402; 1954, nos. 398, 402, all as by Chiari.

Literature:
Blunt and Cooke 1960, p. 79, under no. 607 (for *Tullia Driving her Chariot*), p. 91, under no. 721 (for *Coriolanus*); Kerber 1968, p. 76, fig. 3; Dreyer 1971, pp. 189–190, pp. 196, 203; Dreyer 1977, no. 91; Rudolph 1983, no. 160 (*Tullia Driving her Chariot*).

These dramatic scenes from Roman history were painted by Giuseppe Chiari for Jacopo Montinioni, treasurer to Pope Innocent XII. Shortly before his death in 1687, the Pope also commissioned from the artist a ceiling fresco of *The Assumption* for a chapel in Santa Maria di Montesanto, Rome.

The designs of both the present pictures appear to have been inspired by drawings and prints produced by artists from the circle of Pietro da Cortona. Such works are now at Windsor (no. 4514; see Blunt and Cooke 1960) and in the Louvre (no. 492). A drawing in The Art Institute of Chicago (fig. 1) appears to be a preliminary sketch by Chiari for *Tullia Driving her Chariot*. Another drawing by Chiari (fig. 2) connected with the same picture is in the collection of the Ratjen Foundation, Munich. As Kerber (1968, p. 76) has observed, in both his painting and the preparatory drawings Chiari has transformed the Cortonesque prototypes into a more cohesive and clearly articulated design:

Figure 1
Giuseppe Bartolomeo Chiari
Tullia in her Chariot
The Art Institute of Chicago, Leonora Hall
Gurley Memorial Collection, 1922.5385

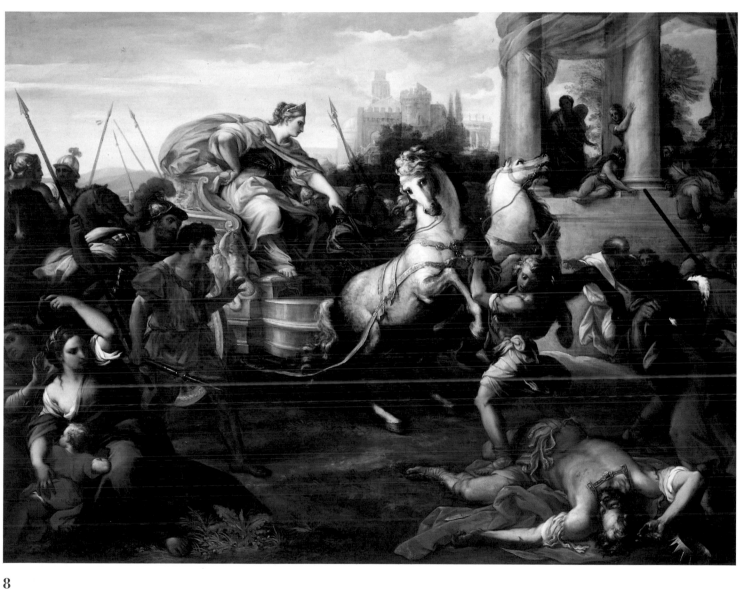

8

Figure 2
Giuseppe Bartolomeo Chiari
Tullia Riding over the Body of her Father Servius Tullius
Ratjen Foundation, Munich

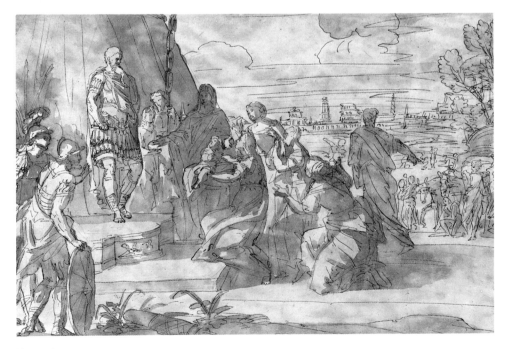

Figure 3
Attributed to Pietro da Pietri
Coriolanus before Rome
Staatliche Museum zu Berlin, Preussischer
Kulturbesitz, Kupferstichkabinett, Berlin

The main figures are held together by the spiral turn of the figure of the horse-tamer, his imploring gesture as he struggles against the team of horses, and his backward glance. Compositional balance is created by the opposition between Tullia's command to move forward and the frightened withdrawal of her retinue. The dense relief-like masses characteristic of the works of the Cortona circle are loosened by Chiari into an ornamental semi-circular arrangement in space.

A preparatory drawing for the design of the picture of Coriolanus (fig. 3) is in the Staatliche Museum zu Berlin, Preussischer Kulturbesitz, Kupferstich-kabinett, Berlin (inv. KdZ 25855 recto). Dreyer (1971, p. 187, fig. 4) has pub-lished that drawing under an attribution to Pietro de Pietri, to whom he also assigns the Burghley House picture, which he believes to be quite different from the picture of Tullia in composi-tion, colour and the articulation of the figures.

However, direct comparison of the two Burghley House pictures, which share the same distinctive and vivid use of colour, strongly suggests that they are both by the same hand, and the previous attribution to Chiari is preferred.

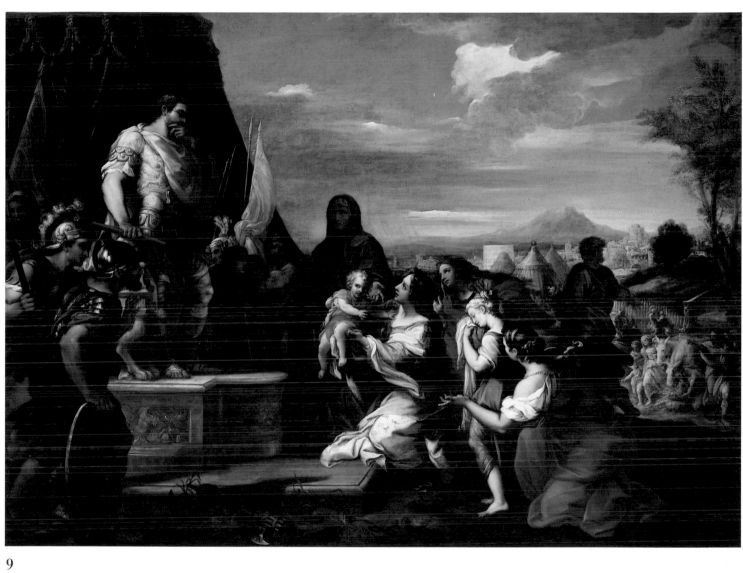

9

10.

GIUSEPPE BARTOLOMEO CHIARI
Rome 1654 – 1727 Rome

The Virgin and Mary Magdalen Mourning over the Dead Christ

Oil on canvas
95.5 by 73 cm; 37½ by 28¾ in.
B.H. No. 412

Provenance:
Bought by the 5th Earl, probably before 1688.
Probably in the 1688 inventory, p. 27, without
attribution, as one of two overdoors: "a
Magdalen & our Saviour, & ye Supulcher"; also
recorded in the 1738 inventory, p. 54, as in
The Dressing Room, without attribution;
recorded in a manuscript inventory of 1793,
partly in the hand of the 9th Earl, as by Carlo
Maratta; also recorded in the 9th Earl's anno-
tated copy of Orlandi, *Abecedario Pittorico*,
1704, p. 116, as by Carlo Maratta; again in
1815, p. 115; 1847, p. 251, no. 419; 1878, p.
52, no. 412; 1954, no. 412, all as by Maratta.

Figure 2
Giuseppe Bartolomeo Chiari
Pietà
The Art Institute of Chicago, Leonora Hall
Gurley Memorial Collection, 1922.5414

Figure 3
Giuseppe Bartolomeo Chiari
Sorrowing Virgin and Angels
By kind permission of the Earl of Leicester
and the Trustees of the Holkham Estate

Figure 1
Giuseppe Bartolomeo Chiari
Pietà
Accademia di San Luca, Rome

The attribution to Giuseppe Chiari, who
was an assistant to Carlo Maratta (see
cat. nos. 33–38) and who continued the
classical tradition of his master after
Maratta's death in 1713, is based on
comparison with another version by
Chiari, of the same design, in the
Accademia di San Luca, Rome, where
Chiari was Principe from 1723 to 1725
(fig. 1). The version now in the
Accademia di San Luca may be the Pietà
which Chiari is known to have painted
for Cardinal Ottoboni (see Voss 1924, p.
605, illus.; Kerber 1968, p. 83; and
Pascoli 1730, p. 214).

A drawing in The Art Institute of
Chicago (fig. 2) appears to be a prepara-
tory sketch, in reverse, for the design of
the painting in Rome. The idea was
used again in Chiari's altarpiece *St John
of God and St Teresa of Avila before a
Pietà* in the Pinacoteca Reposso, Chiari,
Lombardy (reproduced in Kerber 1968,

pl. 22). The figure of the Virgin appears
to be based on the same model as a
Sorrowing Virgin in a drawing at
Holkham Hall (Portfolio II, 50) attrib-
uted to Chiari (fig. 3).

Chiari's design was obviously inspired
by knowledge of Michelangelo's *Pietà* in
St Peter's, and Annibale Carracci's Pietà,
now in the Louvre and originally in the
Mattei chapel of S. Francesco a Ripa in
Rome. The essence of Chiari's classical
style, however, softens the classical
forms and the contours of the figures,
and concentrates instead on the harmo-
ny and rhythm of the surface design. As
Kerber has observed in a comparison of
the Accademia di San Luca painting
with the Chicago drawing, "The system-
atic ordering of the surface that charac-
terizes the painting does not exist in the
drawing; as is always true in Chiari's
work, in the final version a *schema* has
been superimposed on the original con-
ception" (Kerber 1968, p. 83).

Only minor variations exist between
the two painted versions. In the
Burghley picture there are two nails
from the cross, not three, and the figure
of Mary Magdalen in the Burghley pic-
ture is dressed in red and gold, not in
red and green as in the Rome picture.
The Burghley painting was probably
commissioned by Lord Exeter as a repe-
tition of the original composition, which
he would almost certainly have seen in
Rome.

Chiari enjoyed considerable favour
among English tourists in Rome. In the
early years of the eighteenth century he
received commissions from John
Talman, Lord Burlington, and Anthony
Earl Harrold of Wrest Park,
Bedfordshire (cf. Friedman 1988, pp.
836ff).

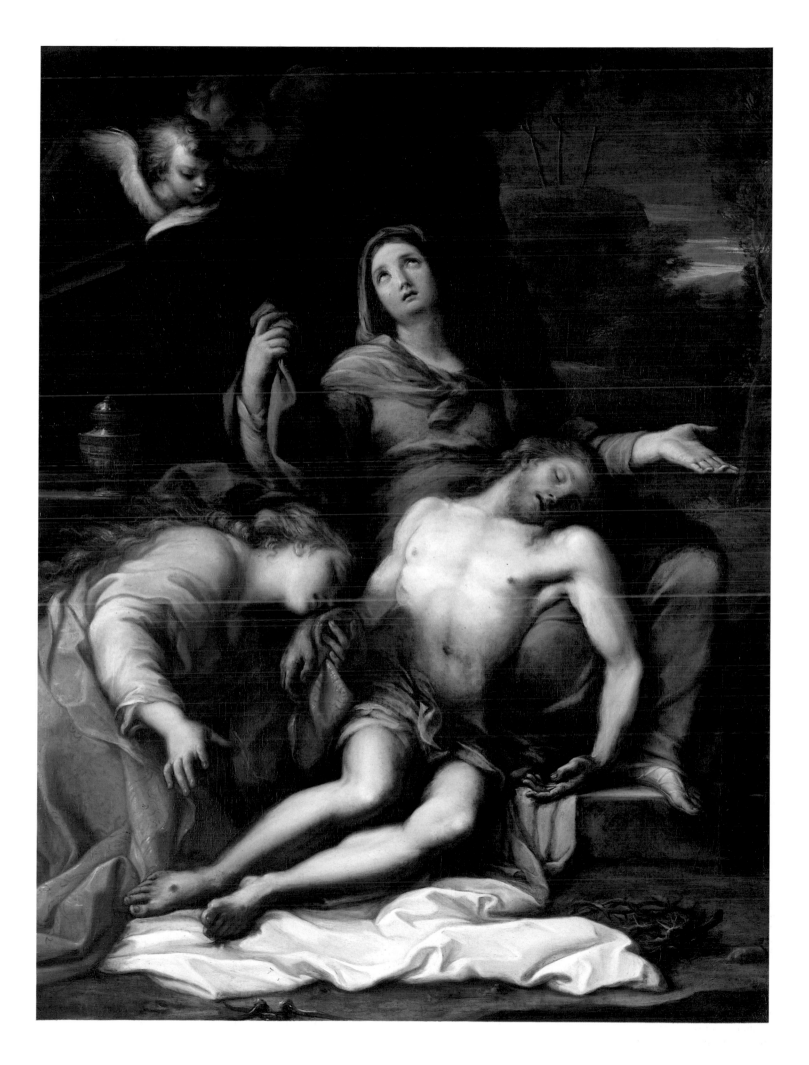

11, 12.

ATTRIBUTED TO CLAUDE GELLÉ, CALLED LORRAINE
Chamagne 1600 – 1682 Rome

An Extensive River Landscape, Two Figures on the Left with Cattle in the Foreground

A Coastal Scene, A Castle to the Right with an Artist Sketching near a Bridge

Oil on canvas
Each 38 by 155 cm; 15 by 61 in.
B.H. Nos. 347, 349

Provenance:
Acquired by the 9th Earl by 1777 and said to
have originated from the Massimi collection (an
old inscription on the stretcher mentions that
both paintings were acquired from the Palazzo
Massimi in Rome as by Nicolas Poussin);
recorded in the 9th Earl's annotated copy of
Orlandi, *Abecedario Pittorico*, 1704, p. 125, as
"2 long landscapes by dº (Claude) in Ld.
Exeter's Collection at Burghley"; recorded in
1815, p. 93, and 1847, p. 233, nos. 363, 366;
1878, p. 38, nos. 347, 349, all as by Claude;
1954, nos. 347, 349, as by Claude, figures by
Poussin.

Literature:
Earlom 1777, under no. 44, as by Claude;
Hazlitt 1930, vol. 10, p. 65, as poor works (seen
circa 1824 at Burghley); Waagen 1854, p. 405,
as by Claude Lorraine ("of the middle period of
the master: remarkable for composition, power
and freshness of tone"); Dussieux 1856, p. 179,
as by Claude; Röthlisberger 1961, vol. 1, pp.
176–177, under L.V.44 and p. 253 under
L.V.93, vol. 2, pls. 382 a and b; Röthlisberger
1968, pp. 167–168, under no. 352; Kitson
1978, pp. 79–80, under no. 44; Russell 1982,
p. 137, under no. 25; Mannocci 1988, p. 223.

Traditionally attributed to Claude since
they were acquired for Burghley House
in the late eighteenth century, each pic-
ture is an elongated version of a known
composition by Claude himself, as
recorded in the *Liber Veritatis*. The
coastal scene relates to L.V.44 (fig. 1)
and was accepted by Earlom as Claude's
original painting. The river landscape
relates to L.V.93 (fig. 2). It is now gen-
erally agreed that L.V.44 records a
Claude painting now in the Cincinnati
Museum of Art (fig. 3), signed and dat-
ed 1639 and measuring 78 by 101 cm

(30¾ by 39¾ in.), and L.V.93 records a
Claude painting now in the Barber
Institute, Birmingham, England (fig. 4),
signed and dated 164(5) and measuring
101.5 by 114 cm (40 by 44¾ in.). The
Burghley House variations were evident-
ly conceived and painted in Rome as a
pair of decorative works, probably over-
doors, and the original designs were
modified to accommodate this new
requirement.

Significant differences are also found
in the principal figures. Röthlisberger
in his critical catalogue of 1961 has

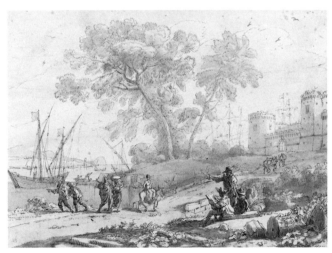

Figure 1
Claude Lorraine
*Coast Scene with an
Artist Drawing*
British Museum, London

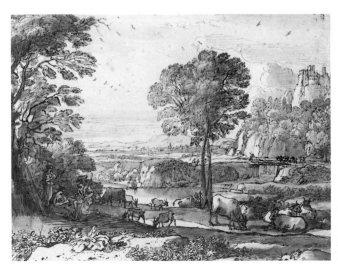

Figure 2
Claude Lorraine
Pastoral Landscape
British Museum, London

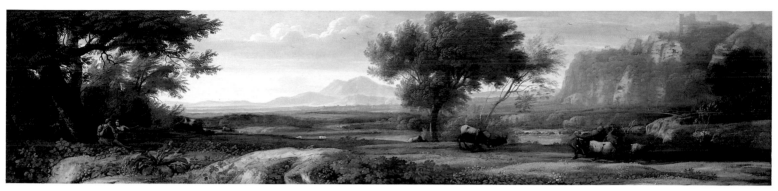

11

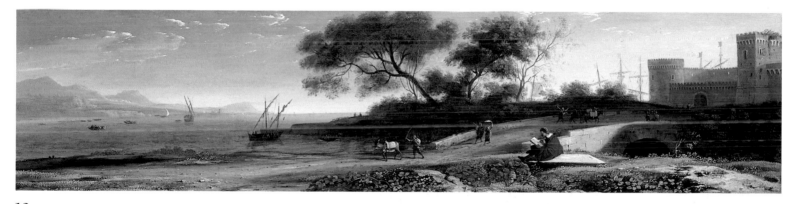

12

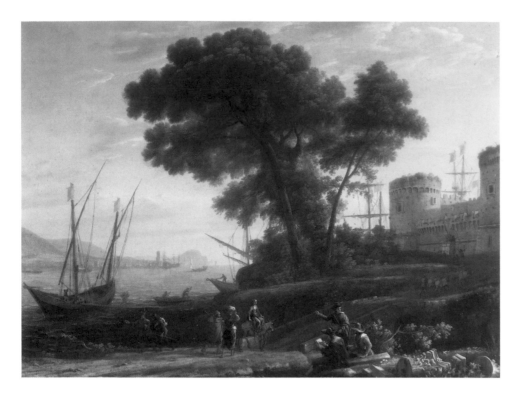

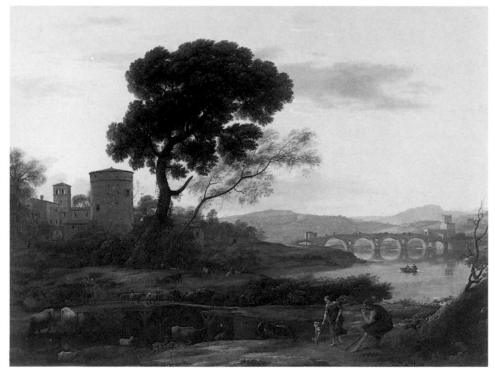

Figure 3 (top)
Claude Lorraine
An Artist Studying from Nature
Cincinnati Art Museum, Gift of Mary Hanna

Figure 4 (bottom)
Claude Lorraine
Classical Landscape
The City of Birmingham Museum and
Art Gallery

House pictures as the work of Claude himself and attributes them instead to an imitator who was acquainted with original works by the French artist. He suggests that "the execution is good but somewhat broader than Claude; it places the pictures in the 17th or early 18th century" (Röthlisberger 1961, vol. 1, p. 176).

This consideration of the Burghley House pictures is complicated by a drawing by Claude in the British Museum (fig. 5), which matches the elongated format of the coastal scene. As Röthlisberger has noted in his 1968 catalogue of Claude's drawings, the British Museum drawing (no. 1895.9.15.911) is not only one of Claude's widest drawings, but it is also unique in being simply an elongated version of the *Liber* drawing 44; and he concludes:

The handling places it at the same time. Factually it differs from the page of the Liber by the addition of a third tree and by the omission of the boats on the left and the tiny figures near the castle. The drawing was obviously used by the painter of Lord Exeter's picture which corresponds to it in shape and design, except that it again contains the boat and the tiny figures near the castle. . . . Though no other comparable example exists, the only plausible suggestion is that Claude did the drawing, possibly on commission, for a *sopraporta* to be executed by another painter. Whoever did Lord Exeter's picture must also, however, have known the composition of L.V.44 in its original state.

Kitson, in his edition of the *Liber Veritatis*, has added a further dimension to the argument with the suggestion that, while the Burghley House *Coastal Scene* "undoubtedly is a copy", it may have been made not from the British Museum drawing "but from a now lost painting of the same size and shape, by Claude himself; this would explain the existence of the drawing, which is otherwise puzzling, and the reinstatement of the boats and animals" (Kitson 1978, p. 80).

argued that the details of both pictures differ from the originals to such an extent that the copies cannot have been painted directly from the originals (which are separated in date by a gap of six years and had both been sent to patrons in Paris), but they were rather based on drawings of the two compositions. Thus the choice of the compositions was made independently of the originals, perhaps by means of the *Liber* (which left Rome circa 1720). Röthlisberger does not accept the Burghley

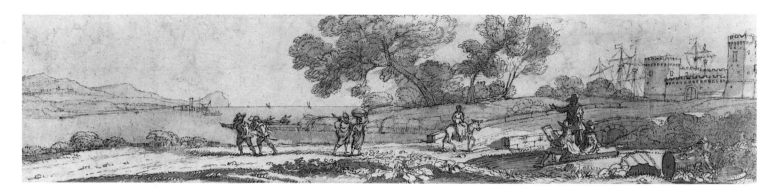

Figure 5
Claude Lorraine
Coastal Scene
British Museum, London

An altogether simpler solution would be to revert to the traditional belief that the Burghley House overdoor paintings are original works by Claude himself, conceived for a decorative purpose as variants of his earlier designs that are recorded in his *Liber Veritatis*. In this case he probably also made a drawing of elongated format, similar to the British Museum drawing, for the river landscape at Burghley.

During a recent examination of the Burghley House pictures by a team of Sotheby experts, including Julien Stock and the compiler of this text, it was decided that the quality of these two pictures was sufficiently high, and their technique sufficiently close to that of Claude, to justify a decision to clean them and subject them to scientific analysis. This work was undertaken in 1993 by U.C.L. Painting Analysis Ltd, History of Art Department, University College, London. The results were compared with the findings of the Hamilton Kerr Institute, Cambridge, England, which carried out a study of nine paintings known to be by Claude (*The Hamilton Kerr Institute Bulletin*, no. 1, 1987). Many close parallels between the technique of the Burghley House pictures and the nine Claudes examined by the Hamilton Kerr Institute were observed.

1. *The Ground*
The Burghley House pictures have a double ground of pale grey over orange red. Orange/red lower grounds occur in four of the nine Claudes examined in Cambridge. Over two of these are grey upper layers, and one of them, *Ascanius Shooting the Stag of Sylvia*, painted in 1682 (Ashmolean Museum, Oxford, England, A376) has an identical ground composition to the Burghley House landscapes. It is only fair to add that the use of such double grounds was a common practice in the seventeenth and eighteenth centuries.

2. *Pigments*
The pigments used on the Burghley House landscapes and the way they are deployed compare remarkably closely to those in the Hamilton Kerr survey. Seven of the nine Hamilton Kerr paintings have exactly the same arrangement of pigments; the other two consist of a single layer: one of ultramarine, the other of smalt. The complexity of the pigment mixtures and the type of combination chosen again compare very closely to the Hamilton Kerr findings. The presence of green earth in almost all the samples makes the comparison particularly significant as it is a somewhat unusual pigment.

3. *Technique*
The paint is built up in multiple layers and repainted by translucent unpigmented layers. There are many places where the painter has altered the composition (e.g., the central tree in the painting with ships). All of this is consistent with the findings of the Hamilton Kerr survey, which observed

(p. 49), "A striking thing in many of Claude's paintings is his use of intermediate layers of medium (varnish or glue?) and the large number of superimposed paint layers". The survey further noticed (p. 49), "Painting each painting twice seems to be inherent in Claude's working method: underlying trees can often be seen shimmering through the final sky".

4. *Palm prints and finger prints*
These are clearly evident in the Burghley House painting with ships. The technique is similar to that found in Claude's *Sea Port* in the National Gallery, London (inv. no. 14).

Notwithstanding the technical evidence, which would suggest that the Burghley House pictures were either painted by Claude himself or by a close associate, such as Desiderii, who emulated his technique, none of the acknowledged Claude specialists is yet prepared to revise his published view or to accept the pictures as autograph. Similar problems arise with other French artists who were working in Rome at the same time, most notably Poussin, whose work was also copied and imitated from an early date (cf. Standring 1988, p. 617, n. 51). Not until more work has been done on studio practice and particularly on the question of autograph copies and variants by artists working in seventeenth-century Rome will it be possible to reach a firm conclusion about these pictures. In the meantime, they serve to highlight a fascinating problem for art historians and connoisseurs.

13.

MARCO D'OGGIONO
Oggiono c. 1475 – 1530 Milan

The Virgin and Child

Oil on panel
41.5 by 39.6 cm; 16⅜ by 15⅝ in.
B.H. No. 501

Provenance:
Bought by the 9th Earl from the Barberini
Palace, Rome, according to a note on the
reverse in the 9th Earl's hand – "out of the
Barberini in Rome" – however it cannot be
traced in the Barberini archives (Lavin 1975);
recorded in the 9th Earl's annotated copy of
Orlandi, *Abecedario Pittorico*, 1704, p. 336, as
"Virgin and child with a blue flower in his
hand by Leonardo da Vinci at Burghley"; also
recorded in 1815, p. 93; 1847, p. 233, no. 367;
1878, p. 60, no. 501; 1954, no. 501, all as by
Leonardo da Vinci.

Literature:
Berenson 1910, pp. 274–275, as by Marco
d'Oggiono; Suida 1929, p. 293, as by Marco
d'Oggiono; Berenson 1968; Marcora 1976, p.
252; Sedini 1989, p. 177, fig. 85a.

Acquired as a work by Leonardo da
Vinci, *The Virgin and Child* was recog-
nized by Bernard Berenson as by his cel-
ebrated imitator, Marco d'Oggiono, a
view which is now generally accepted.
Sedini has published another version of
this painting, which was last recorded in
the Schweitzer collection, Berlin, in
1918.

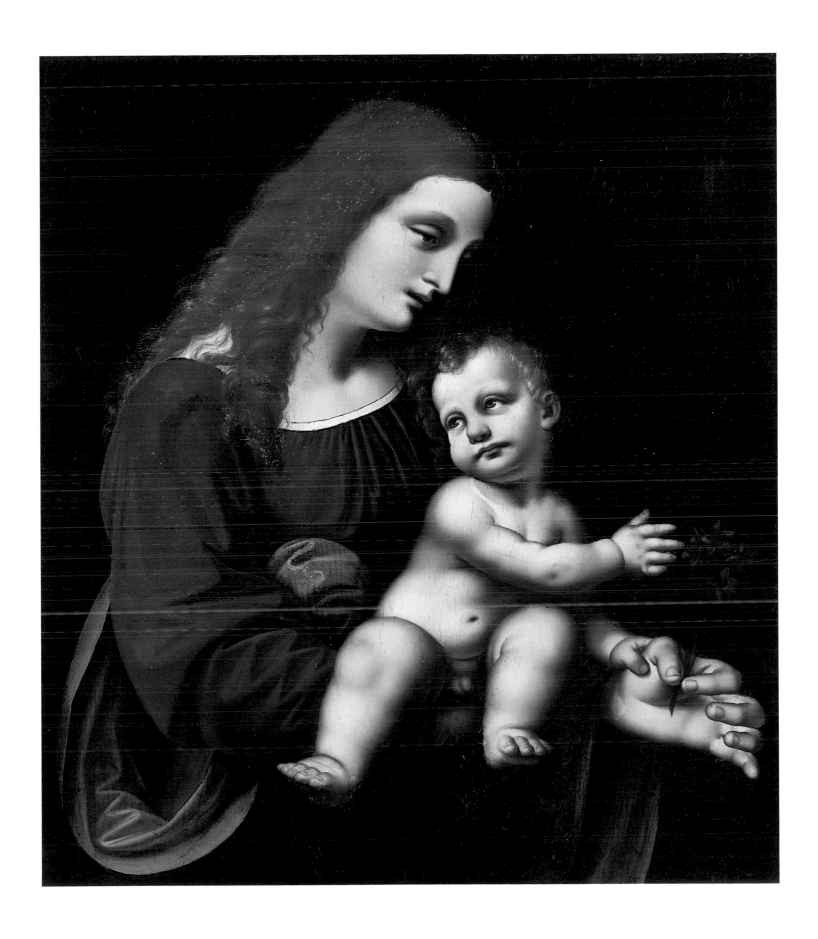

14.

CARLO DOLCI
Florence 1616 – 1686 Florence

Christ Consecrating the Elements

Oil on canvas
87.5 by 72.5 cm; 34½ by 28½ in.
B.H. No. 265

Provenance:
Bought by the 5th Earl in Italy and first
recorded as an addition to the 1688 inventory,
p. 53, amongst "Several pictures bought and
brought into Burghley house since the forego-
ing Inventory", as follows: "one picture of
Christ Consecrating the Bread and Wine, no
frame - by Carlo Dolci". Recorded again at
Burghley House in 1738, p. 22, in the Shell
Closet; 1797, p. 93; 1815, p. 79; 1847, p. 221,
no. 298; 1878, p. 28, no. 265; 1954, no. 265.

Literature:
Waagen 1854, p. 405 ("good example of the
pictures at Corsham House, and in the
Dresden Gallery. Of the three I am inclined to
prefer the last"); McCorquodale 1979, p. 48,
under no. 17.

Figure 1

The picture, acquired by the 5th Earl
probably in Florence circa 1683, was
long considered to be the principal
jewel of the Burghley House collection.
This is reflected in its elaborate carved
frame (fig. 1). In 1815 Drakard had
described it as "the flower of this diver-
sified collection", and when Sir Walter
Scott visited Burghley in 1826 he
observed that the picture was "worth a
King's ransom" (see Anderson 1972,
p. 213).

Baldinucci, in his account of Carlo
Dolci's work, described several auto-
graph versions of Christ blessing the
Bread: "Del Cristo son fuori più origi-
nali: siccome di una mezza figura del
medesimo, in atto di benedire il pane"
(Baldinucci [1681-1688 ed.] 1845, vol.
5, p. 356).[1] As McCorquodale has
observed (1979, p. 48), chronologically
this reference occurs in Baldinucci's
narrative shortly before Luca Giordano's
arrival in Florence in 1682. Among the
originals which Baldinucci had in mind
may be included one, recorded as being
in Pistoia Cathedral in 1677 (see K.
Busse in Thieme-Becker 1913, pp.
385–388). Apart from the present pic-
ture, one was already in the Methuen
collection at Corsham Court, another
was already in the Dresden
Gemäldegalerie. As McCorquodale
(1979, p. 48) has written,

> By means of rigorously simplified
> composition, preferably with a single
> figure filling the entire picture, Dolci
> achieved a degree of intense concen-
> tration on the painting's theme rare
> in seventeenth century art. Using the
> highest possible degree of surface
> realism (which led Ruskin to describe
> Dolci's figures as "polished into inani-
> ty") Dolci gave every detail of such

paintings equal prominence with the
result that both figures and still life
have a disturbing "presence". Details
such as the light reflected from the
paten onto the underside of Christ's
hand, the minutely observed linen and
the curls of his hair all contribute to
this somewhat hallucinatory quality.

Dolci's intense religiosity and meticu-
lous technique were greatly admired in
his own lifetime, and his reputation
extended far beyond his native Florence.
Lord Exeter would have encountered his
art at the Grand Ducal Court and again
through his friendship with Andrea del
Rosso, one of Dolci's principal patrons in
Florence, who gave him Dolci's *Rest on
the Flight into Egypt*, which is still at
Burghley House. Another contact was
Lorenzini, probably a courtier at the
Grand Duke's Court, who was reported
by the steward Culpepper Tanner to have
"told my Lord of a Coppie of the addora-
tion done by Carlo Dulce which if itt
Cannot be done by the time his Lordship
desires may be done and Sentt after by
some opportunity" (letter, Tours 17
August 1681, to Mr Mann). This is obvi-
ously a reference to *The Adoration of the
Magi* (B.H. No. 400).

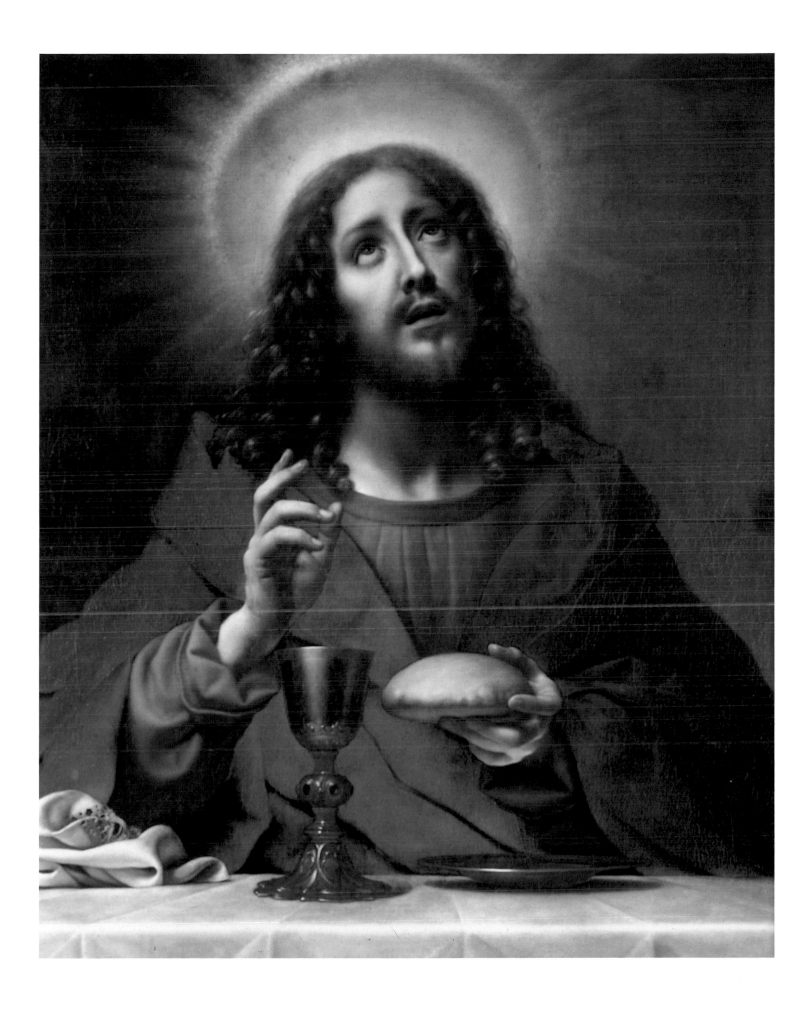

15, 16.

PIETRO FABRIS
Active Naples 1763 – 1779 Naples

Peasants Playing Cards and One Flying a Kite

Peasants Dancing and Eating with Vesuvius in the Background

A pair
Oil on canvas
Each 44 by 72.5 cm; 17⅜ by 28½ in.
The first (cat. no. 15) signed and dated, lower left: Fabris P.
The second (cat no. 16) signed and dated, lower left: Fabris P. 1770.
B.H. Nos. 548, 549

Provenance:
Acquired in Naples by the 9th Earl, who was in Italy from circa 1768 to 1770 and may have bought the pictures directly from the artist. Recorded with other paintings by the artist at Burghley House in a manuscript inventory of 1793, partly in the hand of the 9th Earl, as follows: "a picture of the erruption of Mt. Vesuvius in 1767 by Fabris, four paintings representing the dress of Italians"; recorded in 1815, p. 62; 1954, nos. 548, 549, in both as by Fabris.

The other three paintings by Fabris recorded in the 1793 inventory remain at Burghley House today: *The Eruption of Vesuvius* of 1767 (B.H. No. 550) and a pair depicting a cobbler and a knife-grinder.

Pietro Fabris, who liked to be known as the English painter, produced a large quantity of works of this kind – lively street and beach scenes on the Neapolitan coast – for the British market. He also exhibited his work in London: at the Free Society in 1769 and at the Society of Artists in 1772 (see Middione and Daprà 1987, p. 78).

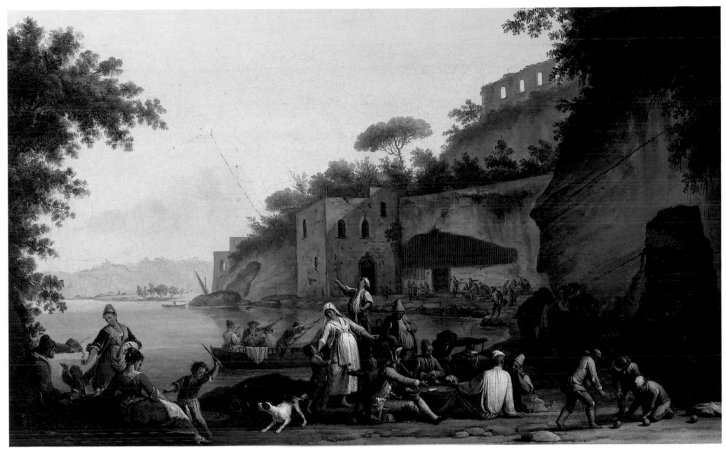

15

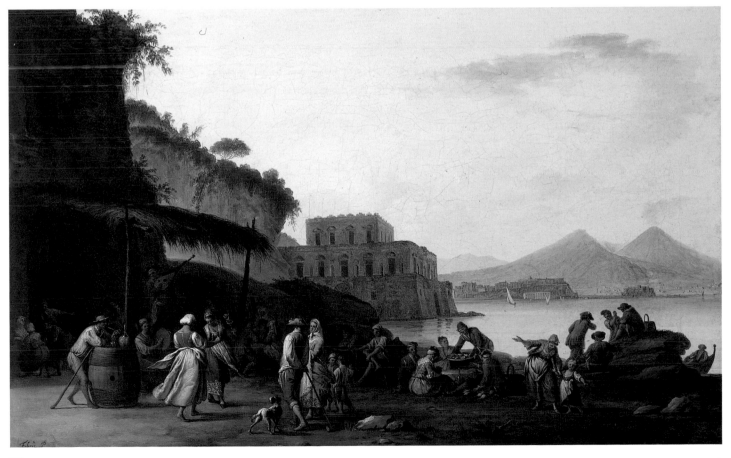

16

17.

GIOVANNI BATTISTA GAULLI, CALLED IL BACICCIO
Genoa 1639 – 1709 Rome

Christ in the House of Simon the Pharisee

Oil on canvas
84.5 by 110.5 cm; 33¼ by 43½ in.
B.H. No. 427

Provenance:
Acquired in Italy by the 5th Earl, in 1684 or
1685; first identifiably recorded at Burghley
House in the 1738 inventory, p. 56, as "Our
Saviour at Supper and Mary Magdalen anoint-
ing his feet. The pot of Ointment stands by …"
and as by "Hyacinto Brandi 2 Feet 10 Inches
long, 3 Feet 8 Inches wide"; also recorded in
the 9th Earl's annotated copy of Orlandi,
Abecedario Pittorico, 1704, p. 160 as by Le
Sueur; also in 1815, p. 116; 1847, p. 225, no.
464; 1878, p. 53, no. 427; 1954, no. 427, all as
by Le Sueur.

Literature:
Waagen 1854, p. 406, as *Mary Magdalen
annointing the feet of Christ* by Le Sueur;
Enggass 1964, p. 122, as by Gaulli; Macandrew
and Graf 1972, p. 249, under no. 12; Graf
1973, under nos. 55 and 56.

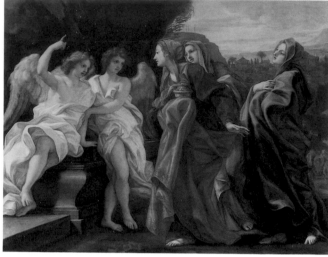

Figure 1
Giovanni Battista Gaulli
The Three Marys at the Tomb
Fitzwilliam Museum,
University of Cambridge

Figures 2–5
Giovanni Battista Gaulli
Studies for *Christ in the
House of Simon the Pharisee*
Kunstmuseum Düsseldorf im
Ehrenhof, Sammlung der
Kunstakademie

Figure 3

Figure 4

Figure 2

Figure 5

The subject of Christ in the house of
Simon is described in Luke 7:36–50.

The picture was acquired by the 5th
Earl, together with its pendant *The
Three Marys at the Tomb*, which was
sold in 1888 and is now in the
Fitzwilliam Museum, Cambridge,
England (fig. 1). *The Three Marys* is
recorded at Burghley House in the 1738
inventory (p. 56) as a pair to the picture
of *Our Saviour at Supper* by Giacinto
Brandi; it is described as "3 angels com-
ing to the Sepulchre, two Angels sit
upon it, the Apostles at a great distance".
The attribution to Gaulli was first pro-
posed by Enggass, who suggests a date
circa 1680–1685.

Four preparatory drawings by Gaulli
for *Christ in the House of Simon the
Pharisee* are at Düsseldorf. One (FP
1140) is for two of the seated men on
the extreme right (fig. 2). Another (FP
1144 recto) is for a servant girl and for
the old man she is serving at table (fig.
3). On the verso (FP 11279 verso) are
three further studies for the old man
(fig. 4). A further drawing (FP 1143) is
for the female figure standing in the
doorway on the extreme right (fig. 5).

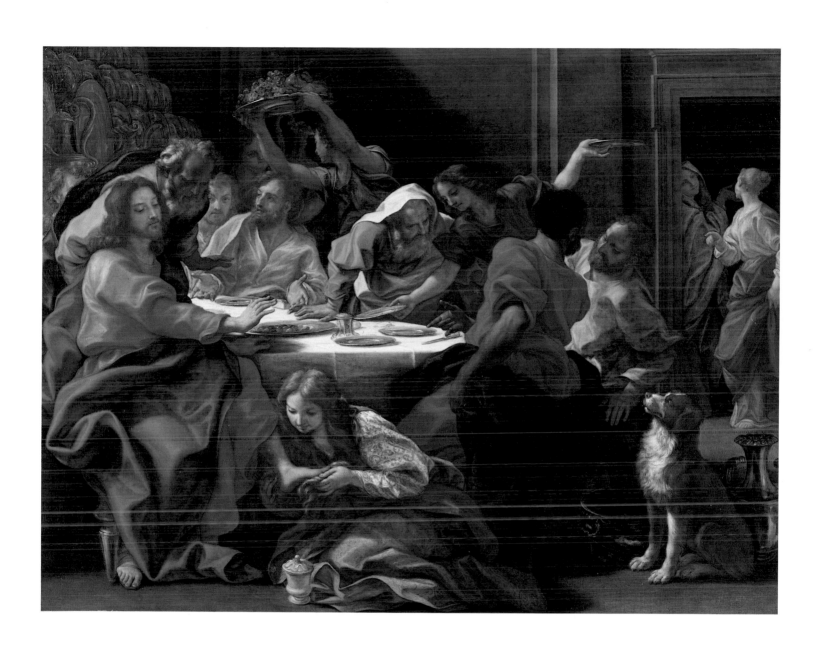

18.

GIOVANNI BATTISTA GAULLI, CALLED IL BACICCIO
Genoa 1639 – 1709 Rome

Venus Dissuading Adonis from the Chase

Oil on canvas
180.3 by 148.6 cm; 71 by 58½ in.
B.H. No. 508

Provenance:
Probably acquired by the 5th Earl in Italy, perhaps on his final visit in 1699; not identifiable in the 1688 inventory, but recorded in the 1738 inventory, p. 72, as "Venus and Adonis, 6 Foot high, in the North Dressing Room", without an artist's name; also recorded in 1878, p. 60, no. 508, and 1954, no. 508, both as by Philip de Champagne [*sic*].

Literature:
Waterhouse 1965, p. 531, as by Baciccio; Spear 1966, pp. 98–112; Stechow 1967, p. 59, no. 66.2; Enggass 1967A, p. 187, in which he doubts the attribution of the Burghley House picture to Baciccio and the connection with the Oberlin *Death of Adonis*; Enggass 1967B, p. 473, accepting the Burghley House picture and the connected Windsor drawing as by Baciccio; Spear 1968, pp. 37–38; Graf 1973, under nos. 53 and 54; Westin 1975, under no. 1; Graf 1976, p. 98, under nos. 249, 250 and 251.

Venus Dissuading Adonis from the Chase was traditionally attributed to Philippe de Champaigne, but in 1965 it was recognized by Waterhouse as being the work of Giovanni Battista Gaulli, a Genoese artist who moved to Rome in the mid-1650s at the very outset of his career. The attribution has been generally accepted and is endorsed by a long sequence of preparatory drawings that were traditionally attributed to Gaulli (for those at Düsseldorf see Graf 1973, nos. 249–251; for those at the Royal Library, Windsor, see Blunt and Cooke 1960, no. 199, pl. 50).

Spear has argued convincingly that Gaulli's *Death of Adonis*, now at Oberlin College in Ohio (fig. 1) and for which there are preparatory drawings in the British Museum, London (fig. 2) and Düsseldorf (fig. 3), may have been conceived as a pendant to the Burghley House picture. The Oberlin picture is not identifiable in the 1738 inventory at Burghley House, but it might well have been acquired by the 5th Earl and sold

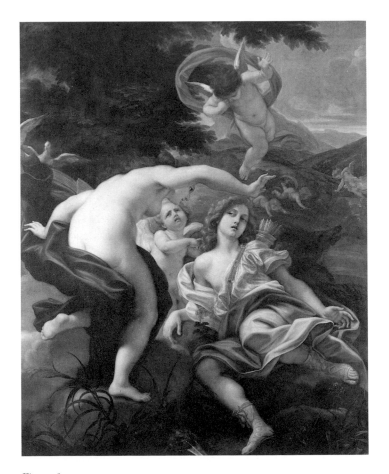

Figure 1
Giovanni Battista Gaulli
Death of Adonis
Allen Memorial Art Museum, Oberlin College, Oberlin, Ohio; Mrs. F.F. Prentiss Fund, 1966

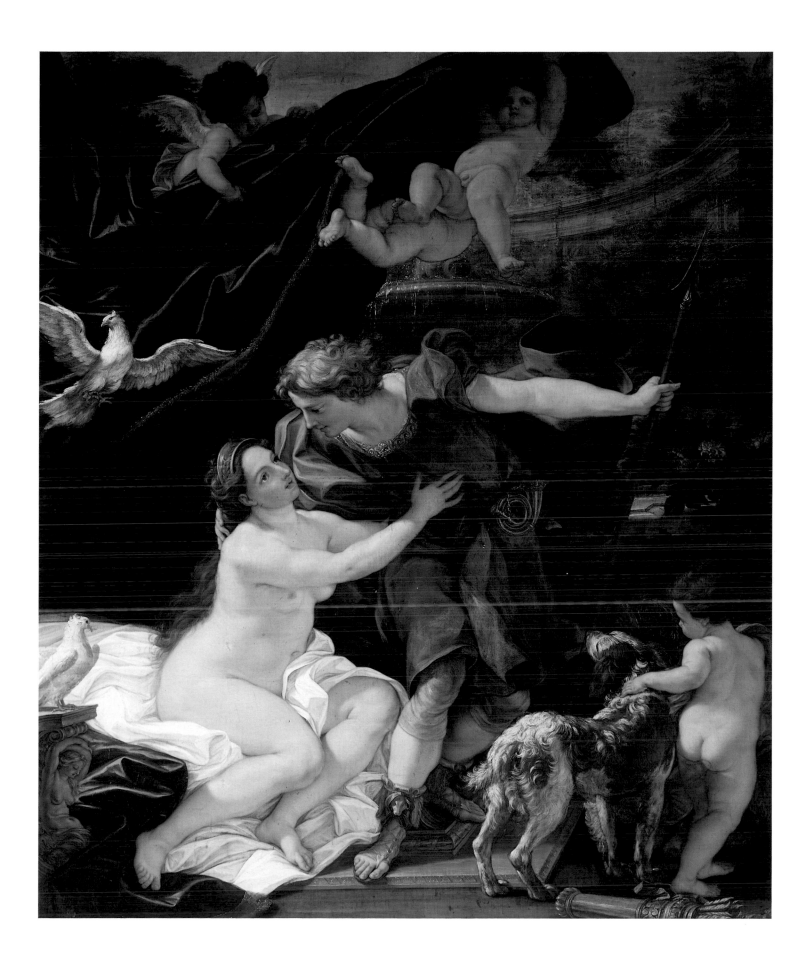

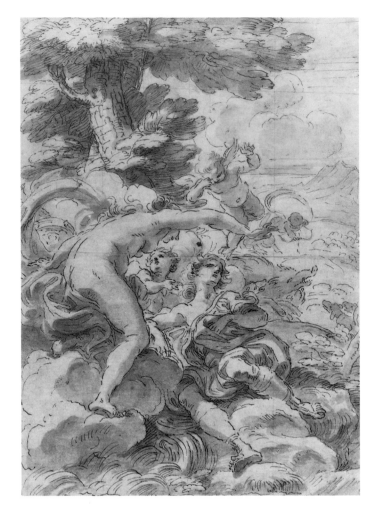

after his death, when many other pictures from his collection also disappeared. A slight discrepancy in size between the two canvases suggests that the Oberlin canvas has been slightly cut down. As Spear (1966, pp. 108–109) has observed of the Burghley House picture:

> Accessories and details of costume strengthen the link between the two canvases. In both, Adonis wears sandals which have straps crossing from three eyelets, a heart-shaped thong, rosette decorations, and an elaborate animal's head ornament at the top. The upper part of his quiver in each painting is formed by alternating concave and convex mouldings and is gold covered. Even the sharp head of the fallen spear in the Oberlin painting is identical with that confidently held in the Burghley composition.

The connection between the two pictures is underlined by comparison of the elaborate compositional sketch for the Burghley picture at Windsor (fig. 4) with the elaborate preparatory drawing for the Oberlin picture in the British Museum (fig. 2). These drawings are also very close to each other in style and technique. Equally a drawing at Düsseldorf for the Oberlin picture (fig. 3) is very similar to the Düsseldorf drawing connected with the Burghley picture (fig. 5).

These pictures and their connected drawings reflect Gaulli's response both to Bernini's sculpture and his drawings. The design of the Burghley House picture is also directly inspired by a Rubens (and studio) painting, *Venus and Adonis*, in the Uffizi, Florence (reproduced in Spear 1968, p. 111, fig. 8), especially for the figure of Adonis and the standing putto on the right.

Figure 2 (top)
Giovanni Battista Gaulli
Preparatory drawing for *Death of Adonis*
British Museum, London

Figure 3
Giovanni Battista Gaulli
Preparatory drawing for *Death for Adonis*
Kunstmuseum Düsseldorf im Ehrenhof,
Düsseldorf

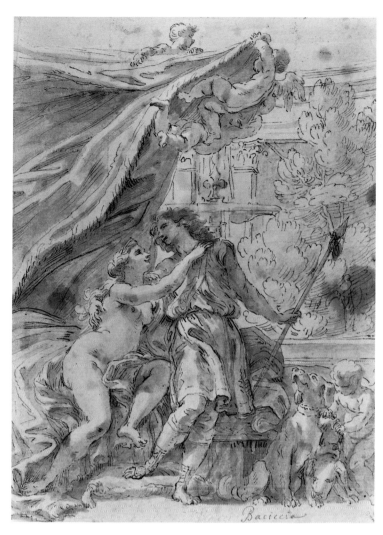

Figure 4
Giovanni Battista Gaulli
Preparatory drawing for *Venus Dissuading Adonis from the Chase*
The Royal Collection, Her Majesty Queen Elizabeth II

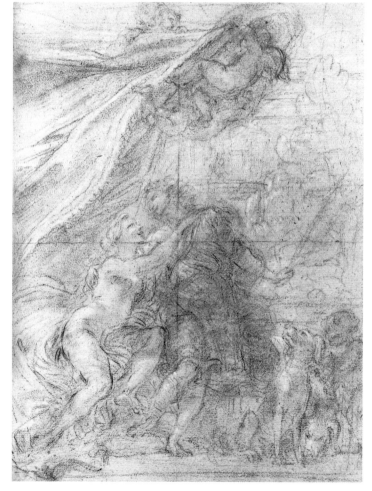

Figure 5
Giovanni Battista Gaulli
Preparatory drawing for *Venus Dissuading Adonis from the Chase*
Kunstmuseum Düsseldorf im Ehrenhof, Düsseldorf

BENEDETTO GENNARI
Cento 1570 – 1610 Cento

Orpheus Playing his Lyre

Oil on canvas
123 by 140.5 cm; 48½ by 55¼ in.
B.H. No. 219

Provenance:
Painted for the 5th Earl; listed in Gennari's
account book dating from 1674–1688, no. 73,
as follows: "Un quadro capace di due meze
figure con dentro Orfeo che co la lira alle mani
sta suonando al di cui armonioso suono con-
corrono gli animali per ascoltarlo (e atorno a
lui vi sta un montone, un cane, un papagallo e
due altri uccelletti per ascoltarlo). Questo per
il sudetto Milord Exeter" (Bagni 1986, pp.
154–155).² Recorded in the 1688 inventory,
p. 34, together with two companion pictures,
in "The Marble Salloon Roome", as follows:
"1 picture over the Chimney of Euridice in
Flames – 2 pictures of Orpheus, and Pluto and
Orpheus playing over ye Doores by Genaro";
recorded again in 1738, p. 31; 1815, p. 108;
1847, p. 212, no. 230; 1878, p. 24, no. 219;
1954, no. 219, all as by Benedetto Gennari.

Literature:
Bagni 1986, p. 95, pl. 58, pp. 154–155.

Figure 1
Benedetto Gennari
Pluto, Orpheus and Euridice
Burghley House

This is one from a series of three pic-
tures painted for the 5th Earl and show-
ing scenes from the story of Orpheus
and Eurydice (Ovid, *Metamorphoses*,
Book X: 86: 105). Another depicts Pluto
with Proserpine and Orpheus. There,
Orpheus persuades Pluto to allow him to
enter the Inferno and rescue Eurydice
from the underworld (fig. 1). The cen-
trepiece represents Eurydice, engulfed
by flames, after Orpheus had disobeyed
one of the conditions for her release and
looked back at her before they had com-
pleted the journey (fig. 2). The pictures
probably date from 1681, to judge from
their position in Gennari's account book
under numbers 72–74 (Bagni 1986, pp.
154–155).

Gennari was the nephew of Guercino,
who taught him to paint and was a
major formative influence on his style.
After an early career in Bologna,
Gennari moved first to Paris in 1672,
and then to London two years later, in
1674. There he presented himself at the
court of King Charles II and his Catholic
queen, Catherine of Braganza, where he
enjoyed considerable success. As
Dwight Miller has observed, this "had
much to do with his Roman Catholic
background and his readiness to pro-
duce the traditional images of the
Catholic faith" (Miller 1983, p. 25).
Gennari continued to work for Charles'
successor, James II, up to December
1688. He then followed James II in
exile, returning to the Continent on
2 April 1689 and joining his court at
Saint Germain.

Figure 2
Benedetto Gennari
Euridice in Flames
Burghley House

Gennari also produced pictures on
more erotic themes for King Charles II
(see Levey 1964, p. 21) and his friends,
including a *Toilet of Venus* for the Duke
of St Albans, a *Sleeping Venus* for Ralph
Montagu, and an *Apollo and Daphne* for
Robert Spencer, Earl of Sunderland.
The Burghley House pictures clearly fall
into this category.

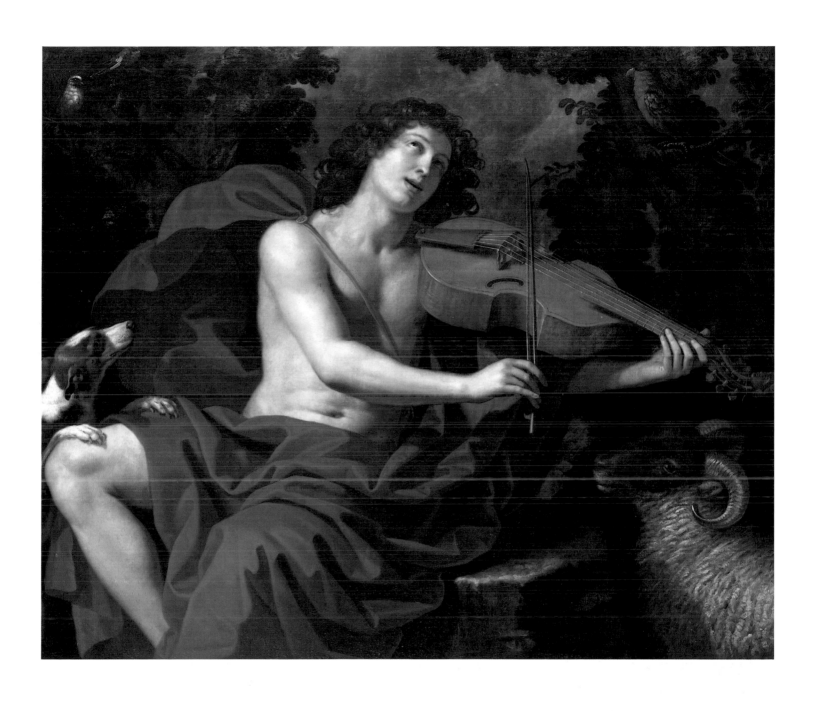

20.

ARTEMISIA GENTILESCHI
Rome 1593 – 1652/1653 Naples

Susannah and the Elders

Oil on canvas
161.5 by 123 cm; 63¾ by 48½ in.
Signed and dated, above Susannah's knees:
ARTEMITIA GENTILESCHI LOMI /
FACIEBAT. A D. M DC XXII
B.H. No. 218

Provenance:
Probably bought in Rome by the 9th Earl and
recorded in a list made out in his hand,
*Extracts from an old catalogue of ye furniture
at Burghley*, as follows: "Susannah and ye
Elders by Arta: Gentileschi from ye Barbarini
Pallace at Rome"; 1815, p. 66; 1847, p. 212,
no. 229; 1878, p. 24, no. 218; 1954, no. 218,
all as by Caravaggio.

Literature:
Waagen 1854, p. 405, as by Caravaggio;
Gregori 1968, p. 415, as attributed to
Artemisia Gentileschi; Ward Bissell 1968, p.
167, under "Questionable and Incorrect
Attributions" and as possibly by Artemisia;
Nicolson 1974, p. 418, fig. 87, as by Artemisia
Gentileschi; Sutherland Harris and Nochlin
1976, p. 121, n. 18, under no. 10, as possibly
Artemisia Gentileschi; Garrard 1989, pp. 202–
204, fig. 172, as by an anonymous seventeenth-
century artist; Contini 1991, p. 113, under no.
7, as possibly by Artemisia Gentileschi.

Recent cleaning of the picture has
uncovered the signature of Artemisia
Gentileschi and the date 1622. The sig-
nature is painted in black with slight
highlights, on a black background,
above the knee of the figure of
Susannah. (Trace of another signature
is found to the left side of the canvas
above the putto's head.) This endorses
not only the traditional attribution
under which the picture was acquired by
the 9th Earl but also Mina Gregori's per-
ceptive intervention in 1968 when she
published it as by Artemisia and refuted
the attribution to Caravaggio, which had
originated in the 1815 inventory. It also
vindicates the decision of the present
owners, and the organizers of this exhi-
bition, who decided to include the pic-
ture under Artemisia's name, notwith-
standing its rejection by Mary Garrard in
her 1989 book, in which her dogmatic
feminist interpretation of the artist led
her, without ever having seen it, to con-
clude that the picture's "expressive
character is incommensurate with
Artemisia's work".

Artemisia had painted an earlier ver-
sion of *Susannah and the Elders*, signed
and dated 1610, which is now in the
Graf von Schönborn Kunstsammlungen
at Pommersfelden (inv. 191) (for this ver-
sion see Contini 1991, no. 7). This earli-
er picture reflects the stylistic influence
of Artemisia's father, Orazio Gentileschi,
both in the figure types and in the
sophisticated fluency of the design. It is
a remarkably precocious achievement by
the young artist, and it has even been
suggested that Orazio himself had a
hand in it (see Spike 1991, p. 773). The
present picture apparently dates from
just after Artemisia had moved from
Florence to Rome. It would have been
executed at about the same time as the
Portrait of a Condottiere in the Palazzo
Comunale, Bologna, which is signed and
dated *Artemisia Gétilesca fa /ciebat
Romae 1622* (cf. G. Papi in Contini 1991,
no. 21). In both these pictures one
senses Artemisia's response to Roman
artists in the circle of Caravaggio, includ-
ing Simon Vouet.

A copy of the Burghley House picture
is in the Castle Museum, Nottingham.

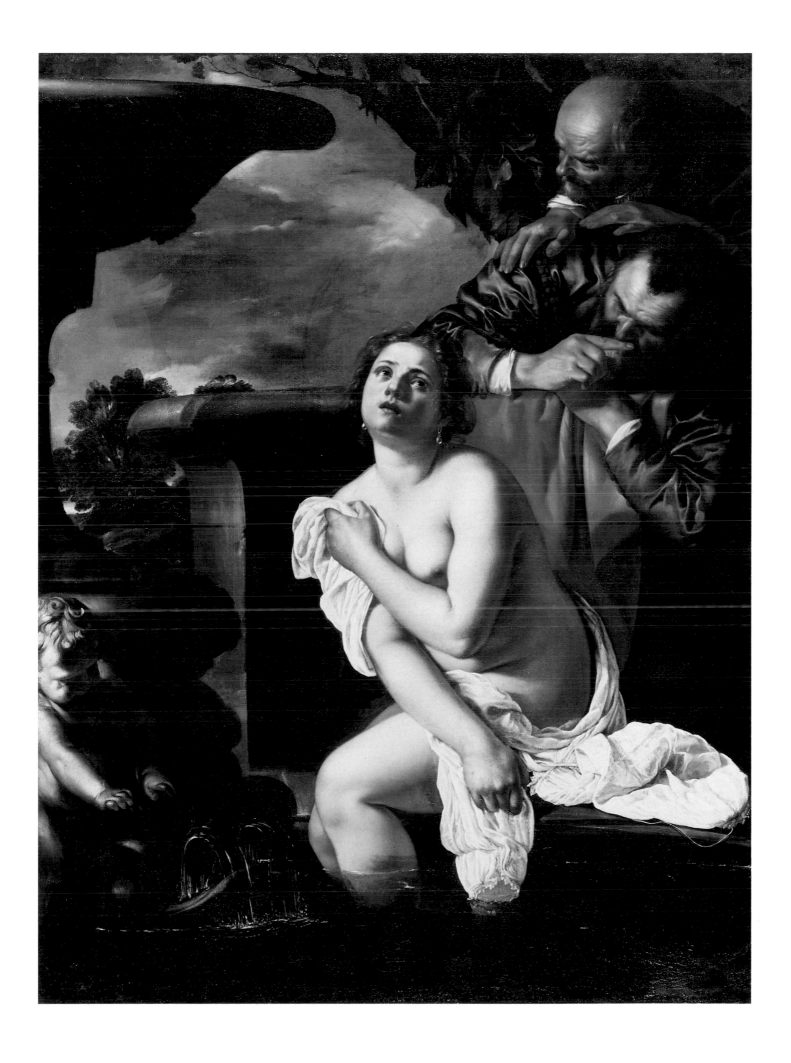

21.

ORAZIO GENTILESCHI
Pisa 1563 – 1647 London

The Madonna and Child in a Landscape

Oil on copper
28.8 by 21.5 cm; 11⅜ by 8½ in.
Inscribed on back of frame: Del F. Gio.
Benedetto Castiglione da Comp a di Gesù
Genovese.
B.H. No. 221

Provenance:
Given to the 9th Earl in Rome by Pope
Clement XIV in 1774, as by G.B. Castiglione;
recorded in a list made out in the 9th Earl's
hand, *Extracts from an old catalogue of ye fur-
niture at Burghley*, as follows: "Virgin with ye
Bambino asleep by B. Castiglione, being a pre-
sent from Clement ye. 14 to Ld. Ex ye 18 of
July 1774 but did not arrive in England until
after ye Ps death". First recorded at Burghley
House in 1797, pp. 77–78; and again in 1815,
p. 67; 1847, p. 213, no. 234; 1878, p. 25, no.
221; 1954, no. 221, all as by Castiglione.

Exhibited:
Northampton, Museum and Art Building, *Italy
and The Grand Tour*, 1959; London, Royal
Academy of Arts, *Italian Art and Britain*,
1960, no. 23; Washington, D.C., National
Gallery of Art, *Treasure Houses of Britain*,
1985–1986, no. 267.

Literature:
Waagen 1854, p. 405, as by Castiglione;
Waterhouse 1960B, no. 23, as by Orazio
Gentileschi; Oertel 1960, p. 95, as by O.
Gentileschi; Nicolson 1960, pp. 76–77, as by O.
Gentileschi; Crinò and Nicolson 1961, p. 145,
n. 15, as by O. Gentileschi; Perez Sanchez
1965, p. 502, as by O. Gentileschi; Ward Bissell
1981, p. 168, no. 39, fig. 84, see also p. 165
and p. 208.

In 1771 the 9th Earl was anxious to
obtain from the Jesuits in Rome a small
picture attributed to Castiglione, but he
met with no success. As James Byres
explained in a letter of 12 June 1771,
"The Jesuits will not part with their lit-
tle picture by Castiglione, the reason
that they asign for it is that they could
not ask above twenty or thirty Zouchins
for it, and that it is the only thing they
have of that Fathers work". It is not
clear if this is the same picture that was
later presented to the 9th Earl by Pope
Clement XIV in circumstances that are
described in some detail in the 1797
Burghley House guidebook:

> If ever there was a Pope of a great and
> exalted soul, it was Ganganelli; and as
> our English nobility have been, in gen-
> eral, remiss in personal respect to his
> Holiness, it left the Earl a more ample
> opportunity of displaying his. This
> occurring on a public day, when the
> Pope passed through the streets of
> Rome, the Earl was pleased to mani-
> fest the same adoration, which he
> expects from all his liege subjects, on
> that occasion; with which his Holiness
> was so struck, that he immediately
> expressed a wish to return it, by some
> reciprocal instance of esteem. Now, as
> the Earl will know the effect of the
> Pope's benediction, and the doctrine
> of indulgencies, he neither wished for
> the one, nor the other. In what way
> therefore, could his Holiness express
> this esteem to a Protestant nobleman,
> unless it was by some little token like
> the present? As the Earl amused
> himself at the Vatican, one day, he
> happened to throw his eyes on this
> piece; and, recollecting that he had
> none in his extensive collection, by
> the same hand, expressed his approba-

tion of it. It was, therefore, with great
satisfaction, that his Holiness heard
this, which he immediately evinced by
ordering it to be conveyed to the
Earl's lodgings, at a very early hour,
the next morning. Such is the brief
history of this piece.

The attribution to Orazio Gentileschi
was first proposed by Denis Mahon prob-
ably circa 1958. Ever since the picture
was exhibited under this name in 1959
and 1960 the attribution has never been
questioned. Indeed the picture provides
a standard for Orazio Gentileschi's work
on a small scale, for which there is little
documentary evidence beyond the few
surviving or known examples (see Ward
Bissell 1981, p. 142, under no. 10). In
design the picture reflects the influence
of Raphael and late Bellini; yet, as
Nicolson observed in 1960, it also
reflects the spirit of Adam Elsheimer,
especially in such details as the creeper
on the wall and the crumbling brick-
work and cracked plaster. Despite its
intimate spirit, the meticulousness of its
technique, and its high finish, the pic-
ture nevertheless is conceived in the
same spirit as Orazio Gentileschi's much
larger and more monumental versions of
the same subject, including a canvas in
the Birmingham Museum and Art
Gallery in England (Ward Bissel 1981,
no. 38) and an altarpiece in the church
of Santa Lucia at Fabriano (Ward Bissel
1981, no. 40), both of which were also
painted before the artist left Italy for
Paris in 1623. The present picture prob-
ably dates from circa 1615–1620.

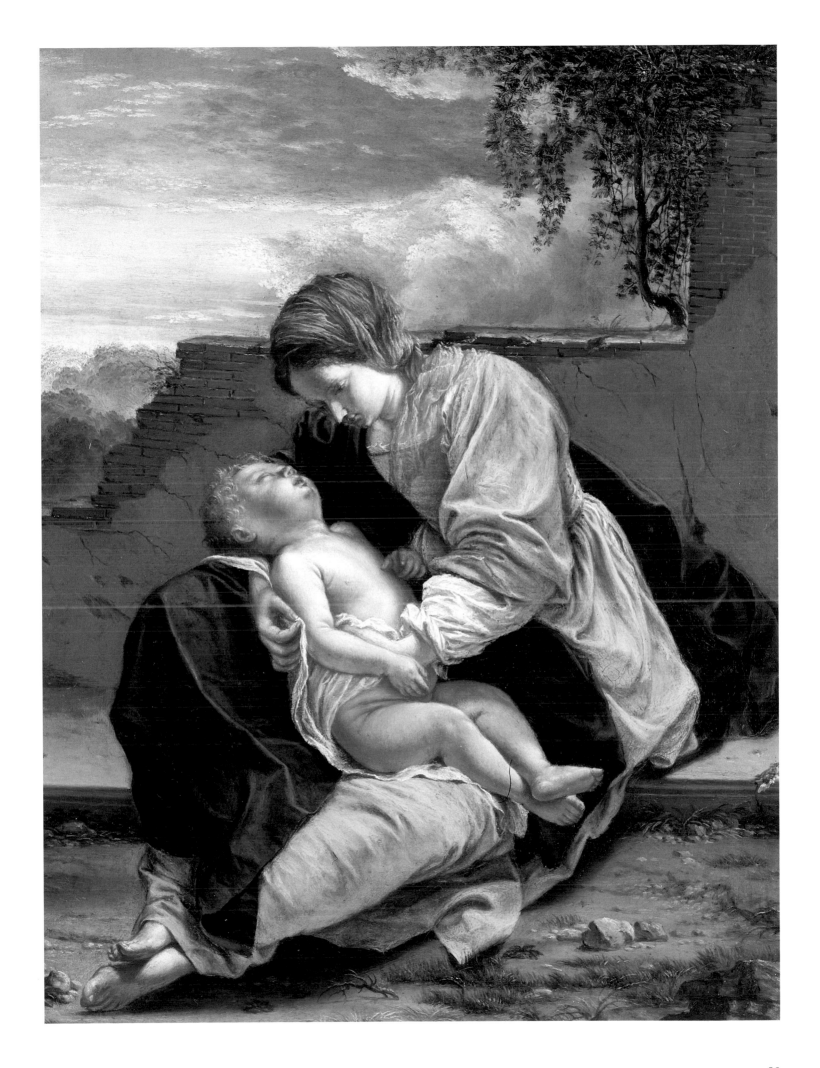

22.

GIACINTO GIMIGNANI
Pistoia 1611 – 1681 Rome

The Adoration of the Magi

Oil on canvas
141.8 by 116 cm; 55¾ by 45½ in.
Signed, lower right: HYACI GIMIGNANUS /
PISTORIE 1641
B.H. No. 320

Provenance:
Bought from Mr Talbot in Rome by the 5th
Earl circa 1684 for fifteen crowns (one of "two
pictures by Gimignano") as recorded by the
steward Culpepper Tanner in a manuscript
notebook at Burghley, Ex 51/10: *An account
of wt I have expended since Naples*, p. 5, under
"The Account of ye charge of pictures at
Rome"; the painting is not traceable in the
1688 inventory and is next recorded at
Burghley House in the 1815 inventory, p. 89,
as by Geminiani [*sic*]; 1847, p. 229, no. 323;
1878, p. 36, no. 320; 1954, no. 320, all as by
Giacinto Gimignani.

Exhibited:
London, Royal Academy of Arts, *Italian Art
and Britain*, 1960, no. 22.

Literature:
Waterhouse 1960A, p. 57, fig. 4; Burdon 1960,
p. 16; Waterhouse 1962 (1969 reprint, p. 62,
fig. 54); Cortese 1967, p. 189 and p. 192, fig.
12; Fischer 1973, p. 33, pp. 145–146, no. 19;
Pampalone 1972, p. 314; Rudolph 1977, p. 49,
tavola 45.

The Adoration of the Magi was bought
together with a companion picture *The
Raising of Lazarus* (fig. 1), which is also
still at Burghley House and which was
also attributed to Giacinto Gimignani.
The design of *The Adoration of the Magi*
relates closely to an earlier picture of the
same subject by Giacinto Gimignani in
the Chiesa dei Re Magi a Propaganda
Fide in Rome, which is signed and dated
1634 (reproduced in Cortese 1967, p.
187, fig. 1). It reflects the artist's admi-
ration for Nicolas Poussin's early work,
in particular *The Adoration of the Kings*
of 1633, which is now in Dresden. In
contrast, the companion picture of *The
Raising of Lazarus* prompts close com-
parison with the work of Alessandro
Turchi, whose daughter married
Gimignani in 1640. Indeed it now
seems probable that it is in fact by
Turchi.

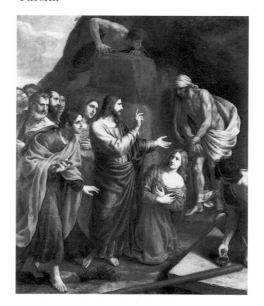

Figure 1
Attributed to Alessandro Turchi
The Raising of Lazarus
Burghley House

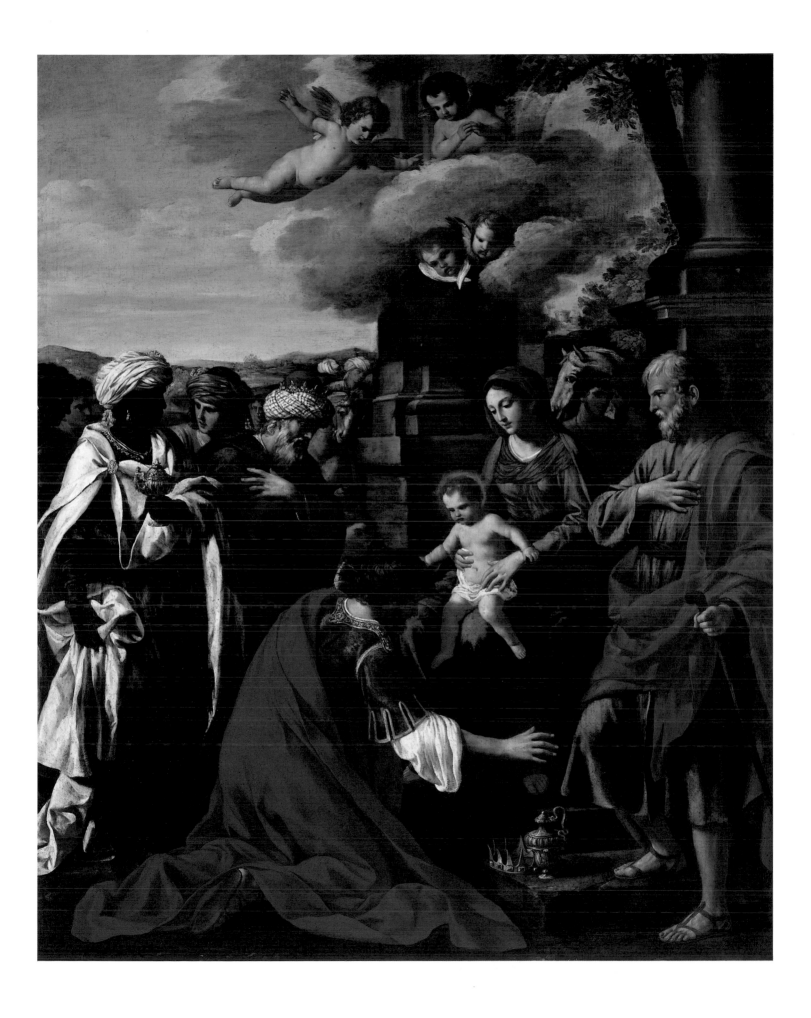

23.

GIACINTO GIMIGNANI
Pistoia 1611 – 1681 Rome

Venus and Cupids

Oil on canvas
72.5 by 58.5 cm; 28½ by 23 in.
B.H. No. 261

Provenance:
Possibly Antonio Ruffo, Duca di Bagnara (see below). Probably acquired by the 9th Earl and first recorded at Burghley House in an inventory entitled "Inventory of the Plate, Pictures, China, Linnen, and House Hold Furniture at Burghley taken by me, Exeter 9", as follows: "the dressing room *Venus and Cupids*; by Nic Posen"; recorded again in the 9th Earl's annotated copy of Orlandi, *Abecedario Pittorico*, 1704, as *Venus with Cupids* by N. Poussin at Burghley. Recorded in 1815, p. 75; 1847, p. 218, no. 287; 1878, p. 27, no. 261; 1954, no. 261, all as by N. Poussin.

Literature:
Blunt 1958, pp. 85–86, fig. 16, as by Giacinto Gimignani; Cortese 1967, p. 195, fig. 12; Fischer 1973, no. 22.

Acquired as by Nicolas Poussin, Gimignani's painting of Venus being attended by cupids is undeniably close in spirit to the French master's early work. Blunt believes it may be the picture first recorded in the collection of Antonio Ruffo, Duca di Bagnara, at Messina in Sicily, in a list of pictures acquired between 1646 and 1649 as "uno quadro con una Venere con scherzo di n.ro 8. Puttini di Mano di Jacinto discepolo di Pietro da Cortona de p. mi 2 è 3 comp.to in Roma dal Sig.r Abbe".[3] The editor of the inventory identified this Jacinto as Giacinto Giannini, an artist not known to have existed. Blunt believes it should be interpreted as Giacinto Gimignani.

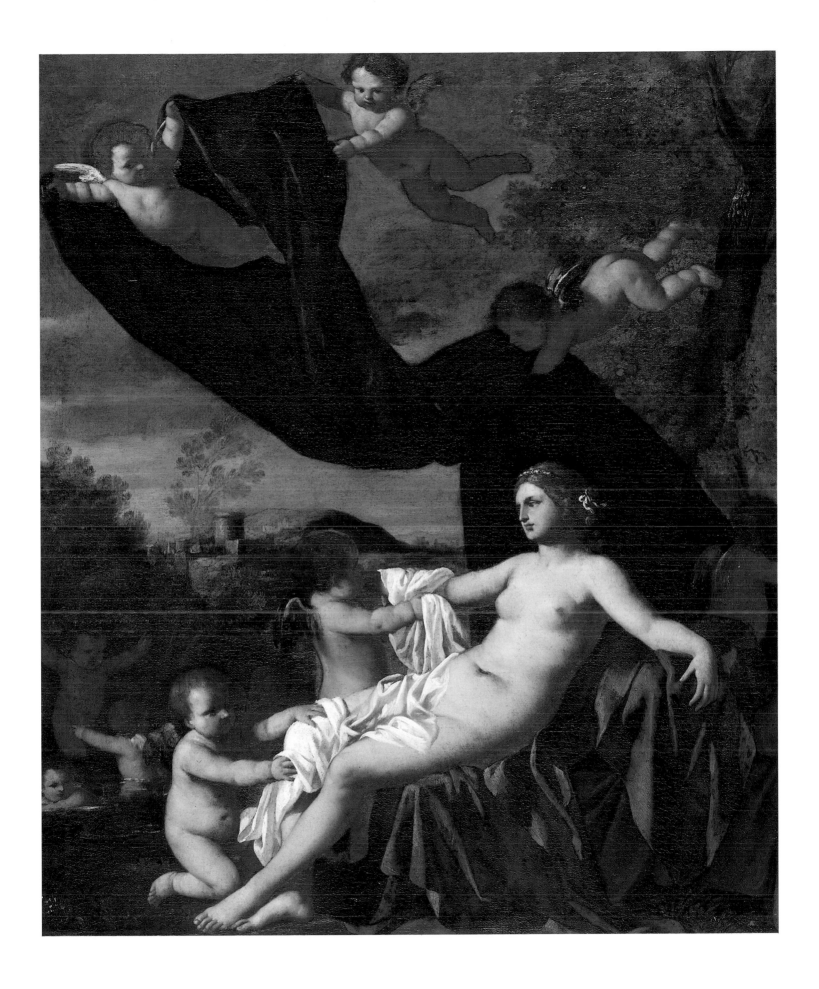

24.

LUCA GIORDANO
Naples 1634 – 1705 Naples

The Rape of Europa

Oil on canvas
246.5 by 301 cm; 97 by 118½ in.
B.H. No. 397

Provenance:
Bought (almost certainly in Florence) with the
companion picture of *The Death of Seneca*
(cat. no. 25) for the 5th Earl, by Mr Balle, as
recorded in a letter written from Genoa, dated
December 1683: "My Lord as Soone as you
departed I made it my business to purchase
these two pieces of Luca Giordano of Senica
and Europa, which by bribinge a younge man I
found outt all ye intreagues aboutt them, and
Soe Sente an authentick broker to buy them,
which hee did effectually for [d?] 190. . . ."
First recorded at Burghley House in the 1688
inventory, p. 32, as "In the Best Bedd
Chambr: 4 very Large pictures in Guilt
fframes (viz) a Seneca, a Europa, St John decol-
lating and a Diana and Acteon by Jordanus";
1738, p. 28; 1815, p. 111; 1847, p. 248, no.
402; 1878, p. 51, no. 397; 1954, no. 397, all as
by Giordano.

Literature:
Peck 1732, p. 43; Ferrari and Scavizzi 1966,
pp. 121–122; Ferrari and Scavizzi 1992, pp.
78–79 and p. 302, no. A.305.

In 1966 Oreste Ferrari catalogued this
painting as a studio version of a lost orig-
inal. During a recent visit to Burghley
House in 1991 with the two compilers of
the present catalogue, he was persuaded
to reconsider this view. In the new edi-
tion of his catalogue raisonné (Ferrari
and Scavizzi 1992), Ferrari has accepted
this picture as Giordano's original ver-
sion, but he draws attention to its
uneven technique. He even speculates
that it may have been painted over the
artist's first thoughts for a quite differ-
ent design: "come se l'opera fosse stata
dipinta su un tela già abbozzata per
un'altra composizione".[4] Alternatively
the *pentimenti* visible beneath the sur-
face may reflect earlier ideas for the pre-
sent picture. The head of what appears
to be a seahorse (but arguably a bull) is

visible at the extreme left of the canvas,
set much further back than the bull
which dominates the picture as we see it
now. A studio version of the design is in
the Schleissheim gallery of the
Bayerische Staatsgemäldesammlungen
in Munich (fig. 1).

The picture was probably painted in
1682, just before the 5th Earl acquired
it. Giordano had come to Florence from
Naples in 1682 at the invitation of the
Corsini family to decorate the family
chapel in the Church of the Carmine.
Towards the end of that year he made
modelli for the gallery of the Palazzo
Riccardi, but he then left the city and
did not return to execute this important
project until 1685. The Burghley House
picture was apparently painted before he
left Florence in 1682.

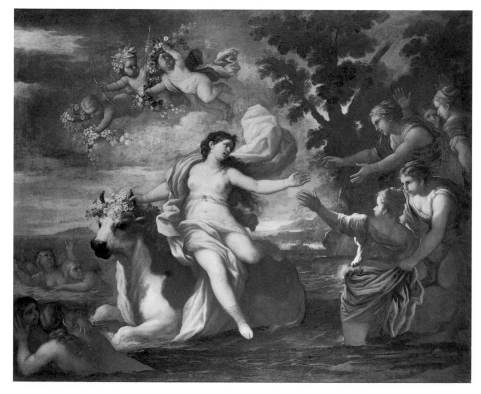

Figure 1
Luca Giordano and studio
The Rape of Europa
Bayerische Staatsgemäldesammlungen, Munich

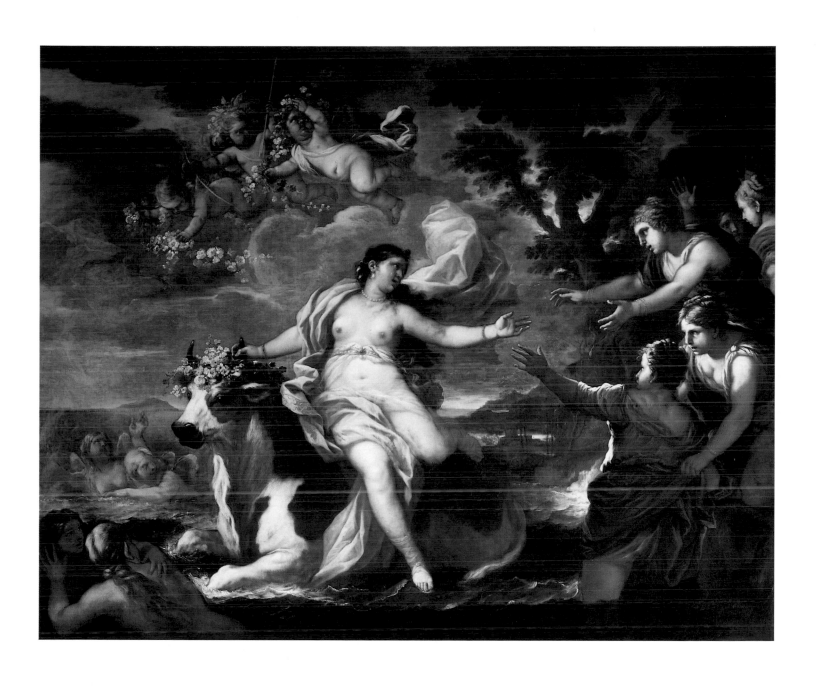

25.

LUCA GIORDANO
Naples 1634 – 1705 Naples

The Death of Seneca

Oil on canvas
246.5 by 301 cm; 97 by 118½ in.
B.H. No. 406

Provenance:
Bought (almost certainly in Florence) with the
companion picture of *The Rape of Europa* (cat.
no. 24) for the 5th Earl by Mr Balle in 1683.
First recorded at Burghley House in 1688
inventory, p. 32, as in the "Best Bedd
Chambr"; again in 1738, pp. 28–29; 1815, pp.
112–113; 1847, p. 247, no. 399; 1878, p. 51,
no. 406; 1954, no. 406, all as by Giordano.

Literature:
Peck 1732, p. 43; Ferrari and Scavizzi 1966,
pp. 121–122; Ferrari and Scavizzi 1992, pp.
78–79 and p. 302, no. A.305.

In 1966 Oreste Ferrari catalogued this
picture as by a pupil of Giordano: "solo
genericamente di orbita del Giordano,
probabilmente di un suo allievo".[5]
During his return visit to Burghley in
1991, however, the two compilers of the
present catalogue were able to convince
Ferrari that the picture is by Giordano
himself. In the new edition of his cata-
logue raisonné (Ferrari and Scavizzi 1992,
pp. 78–79), Ferrari now accepts the pre-
sent picture as an autograph work by
Giordano, but he draws attention to its
uneven technique and suggests that it
may have been left incomplete in some
areas, especially the left arm of the figure
on the left and the whole of the upper
part of the composition: "Si presentano
stranamente, incompiute, specialmente la
Morte di Seneca, ove il braccio della figu-
ra accovacciata a sinistra e tutta la parte
superiore sono appena abbozzate".[6]

Giordano painted several variant inter-
pretations of this subject. Others are in
the Louvre (inv. 2578; Ferrari and
Scavizzi 1992, no. A.358, fig. 468) and in
the Dresden Museum (Ferrari and
Scavizzi 1992, no. A.647). Ferrari dates
the Louvre picture circa 1684–1685 and
the Dresden picture circa 1699. There
are also studio versions in the Palazzo
Reale, Madrid (Ferrari and Scavizzi 1992,
no. A.335b, fig. 438) and in the Palazzo
di Aranjuez in Spain. The present picture
was probably painted in 1682, just before
the 5th Earl acquired it.

The picture inspired a poem by Matthew
Prior (1664–1721), who became tutor to
the 5th Earl's sons before the family left
for Italy in 1688.

While cruel Nero only drains
The moral Spaniard's ebbing veins,
By study worn, and slack with age,
How dull, how thoughless is his rage!
Heighten'd revenge he should have took,
He should have burnt his tutor's book;
And long have reign's supreme in vice;
One noble wretch can only rise;
'Tis he whose fury shall deface
The Stoic's Image in this piece,
For, while unhurt, divine Jordain,
Thy work and Seneca's remain,
He still has body, still has soul,
And lives and speaks restored and whole.

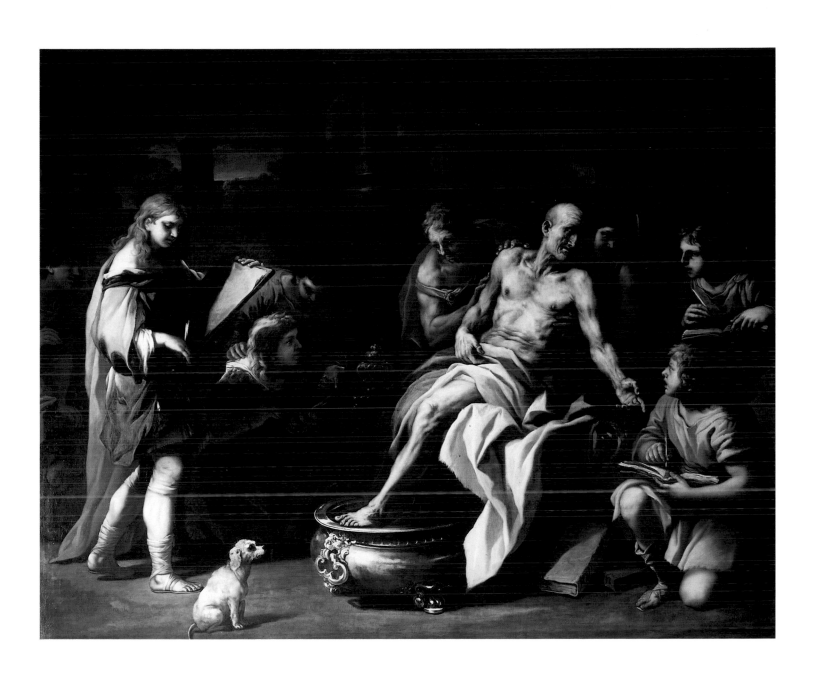

26.

GIOVANNI FRANCESCO BARBIERI, CALLED GUERCINO
Cento 1591 – 1666 Cento

Jacob Receiving the Bloody Coat of Joseph

Oil on canvas
115.5 by 94 cm; 45½ by 37 in.
B.H. No. 335

Provenance:
Acquired by the 9th Earl from the Barberini Palace (recorded in a list made in the 9th Earl's hand, *Extracts from an old catalogue of ye furniture at Burghley*); also recorded in the 9th Earl's annotated copy of Orlandi, *Abecedario Pittorico*, 1704, p. 287, as by Guercino; also recorded in 1815, p. 93; 1847, p. 232, no. 353; 1878, p. 38, no. 335; 1954, no. 335, all as by Giordano.

Literature:
Waagen 1854, p. 405, as by Guernico ("Very carefully executed, and remarkably clear in the colouring").

There is no reference to the present picture in Guercino's accounts, *Libro dei Conti* (see Malvasia 1678, 1841 ed., vol. 2, p. 307ff), and for this reason Sir Denis Mahon has been disinclined to accept it as an autograph work. Nevertheless, the high quality of the picture and its distinctive style suggest that we may after all be concerned with an autograph late work by the Bolognese master. The picture seems particularly close to Guercino's work of the 1650s, such as *St Peter Weeping* in the collection of the Cassa di Risparmio, Bologna, which is documented in the *Libro dei Conti* under 11 October 1650 (see Salerno 1988, p. 339, no. 269). Mahon has raised the possibility that the present picture might be by Cesare Gennari, who was attached to Guercino's studio, but it is difficult to find any work of comparable quality by that hand.

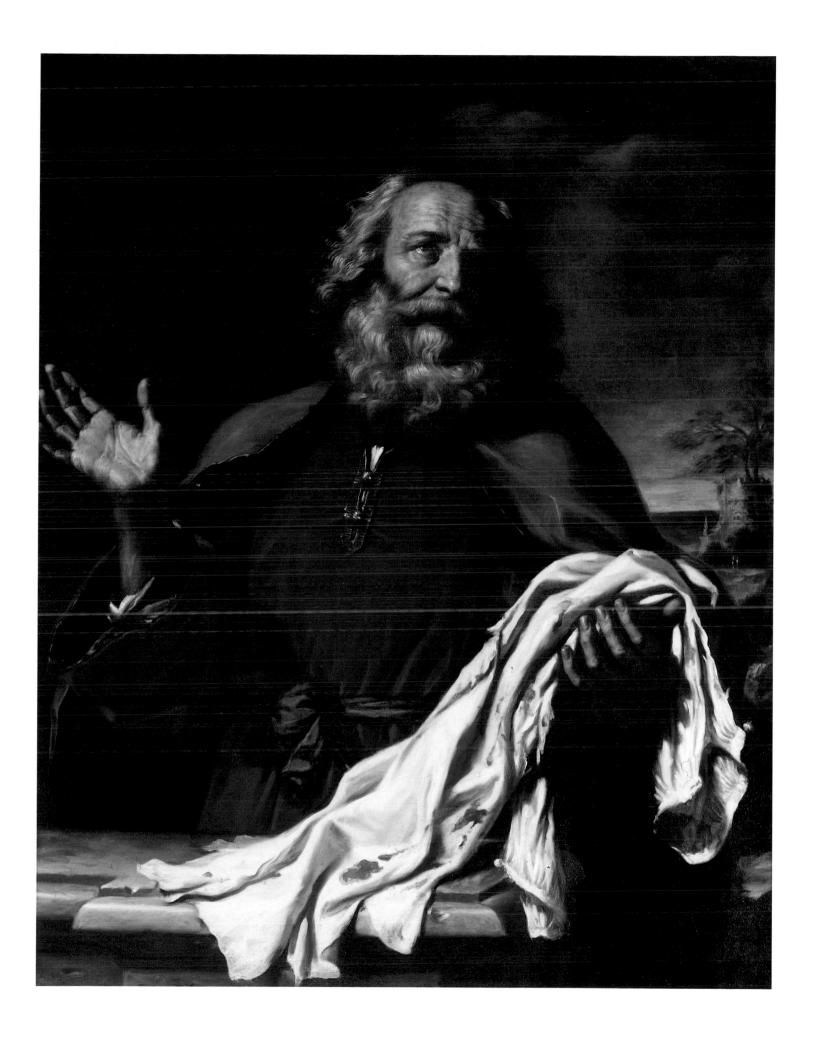

27.

DAVID DE KONINCK
Antwerp 1636 – 1699 Brussels

Cockerels Fighting

Oil on canvas
ll4.5 x 147.5 cm; 45 x 58 in.
Signed, centre left on fallen stone: F / DAVID.
DE.CONINCK
B.H. No. 111

Provenance:
Purchased in Rome by the 5th Earl in 1684, as
recorded in *An account of wt I have expended
since Naples*, p. 5, under the title "The account
of ye charge of pictures at Rome / To Sigr.
Davide - 125 - 0"; 1688 inventory, described as
hanging in the "Midle or 4th Roome and ye 2
Clossetts" of the "Lower Gallery" and as "2
peices of Birds & beasts over ye Doores done
by David of Rome"; 1738, p. 68, as hanging in
"The Drefsing Room over one Door, a Picture
of Wild Fowl, / a Dog swimming after 'em in
the water. / over the other Door, two Game
Cocks / fighting, by David of Rome"; 1797,
probably p. 81; 1815, p. 65; 1847, p. 197, no.
119; 1878, p. 18, no. 111; 1882, p. 23, no. 111;
1954, no. 111.

David de Koninck (often known as
Coninck in Italy) left his home city of
Antwerp and arrived in Rome around
1670. Not only was he one of the many
northern artists working in Italy who
were patronized by the 5th Earl, but he
was also one of the most favoured.
Some eight paintings by him are at
Burghley today. One, however (B.H. No.
471), was certainly acquired by the 9th
Earl. It would seem from the evidence
in the 1684 travel accounts that, with
the exception of Carlo Maratta (cat. nos.
33–38), no artist was paid as much as de
Koninck. It is unclear whether this
reflects the high prices he could com-
mand or whether all six pictures were
acquired at the same time, for the
account entry does not qualify the pay-
ment.

De Koninck obviously ran an active
studio in Rome in which numerous ver-
sions of compositions were produced,
with changes in size and format and
always with subtle alterations to the ele-
ments and layout. Many of his works
are of variable quality, yet there is no
doubt that all eight pictures at Burghley
are outstanding. The foreground rabbits
are one of the artist's most frequently
used compositional devices. (See a simi-
lar painting at the Narodowe Museum in
Poznan [inv. no. 55–1967, catalogued
incorrectly as Pieter Boel].

Cockerels Fighting hangs today in the
private dining room at Burghley House,
along with its pendant *A Spaniel and
Eagle Surprising Duck* (B.H. No. 120)
(fig.1). Though unequivocally a pair, the
paintings contrast considerably in their
colours and overall tonality. Unlike its
bright and warmly coloured pendant, *A
Spaniel and Eagle Surprising Duck* is of
an altogether cooler tonality, made up of
cold blues, greys, greens and browns
(see also cat. no. 28).

Figure 1
David de Koninck
A Spaniel and Eagle Surprising Duck
Burghley House

28.

DAVID DE KONINCK
Antwerp 1636 – 1699 Brussels

Hounds and Game

Oil on canvas
146 x 110.5 cm; 57½ x 43½ in.
B.H. No. 374

Provenance:
Purchased in Rome by the 5th Earl in 1684, as recorded in *An Account of wt I have expended since Naples*, p. 5, under the title "The account of ye charge of pictures at Rome / To Sigr. Davide – 125 - 0"; 1738, p. 8, as hanging in the "Drefsing Room" and "over the chimney is a Piece of Dead Game / a wild Boar, Buck, Hare, and several Dogs / watching them, the Gun lies by, 1½ yd high / Ell long, in a Frame the same as the doors"; 1797, p. 25, as hanging in the South Dining Room, "over the mantle-piece, just opposite the family, when at dinner, is an exceeding fine picture of game; over which, a very expressive resemblance of an old pointer, who seems the sire of a long race of sons, appears to preside"; 1815, p. 107; 1847, p. 242; 1878, p. 48, no. 374, as by Snyders; 1882, p. 61, no. 374, as by Snyders; 1954, no. 374, as by Snyders.

The prominent spotted hound is almost certainly a precursor of the modern Dalmatian, which was first recorded as a gun dog in the Balkans and Italy, then by the mid-seventeenth century as a guard against highwaymen in France. In keeping with David de Koninck and his studio's habit of re-employing distinctive elements, this spotted dog appears again and again in other compositions and versions of the Burghley picture. The closest painting of comparably high quality is in the Earl of Bradford's collection at Weston Park. That picture is, however, of a horizontal format (fig. 1) and most significantly lacks the dead deer and boar, whilst the hound surveying the landscape from the hillock has been moved to the right-hand side. A poor imitation of de Koninck's work in which the spotted hound re-appears is at Corsham Court (Corsham catalogue no. 152) along with another (Corsham catalogue no. 148) of the Burghley *Cockerels Fighting* (cat. no. 27). The Corsham pictures are from a set of six small panels (25 by 30 cm; 9¾ by 11¾ in.), which shows how the taste for de Koninck's work in England continued into the eighteenth century. Indeed the 9th Earl acquired from Signor Ammerani in Rome *Two Pigeons in a Basket* (B.H. No. 471), though its pendant, *A Cat Espying Dead Song-Birds* (B.H. No. 474) seems to have already been at Burghley.

Whilst the different generations of the Cecil family in this century have chosen to hang the pair of David de Konincks (cat. no. 27) in their private dining room, so this painting has hung since at least 1797 in the room that served as the dining room in previous centuries. That the 5th Earl's particular liking for de Koninck should have been reflected in his descendants is a telling comment on the Earl's choice of this particular artist and an affirmation of the unerring quality of his eye.

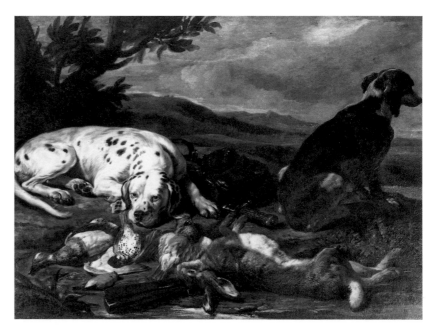

Figure 1
David de Koninck
Still Life with a Dog
The Earl of Bradford, Weston Park

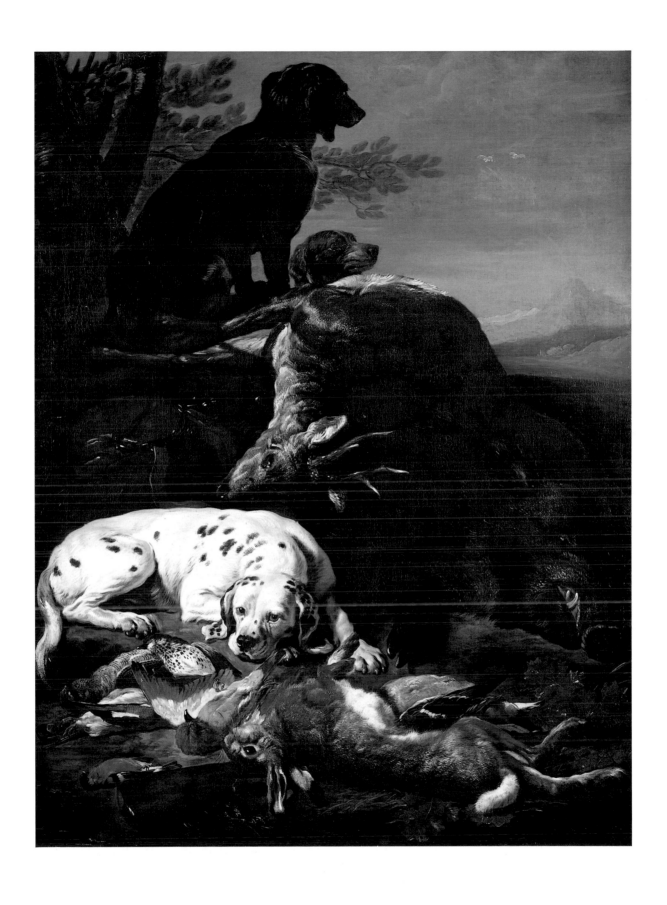

29.

FILIPPO LAURI
Rome 1623 – 1694 Rome

Erminia and the Shepherds

Oil on copper
30.5 x 40.5 cm; 12 x 16 in.
Signed, lower right, with initials: F.L.
Inscribed on reverse, probably by the artist:
Lauro
B.H. No. 143

Provenance:
Purchased in Rome by the 5th Earl in 1684, as recorded in *An Account of wt I have expended since Naples*, p. 5, under the title "The account of ye charge of pictures at Rome / To Phillippo Lauro - 100 - 0"; 1815, p. 51; 1847, p. 199, no. 126; 1878, p. 20, no. 143; 1882, p. 25, no. 143; 1954, no. 143.

Balthasar Lawers, the father of Filippo Lauri, came from Flanders, settled in Rome and married the sister of the painter Angelo Caroselli. Filippo, having been born and dying in Rome, can thus be considered thoroughly Italian despite his northern paternal ancestry. The year after Lord Exeter made purchases from Lauri, the artist was sufficiently highly regarded to become President of the St Luke Academy (Riccio 1959, p. 13).

The high payment of 100 crowns in 1684 reflects both Lauri's status as a respected artist and the number of works bought, there being at least nine pictures by him at Burghley today. By 1688 six were recorded as being in "My Lady's Clossett" but not *Erminia and the Shepherds*, which is unlikely to have been acquired later than 1688, as Lord Exeter probably was not in Italy again until 1693, and Lauri died in December of 1694. Although Lauri came to specialize in relatively small-scale works, often on copper, his masterpiece is probably *Jacob Fleeing from Laban* in the Royal Collection (Levey 1964, no. 531), which is on an altogether larger scale

Figure 1
Filippo Lauri
Preparatory study for *Erminia and the Shepherds*
Gallerie dell'Accademia, Venice

than was normal for him. Lauri's work was obviously popular, or perhaps his inventive abilities were limited. He and his studio produced any number of versions or derivatives of individual compositions which vary enormously in quality as well as in their constituent elements. A version of this work on canvas, almost twice the size, was last recorded at Finarte in Milan on 1 December 1981, lot 19. In that painting the pose of the two central figures is identical, but a shield lies against the rock on which the two baskets sit and two putti appear on the right (with one weeping). The standing shepherd boy to the left is changed, and the trees and vegetation differ considerably from the Burghley painting.

A drawing on three sheets of paper, partly superimposed since restoration in 1987 (see *Old Master Drawings* 1990, no. 29), that is clearly related to the Burghley picture is in the Gallerie dell' Accademia, San Luca in Venice (no. 5 363 A, B, C). Despite the many differ-

ences it is obviously related to this painting. Instead of being a preparatory study, its *pentimenti* indicates that it represents an early stage in the formulation of the scene (fig. 1).

The subject is taken from Tasso's *Jerusalem Delivered* (7:6ff). Erminia, a princess of Antioch who was rescued by Tancred, falls in love with him but reluctantly leaves for Jerusalem where Tancred engages in single combat with the pagan Argantes. She beholds the fight and, fearing for her hero, seeks him out disguised in the armour of Clorinda, who is loved by Tancred. Erminia has to flee when she is assaulted by an advance guard of Tancred's Christian army. She comes upon a shepherd family and the old father compares his rustic contentment to her troubled life and the war raging not far away. As an evocation of the virtues of pastoral life, the story was extremely popular amongst Baroque painters.

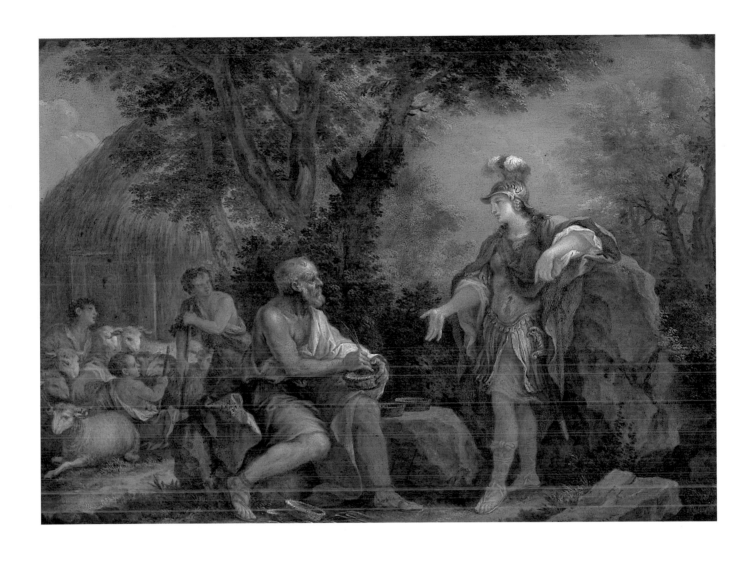

30.

PIETRO LIBERI
Padua 1614 – 1687 Venice

Logic Between Vice and Virtue

Oil on canvas
150 by 136.5 cm; 59 by 53¾ in.
B.H. No. 139

Provenance:
Bought in Italy by the 5th Earl; perhaps one of
the pictures first recorded in the 1688 inven-
tory alongside other pictures by Liberi: "In
My Ladyes Dressing Roome: 3 pictures over
the Doores, Ld. Burghley pulling fortune, pru-
dence and fortune and one Embracing fortune
- by Sigr Librei". Subsequently recorded in
1738 inventory, p. 18, as "a Painter presenting
his first Works to Fortune"; also recorded in
1797, p. 56, as "a statuary, presenting his first
work to Fortune" by Pietro Liberi; 1815, p.
117, as "Pygmalion first offering to Venus" by
P. Liberi; 1847, p. 199, no. 123; 1878, p. 20,
no. 139; 1954, no. 139, all as by Liberi.

Literature:
Potterton 1979, pp. 30–31, fig. 19.

The subject, described in old inventories
as *Pygmalion's first offering to Venus*,
has not been identified satisfactorily but
might well represent *Logic between Vice
and Virtue*. It is one of six pictures
apparently bought directly from the
artist in Venice by the 5th Earl. The
others are *Fortune Embracing Prudence*
(fig. 1), *Jupiter and Juno* (fig. 2), *The 6th
Earl of Exeter when a Child, Pulling
Fortune by the Hair* (fig. 3), *Adoration of
the Shepherds* and *Christ Appearing to
Mary Magdalen* (for which a payment of
50 pistols or 75 Zechins was made to
the artist in Venice on 2 June 1684,
through Mr Thomas Hobson [recorded
in a travel notebook at Burghley House,
Ex 51/9: *The Florence Account*, drawn
up by the steward, Culpepper Tanner]).
Liberi's paintings, which are notable for
their sensuality and facility of execution,
were inspired by the Venetian
Renaissance tradition of Titian and
Veronese.

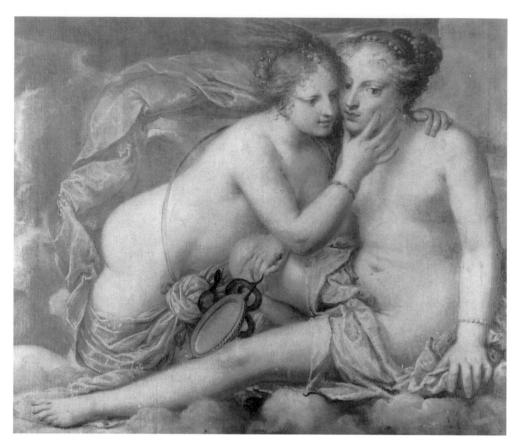

Figure 1
Pietro Liberi
Fortune Embracing Prudence
Burghley House

Figure 2
Pietro Liberi
Jupiter and Juno
Burghley House

Figure 3
Pietro Liberi
*The 6th Earl of Exeter when a Child,
Pulling Fortune by the Hair*
Burghley House

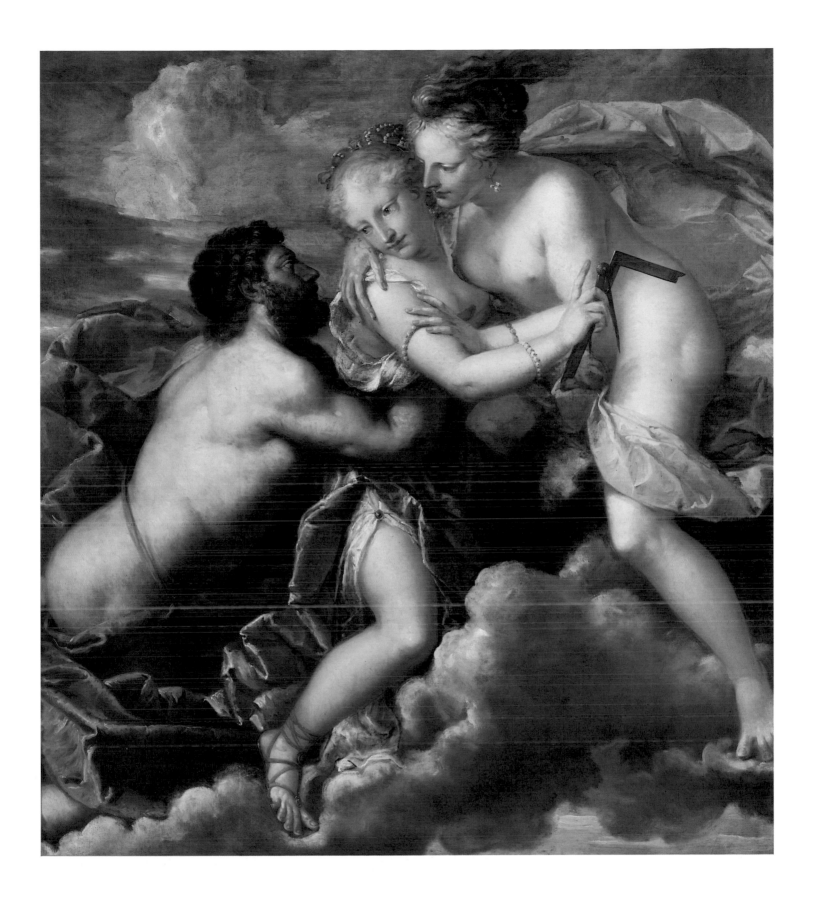

31.

JOHANN CARL LOTH
Munich 1632 – 1698 Venice

The Adoration of the Shepherds

Oil on canvas
121 by 158 cm; 47½ by 62¼ in.
B.H. No. 411

Provenance:
Presumably purchased by the 5th Earl in
Venice circa 1684 but only first identified with
certainty in a 1793 manuscript partly in the
hand of the 9th Earl; 1815, p. 115, as by
Cignani; 1847, p. 251, no. 417, as by Loth;
1878, p. 52, no. 411; 1882, p. 67, no. 411;
1954, no. 411.

Literature:
Ewald 1965, p. 71, no. 137A and pl. 47;
Donzelli and Pilo 1967, p. 246.

Whilst the other works by Johann Carl
Loth in the Burghley collection (B.H.
Nos. 71 and 368) are grand and heroic
in size and subject, *The Adoration of the
Shepherds* is decidedly more intimate in
character and scale. It has the typical
warm tonality and colouring of Loth
with the traditional red ground. In
many of Loth's works this ground
re-appears through now thinning top lay-
ers of paint, giving them a kind of "hot
blush". This picture, having been thick-
ly painted and still being in an excellent
state of preservation, allows us an all-too-
rare insight into how Loth's works must
have looked when they initially left the
studio. It is tempting to surmise that
this might have been the 5th Earl's first
purchase from the artist, which then
resulted in the commissioning of *The
Finding of Moses* (cat. no. 32) and its
pendant *The Idolatory of Solomon* (fig. 1
under cat. no. 32).

As a northerner, Loth soon assimilat-
ed the Italian idiom after his arrival in

Venice in 1655. Through his father,
who had studied with Carlo Saraceni
(see cat. no. 48), Johann Carl acquired
his latter-day Caravaggism. Subse-
quently he is believed to have worked
with Pietro Liberi (cat. no. 30), an artist
much favoured by the 5th Earl, and it
seems likely that the introduction to
Loth would have come via Liberi to
whom a payment of "50 pistols" or "75
Zechins" was made in 1684 for his
Christ Appearing to Mary Magdalene
(B.H. No. 74).

Loth returned to the subject of *The
Adoration of the Shepherds* on a number
of occasions, most notably the huge can-
vas (5 by 6 metres; 16½ by 19½ feet) in
the Cathedral at Trent (Ewald 1965, no.
138). The Burghley painting is the only
extant small-scale work of the subject,
though a sketch for the Trent canvas,
recorded as belonging to the 5th Earl's
friend, the Grand Duke Ferdinand of
Tuscany, was slightly smaller but is now
lost (Ewald 1965, no. 141).

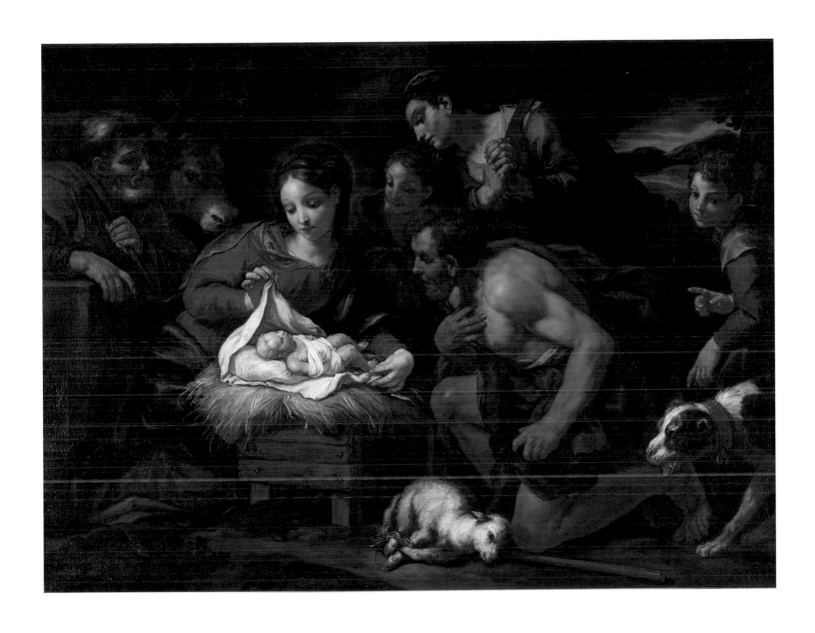

103

32.

JOHANN CARL LOTH
Munich 1632 – 1698 Venice

The Finding of Moses

Oil on canvas
185 by 274 cm; 72¾ by 107¾ in.
B.H. No. 71

Provenance:
Acquired by the 5th Earl in Venice, circa 1684
and first recorded in the 1688 inventory, p. 25,
as in "The Dineing Roome: 2 Large peices in
Guilt frames (viz) Solomon's Idolatry, / Moses
in ye Rushes by Carlo Loti"; 1738, p. 85,
"Moses saved from Drowning" and as hanging
in the chapel; 1797, p. 58 and pp. 118–119,
". . . we know none, who excited our admira-
tion so much as the ingenious Carlo Lotti in
his piece of the Finding of Moses"; 1815, p.
32; 1847, p. 186, no. 62; 1878, p. 13, no. 71;
1882, p. 17, no. 71; 1954, no. 71.

Literature:
Ewald 1965, pp. 64–65, no. 78a; Donzelli and
Pilo 1967, p. 246.

By 1738 this painting, its pendant *The
Idolatory of Solomon* (B.H. No. 368 and
fig. 1) and six other large-scale canvases
all by Venetian *seicento* painters were
hanging in the chapel at Burghley
House, where they have remained ever
since. (Two, *Samson and Delilah* and
Samson Slaying the Philistines, had dis-
appeared by 1797.) Whether all eight
were commissioned and purchased with
that location in mind is not certain. The
1688 inventory indicates that no paint-
ings were in the chapel and only three
others of this group of eight can be iden-
tified individually elsewhere in the
house at that date (see cat. no. 60).
With the exception of *Christ Appearing
to the Magdalene* by Pietro Liberi (B.H.
No. 74), none of the group is of New
Testament subjects and today they might
seem inappropriate for such a location.
As the other three paintings of the
group cannot be identified in the 1688
inventory, it is perfectly possible that
since they were all only commissioned

some four years earlier they had not yet
all arrived at Burghley.

In the second half of the eighteenth
century the 9th Earl acquired the altar-
piece of *The Wife of Zebedee Petitioning
our Lord* by Paolo Veronese (B.H. No.
610 and see cat. nos. 58, 59; also illus-
trated on p. 21) and placed it over the
altar of his completely re-designed and
re-furnished chapel. At that time the
remaining six Venetian *seicento* works
were reframed *en suite* with that put
around the Veronese itself. Almost cer-
tainly when the chapel was subdivided
and an organ installed, there was insuffi-
cient room for all eight paintings and
the two scenes from the story of Samson
- one erotic and the other violent - were
disposed of as being inappropriate.

A preparatory drawing for the pendant
Idolatory of Solomon is in The
Metropolitan Museum of Art (no.
87.12.70, in pen and ink with white
heightening on grey-brown paper), yet
no drawings for *The Finding of Moses*
seem to exist.

Figure 1
Johann Carl Loth
The Idolatory of Solomon
Burghley House

33, 34.

CARLO MARATTA
Camerano 1625 – 1713 Rome

Christ and the Woman of Samaria at the Well

The Penitent Magdalen with an Angel

Oil on canvas
Each 98 by 116 cm; 38½ by 45½ in.
37. Signed on the well, lower centre: Carolus
Maruttus. P
38. Signed, lower left: Carolus Maruttus
B.H. Nos. 408, 426

Provenance:
Bought by the 5th Earl and first recorded in
the 1688 inventory, p. 33, as by Carlo Maratta
and "In The Best Bedd Chamber: 2 pictures
over ye Doores a Magdalen praying, & our
Saviour and ye Samaritan wo: by Carlo
Marattus". According to a later list, in the 9th
Earl's hand, *Extracts from an old catalogue of
ye furniture at Burghley*, these pictures to-
gether cost 360 crowns. Also recorded in
1738, pp. 28, 30; 1815, pp. 114, 115; 1847, pp.
250, 253, nos. 404, 425; 1878, pp. 52, 53,
nos. 408, 426; 1954, nos. 408, 426, all as by
Maratta.

Carlo Maratta, whose "grand manner"
style breathed new life into the Roman
classical tradition which had been estab-
lished early in the seventeenth century
by Annibale Carracci and Domenichino,
was admired from an early date by
British travellers and collectors in Italy.
Among the first who commissioned por-
traits were Wentworth Dillon, 4th Earl of
Roscommon, whose painting dates from
circa 1664 and is now at Althorp; the
2nd Earl of Sunderland, whose portrait
is also at Althorp; Sir Thomas Isham of
Lamport Hall, whose portrait was paint-
ed in 1677; and the 5th Earl of Exeter,
which is no longer at Burghley and
remains unidentified.

 All these British patrons are men-
tioned in Bellori's *Life of Maratta*
(Bellori 1732, pp. 97–98). Bellori also

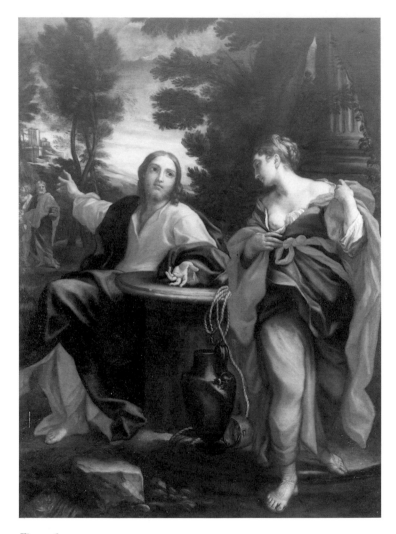

Figure 1
Attributed to Giuseppe Chiari
Christ and the Woman of Samaria
On London art market 1977

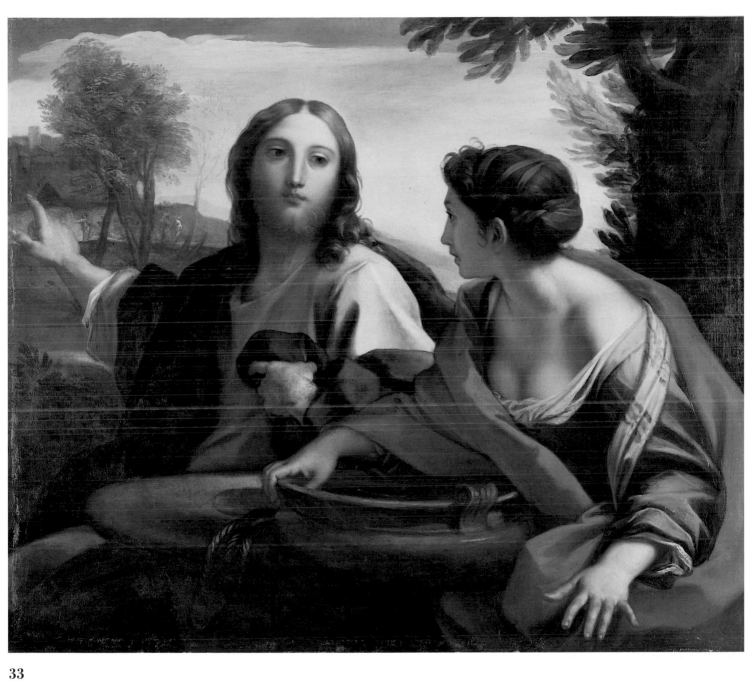

33

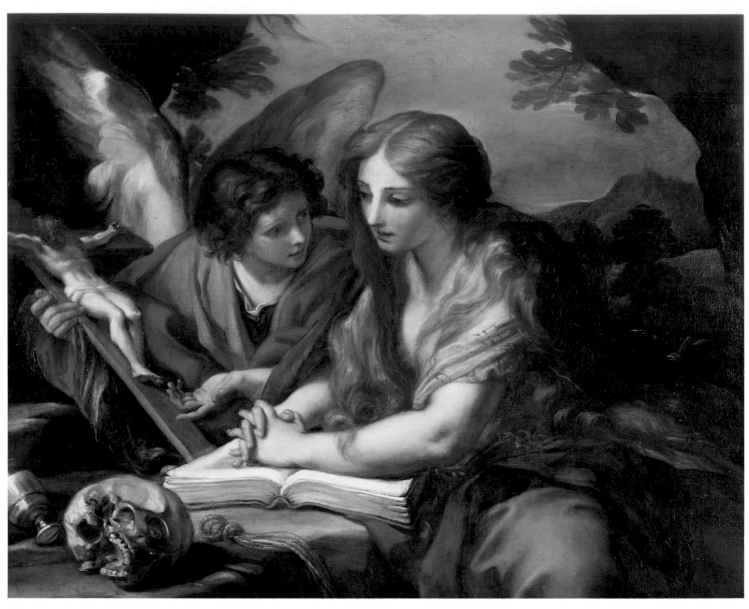

34

refers to John Herbert, a Master of the Bench of the Inner Temple, who commissioned not only a portrait (now in the collection of the Honourable Society of the Inner Temple) but apparently also two half-length pictures of *Christ and the Samaritan Woman* and *The Penitent Magdalen*. Bellori writes:

> Seguitò a fare non pochi Ritratti de' Sig.ri Inglesi, che venivano a Roma, riportandone liberalissimi premj, e tra questi il Mylord di Sunderland in piedi appoggiato nobilm.te ad un basamento de marmo, ed il Mylord Roscomen parimente in piedi in atto de accennar con una mano di Commando, l'uno e l'altro divisato vagamente, come dicono in abito Pittoresco all'antica. Fece il Ritratto del Conte Exceter, e l'altro del Cavalier Tomaso Isham a sedere col Ritratto in piccolo di una dama in mano. Ritrasse il Sig.r Carlo Fox ed il Sig.r Gio: Herbest studiosis.mo della Pittura, che invaghitosi del dipingere di Carlo, volle con il Ritratto due mezze figure di sua mano, le due Penitenti: Madalena al deserto, che contempla la Croce presentatagli dagl'Angeli, e la Samaritana al Pozzo avanti il Sig.re.[7]

These two religious pictures of *le due Penitenti* from Herbert's collection can no longer be identified, and it is perhaps worth considering the possibility that they were eventually acquired instead by the 5th Earl of Exeter. In any event, the two Burghley canvases exactly match Bellori's description of the pictures painted for Herbert.

Maratta's interpretation of both subjects appears to have had a wide appeal. Another version of the *Penitent Magdalen* which is at Holkham Hall was acquired by Thomas Coke, 1st Earl of Leicester (1697–1759). Numerous variant versions of Maratta's *Christ and the Woman of Samaria* exist, but they are of vertical full-length format. In design they may owe more to Annibale Carracci's painting of the subject, now in the Museum of Fine Arts, Budapest, but formerly in the Casa Oddi, Perugia.

Maratta etched Carracci's painting in 1649. One of these vertical versions, sold at Sotheby's, London, 6 April 1977, lot 80, as by Giuseppe Chiari (fig. 1), includes a figure of Christ which is remarkably similar to the equivalent figure in the Burghley House picture, and may well be by Maratta. However, a variant of this composition, with an entirely different model for the figure of Christ, which was painted for Graf Christian von Schaumburg-Lippe and is now at the castle of Buckenburg, is signed by Giuseppe Chiari and dated 1712 (see Kerber 1968, p. 81, and Voss 1924, p. 605). Another version of the Buckenburg picture, which was formerly in the Earl of Pembroke's collection at Wilton House, was engraved by James Dean in 1786 (reproduced in Kerber 1968, fig. 18); yet another, from the collection of Samuel Cunliffe-Lister, was sold at Christie's, London, 12 December 1975, lot 30.

The 5th Earl appears to have had direct contact with Maratta when in Rome, on the way home from Naples, during the winter of 1683–1684. A payment to Carlo Maratta of 600 crowns is included in "The account of ye charge of pictures at Rome" in a manuscript notebook at Burghley House (Ex 51/10: *An Account of wt I have expended since Naples*, drawn up by the steward Culpepper Tanner). This payment might have included the cost of the pictures exhibited here or might refer to other pictures by Maratta at Burghley.

35, 36, 37, 38.

CARLO MARATTA
Camerano 1625 – 1713 Rome

Ixion Embracing the Cloud
Danae and the Shower of Gold
Leda and the Swan
Jupiter and Semele

A set of four
Oil on canvas
Each 30.5 by 38 cm; 12 by 15 in.
B.H. Nos. 238, 245, 239, 244

Provenance:
Bought by the 5th Earl and first recorded in
the 1688 inventory, p. 25, as in "My Lords
Clossett"; one pair is described without attribu-
tion, "2 peices a Lyda, a Ixion no frames", and
another pair is described just below as "a
Daphne & Apollo, without a frame, a Diana
Bathing alone no frame", both as by "Carlo
Mauratto". What would appear to be the same
group of pictures is recorded in the 1738
inventory, pp. 55–56, as "4 small pieces;
Jupiter and Alcmene, Danae and the Golden
Shower, Leda and the Swan, Ixion and the
Cloud"; also listed in a manuscript inventory of
1793 partly in the hand of the 9th Earl as by
Maratta; also recorded in 1815, pp. 69–71;
1847, pp. 214–215, nos. 249, 250, 255, 256;
1878, nos. 238, 239, 244, 245; 1954, nos. 238,
239, 244, 245, all as by Maratta.

Literature:
Schaar and Sutherland Harris 1967, pp. 192–
193.

Figure 1
Carlo Maratta
Preparatory sketch for *Ixion Embracing
the Cloud*
Kunstmuseum Düsseldorf im Ehrenhof,
Düsseldorf

Figure 2
Carlo Maratta
Preparatory sketch for *Leda and the Swan*
Kunstmuseum Düsseldorf im Ehrenhof,
Düsseldorf

A drawing at the Kunstmuseum der
Stadt Düsseldorf (F.P. 2711) (fig. 1)
appears to be a preparatory sketch by
Carlo Maratta for *Ixion Embracing the
Cloud*, although Schaar (Schaar and
Sutherland Harris 1967, no. 692) has
catalogued it as by Passeri after a lost
painting by Maratta, and has judged the
Burghley House picture to be a copy.
Another drawing in Düsseldorf (F.P.
2646) (fig. 2) appears to be a preparato-
ry study by Maratta for *Leda and the
Swan*, although Schaar again attributes
it to Passeri after Maratta, and again
judges the Burghley House picture to be
a copy.

 Doubtless each of these four celebrat-
ed designs was repeated many times in
Maratta's studio. Indeed, a series of stu-
dio versions is recorded in the collection
of Maratta's second wife, Francesca
Gommi, in an inventory of 1701. They
were inherited by Maratta's daughter
Faustina, who disposed of much of her
inheritance circa 1723 (information
kindly provided by Dr Stella Rudolph).
Another version of *Danae* in the collec-
tion of the Duke of Hamilton at
Lennoxlove has an old label on the
reverse inscribed "School of Maratta
touched in by himself" (fig. 3). B.
Kerber believes it may be by Maratta's
pupil Giuseppe Chiari (Kerber 1968, p.
80). At least two of the designs were
engraved. The print after the *Danae* is
by Bernard Farjat. The print after *Leda
and the Swan* is by Bapta Sintes and is
dated 1707 (fig. 4).

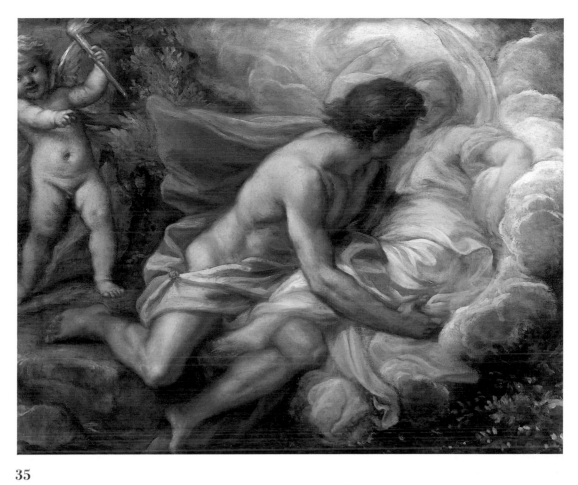

35

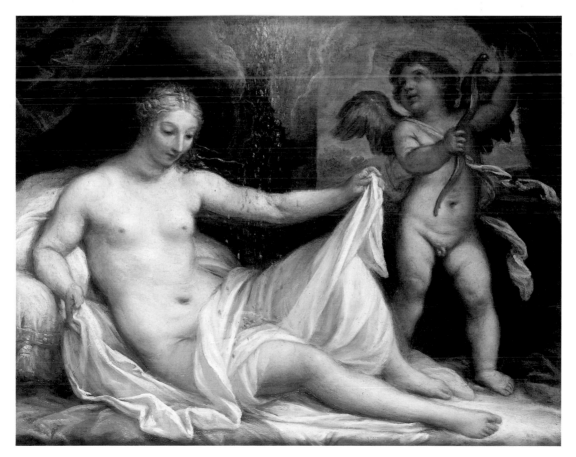

36

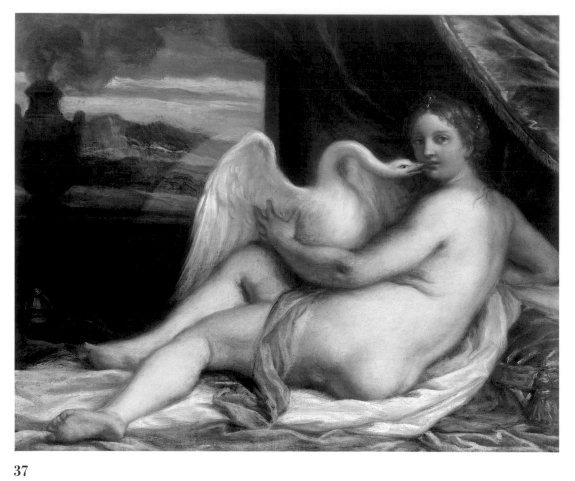

37

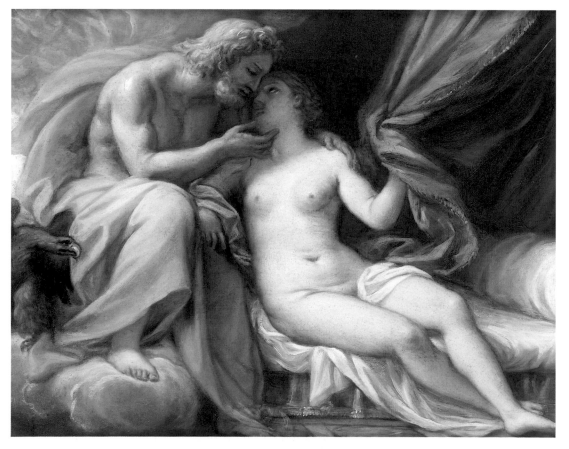

38

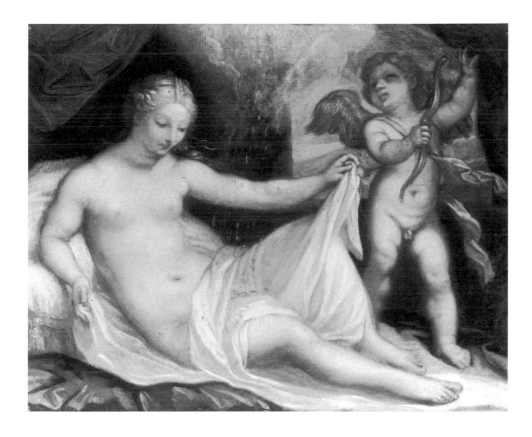

Figure 3
Carlo Maratta and studio
Danae and the Shower of Gold
In the collection of the Duke of Hamilton,
Lennoxlove

Nevertheless there are good grounds for believing that the Burghley House pictures are original works by Maratta himself, rather than studio copies. *Leda and the Swan* is based closely on the Düsseldorf drawing. *Pentimenti* reveal how the artist followed the swan's extended wing, seen in the drawing, before changing his mind and reducing it. The engraving of 1707 matches the final form of the Burghley House picture, with the reduced swan's wing. All this suggests that the Düsseldorf drawing is Maratta's original sketch, and that the Burghley House *Leda* represents a further spirited and creative stage in the evolution of the design, prior to any studio copies or the reproductive print (although the reproductive print shows the composition in the same sense, and is not a reverse image as one might have anticipated). This conclusion is supported by documentary evidence which indicates that all four Burghley pictures were already in the house by 1688. Moreover, it is virtually inconceivable that paintings of this kind would have been bought in the early years of the eighteenth century after the 5th Earl's death

and prior to the 1738 inventory, since at this time the estate was burdened with debt and no serious collecting took place.

A date before 1688 for the four Burghley House pictures and the connected drawings is much earlier than Dr Stella Rudolph would have suggested on the evidence of style (oral communication, 1994). These pictures and the connected drawings therefore offer a valuable opportunity to reconsider received ideas on Maratta's chronology and stylistic development, as well as his working methods and studio practice.

Figure 4
Bapta Sintes
Leda and the Swan
Courtauld Institute of Art, London

39.

PIER FRANCESCO MOLA
Coldrerio 1612 – 1666 Rome

An Old Man at a Brazier: An Allegory of Winter

Oil on canvas
95 by 76 cm; 37 ⅜ by 30 in.
Inscribed on reverse: Legato dell Emo:
Sig. card Paluzzo Altieri li 31 luglio 1698
B.H. No. 318

Provenance:
Palazzo Altieri, Rome; probably acquired in
Rome by the 9th Earl and recorded in a list
made out in his hand, *Extracts from an old cat-
alogue of ye furniture at Burghley*, as "Winter
by Mola from the Barberini Pallace at Rome";
subsequently recorded in 1815, p. 89; 1847,
p. 229, no. 321; 1878, p. 36, no. 318; 1954,
no. 318, all as by Mola.

Literature:
Cocke 1972, pp. 64–65, no. R.8, as not by
Mola and perhaps acceptable as an early work
by Johann Carl Loth.

This painting was acquired by the 9th
Earl as a work by Pier Francesco Mola.
Richard Cocke (1972) rejected Mola as
the artist, but that attribution now
seems more plausible and should be
reconsidered. The picture appears to be
by the same hand as the *Homer* in the
Galleria Nazional d'Arte Antica, Palazzo
Corsini, Rome (see Laureati 1989, no.
I.36) and the equally fine version from
Dresden (Laureati 1989, no. I.37).
Although these two pictures and other
puzzling Riberesque philosophers and
poets attributed to Mola (see Laureati
1989, nos. I.34, *Death of Archimedes*,
and I.39, *Socrates*) are generally dated
circa 1660, towards the end of Mola's
career, it is not entirely impossible that
they are instead early works when the
artist might have been influenced by the
vigorous and painterly art of Serodine,
which he could well have seen both in
Ascona and Rome (see Brigstocke 1990,
p. 62).

40.

PIER FRANCESCO MOLA
Coldrerio 1612 – 1666 Rome

The Vision of St Bruno

Oil on canvas
130 by 96 cm; 51¼ by 37¾ in.
B.H. No. 308

Provenance:
Probably acquired by the 9th Earl; recorded in
his annotated copy of Orlandi, *Abecedario
Pittorico*, 1704, p. 423, as "St Bruno by P.F.
Mola at Burghley"; also recorded in 1815, p.
90; 1847, p. 229, no. 335; 1878, p. 35, no.
308; 1954, no. 308, all as by Mola.

Literature:
Cocke 1972, p. 44, no. 5; Carr 1991, pp. 99–
126.

This appears to be an autograph ver-
sion, on a reduced scale, of Mola's cele-
brated picture, painted circa 1663–1666,
for Cardinal Flavio Chigi in Rome and
now in the J. Paul Getty Museum in
Malibu, California (fig. 1). Another
small-scale version, from the collection
of King Louis XIV, is in the Louvre,
Paris, and measures 94 by 70 cm (37 by
27½ in.) (Cocke 1972, no. 34). A copy of
the Chigi picture was recorded in the
inventory of Mola's studio at the time of
his death ("tela d'imperatore"; a stan-
dard size of approximately 135 by 85 cm
[53 by 33½ in.]). Cocke suggests that
the present picture may have been laid
in by the artist's studio assistants and
then retouched by Mola. This would be
consistent with normal studio practice at
the time, and would explain *pentimenti*
visible in the picture.

Figure 1
Pier Francesco Mola
Vision of Saint Bruno
Collection of the J. Paul Getty Museum,
Malibu, California

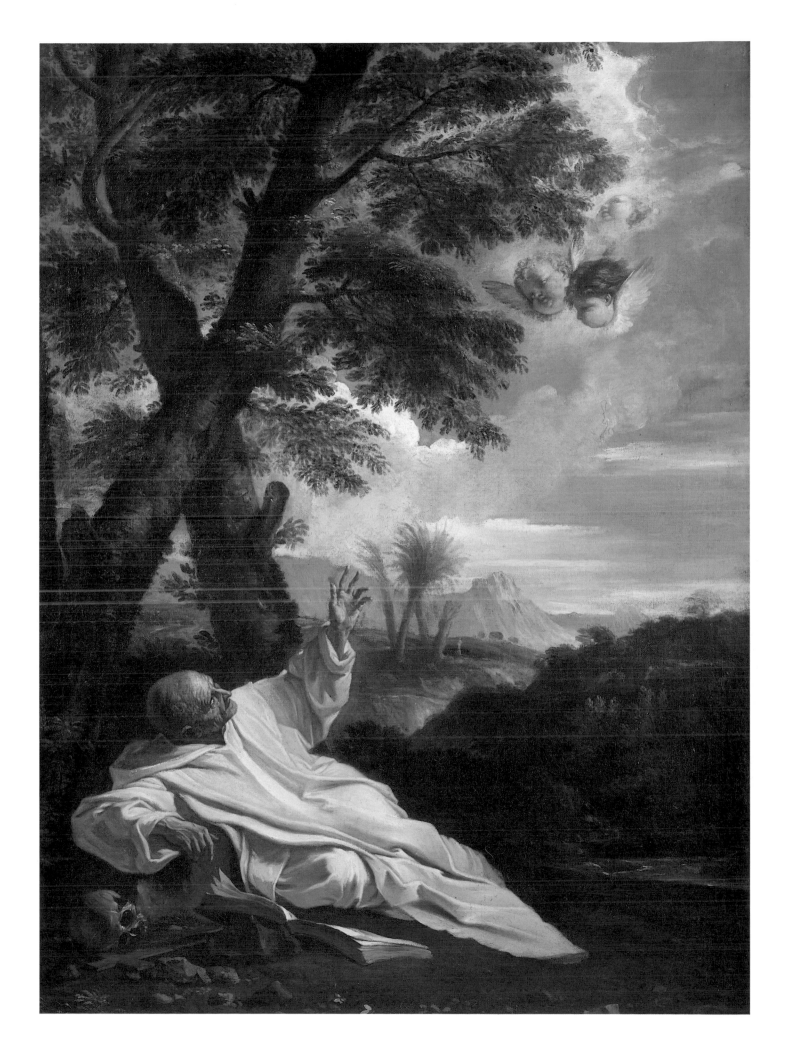

41.

MATTIA PRETI, CALLED THE CAVALIERE CALABRESE
Taverna 1613 – 1699 Malta

The Triumph of Time

Oil on canvas
220 by 300 cm; 86⅝ by 118⅛ in.
Signed, lower right: F.M.P.C. / F.
B.H. No. 379

Provenance:
Bought in Italy by the 5th Earl and recorded in
the 1688 inventory, p. 14, as being in "The
Plaster Dineing Roome & Clossett: 1 peice of
old Time done by Fra: Mattheus Knt of Malta";
recorded in the 1738 inventory, p. 36, in the
Red Velvet Dining Room as by "Francis
Mathews, Knight of Malta"; again in 1797, p.
25; 1815, p. 106; 1847, p. 241, no. 370; 1878,
p. 48, no. 379; 1954, no. 379, all as by Preti.

Literature:
Waagen 1854, p. 405, as follows: "A large pic-
ture, and more carefully executed than usual
with this painter, who merely aimed at effect";
Spinosa 1984, illus. pl. 575.

The signature "F.M.P.C. / F." is an
abbreviation for Fra Mattia Preti
Calabrese fecit.

The 1738 Burghley House inventory
includes a long description of the sub-
ject:

> On one Side of the Room the
> Progress of Time through the Temple
> of Hercules crowned with Flowers, in
> his hand a Scithe lifted up; under a
> Boy with a Pair of Compasses in one
> Hand, an Hour-glass in the other,
> underneath him Death just cutting the
> Thread of Life: On one side is Time,
> Kings, Conquerors, Popes, Cardinals
> and people of all Ages; underneath
> him Monuments, some from behind
> the Image of Hercules, by Francis
> Mathews, Knight of Malta.

Although recorded at Burghley House
as a signed work by Preti since 1688,
this picture has escaped scholarly atten-
tion and remains unpublished, apart
from a photograph, without critical com-
ment, in Spinosa's 1984 survey of
Neapolitan art. The picture's early histo-
ry is not recorded, but from the evi-
dence of style it probably dates from the
late period of the artist's career, when
he was working in Malta but was still in
contact with patrons in Naples and
Sicily. It might well have been painted
only shortly before the 5th Earl bought
it. John Spike proposes a date after
1680 on the basis of the picture's
restricted range of colour (oral commu-
nication, 1994).

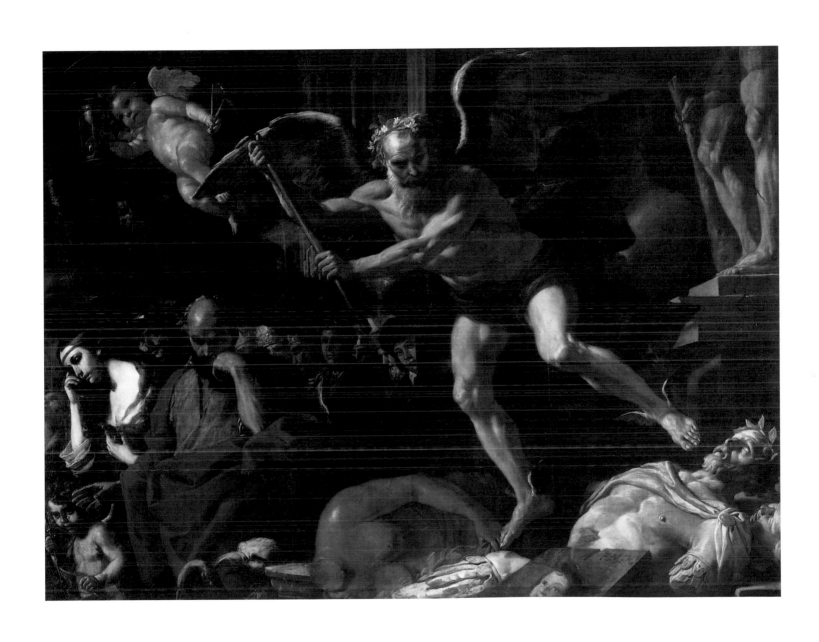

42, 43.

GIUSEPPE RECCO
Naples 1634 – 1695 Alicante

A Still Life of Flowers in an Urn with a Figure

A Still Life of Flowers

A pair
Oil on canvas
Each 256 by 201 cm; 100 by 79 in.
42. Signed and dated, centre right: EQVES
RECCVS / F.1683
43. Signed, centre left: EQVES RECCVS
B.H. Nos. 309, 314

Provenance:
Acquired by the 5th Earl through his agent
George Davies, in Naples, directly from the
artist for 400 ducats, of which the first install-
ment of sixty-six ducats was paid on 10 May
1684 (see D'Addosio 1913). First recorded at
Burghley House in the 1688 inventory, p. 24,
as being "In My Lords Dressing Room: 1
peice of fruite and flowers in flower potts with
black and Guilt frames by Reccus"; both subse-
quently listed in the 1738 inventory, p. 9, in
the Dressing Room as by Eques Reeves;
recorded again in the 9th Earl's annotated
copy of Orlandi, *Abecedario Pittorico*, 1704, p.
516, as "two fine Flower pieces by Eques
Reccus at Burghley". Also recorded in 1815, p.
90; 1847, p. 229, nos. 324, 329; 1878, p. 35,
no. 309 and p. 36, no. 314, as by Ricchio;
1954, nos. 309, 314, as by Recco.

Exhibited:
London, Royal Academy of Arts, *Painting in
Naples 1606–1705. From Caravaggio to
Giordano*, 1982, nos. 116 and 117.

Literature:
D'Addosio 1913, p. 493, as follows:
A 10 maggio 1684 - Giorgio Davies paga Dti
66, a compto di Dti 100, a Giuseppe Recco in
nome et parte del Conte di Exeter et sono per
caparra del prezzo di due Quadri di fiori che
deve consignare al d.to Conte de palmi 10, et
8; quali due Quatri sono venuti a conventione
pel prezzo di Dti 400, e perchè resta da finirsi
uno d'essi Quatri quali sono incominciati si
obbliga dto Recco di finirlo per tutto il mese di
maggio corrente. Con dichiaratione fenito che
sarà assieme con l'altro Quatro restano ad elet-
tione di dto Conte di pigliarseli tutte e due o
vero uno di essi, quale li piacerà, se li piglia
tutte due resta a conseguire altri Dti 300, se
uno Dti 100. Cosi accordati fra loro.[8]
Divitiis 1982, pp. 376-393; Middione 1982, p.
223, nos. 116, 117; Salerno 1984, pp. 214, 219,
pl. 52.11; Spinosa 1984, pl. 628; Zeri 1989, p.
910.

This outstanding pair of Neapolitan
flower paintings was apparently commis-
sioned on behalf of the 5th Earl of
Exeter by George Davies, the British
Consul in Naples. In May 1684, Davies
paid sixty-six ducats to Giuseppe Recco
as an advance on the two pictures, the
sizes of which were specified as ten by
eight palms. One of the pictures was
already finished (presumably the *Still
Life of Flowers in an Urn with a Figure*,
which is signed and dated 1683). The
other picture was to be completed by the
end of May 1684. The full price for the
pair was to be the very considerable sum
of 400 ducats. Lord Exeter nevertheless
reserved the right to select only one pic-
ture, an option he did not exercise. The
agreement, dated 10 May 1684, has
been transcribed and published by
D'Addosio (1913, p. 493). Evidently
Lord Exeter had a high regard for

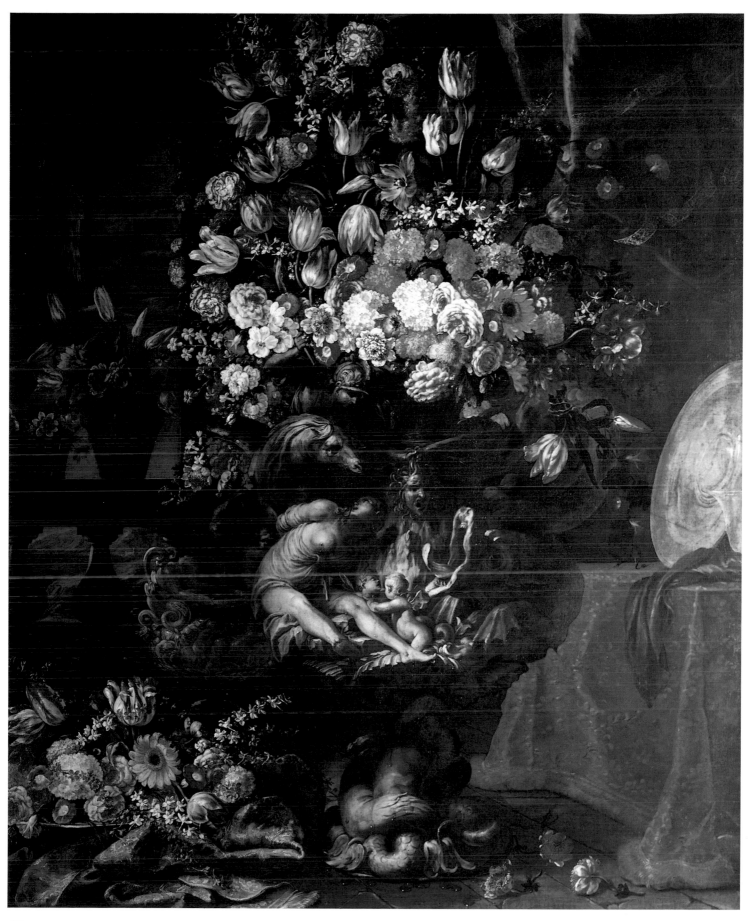

42

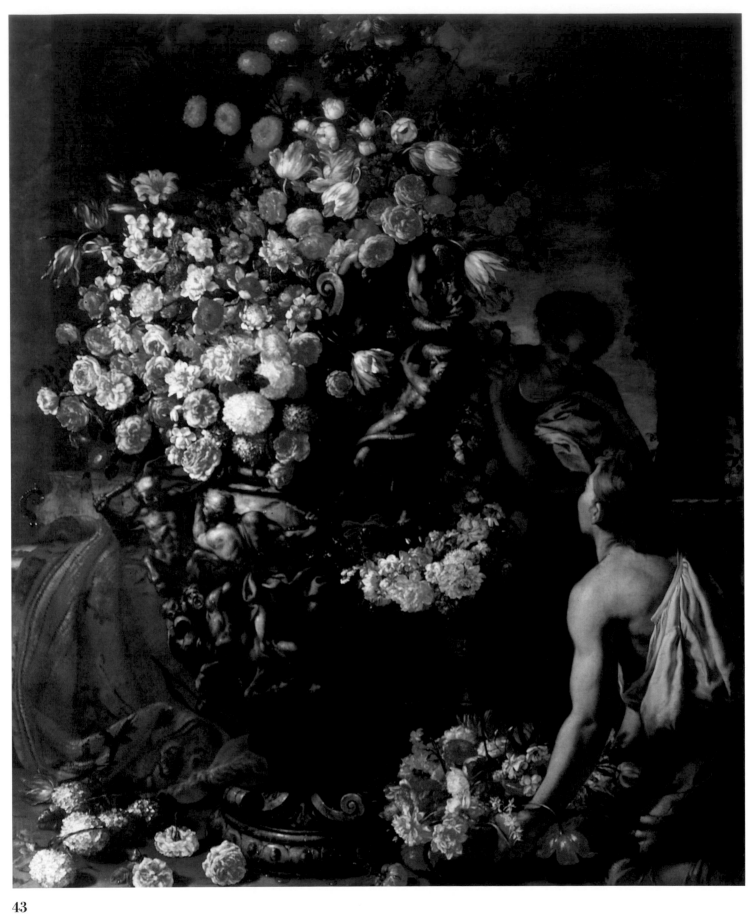

43

Recco, since shortly afterwards, on 8 October 1685, he made a further payment to the artist, again through Davies, for two large paintings of fish and four small paintings, two of fish and two of game (D'Addosio 1913, p. 494). The two large fish pictures are then recorded in the 1688 Burghley House inventory, "hanging in My Lords Dressing Room" alongside the two flower pictures exhibited here, but they have since disappeared without trace.

As Middione (1982) has observed, the two flower paintings "show Recco's art in its most mature phase, incorporating the most recent developments in European still-life painting; the richness of design and colouring recalls the work of J.B. Monnoyer". The two female figures in one of the pictures appear to be by a different hand. Divitiis speculated on the possible involvement of Giordano, who collaborated with Recco on a documented painting of a *Fisherman with a Still Life of Fish*, signed and dated 1668, and painted for the Marchese de Noja (Divitiis 1982, p. 389, fig. C) and a recently discovered *Marine Still Life with Neptune and two Nereids* from the Buen Retiro, Madrid, now (1994) with Colnaghi's, New York (oil on canvas, 234.5 by 296 cm [92½ by 116½ in.]). Middione has suggested an artist from the circle of the young Solimena. The magnificent reliefs on the two vases in the present pictures – one representing Perseus and Andromeda, and the other a battle of Lapiths and Centaurs, and two nude men bathing with a serpent – may also have been delegated by Recco to a collaborator.

44.

SEBASTIANO RICCI
Cividal di Belluno 1659 – 1734 Venice

The Rape of Dejaneira

Oil on canvas
116 by 164.5 cm; 45¾ by 64¾ in.
B.H. No. 124

Provenance:
First recorded at Burghley House in 1878, p. 18, no. 124, as by Giordano; 1954, no. 124, also as by Giordano.

Exhibited:
London, Colnaghi's, *Works by Sebastiano Ricci from British Collections*, 1978, no. 4.

Literature:
Daniels 1976A, p. 115, no. 411, fig. 176; Daniels 1976B, no. 284.

The centaur Nessus attempts to abduct Dejaneira, the wife of Hercules, after he has carried her across the river Evenus. The design of this picture reflects the influence of Giordano. Indeed it is close to a picture of the same subject by Giordano which was acquired by the 5th Earl and is now at Burghley House (see Ferrari and Scavizzi 1992, p. 302, A306).

Daniels expressed uncertainty as to whether the picture should be dated 1706–1707, when Ricci was working in Florence, or 1712–1713, at the beginning of Ricci's stay in England. In either case, it cannot be considered as an acquisition by the 5th Earl, to whose taste it might seem closer than that of the 9th Earl.

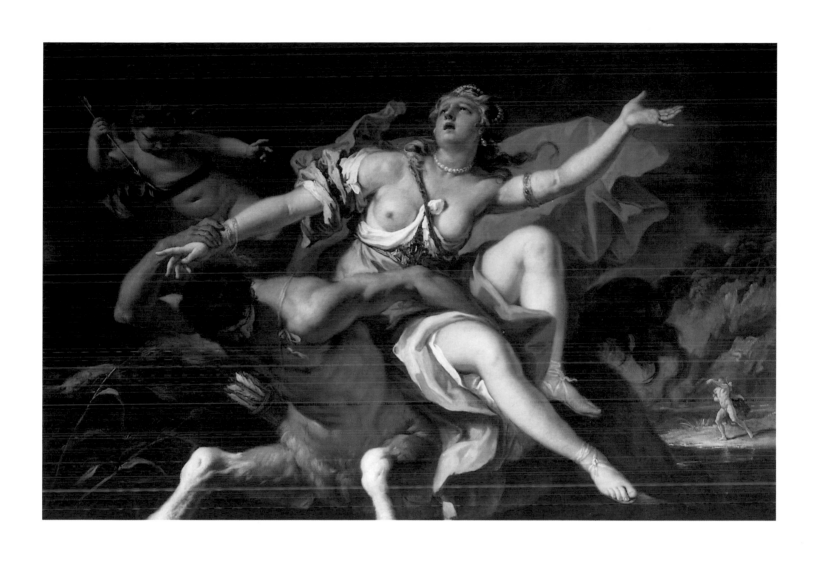

45, 46.

ASCRIBED TO GIOVANNI BATTISTA RUOPPOLO
Naples 1629 – 1693 Naples

A Still Life of Fruit with a Melon

A Still Life of Fruit with Pomegranates

A pair
Oil on canvas
Each 95.3 by 72.5 cm; 38 by 29⅛ in.
B.H. Nos. 112, 102

Provenance:
Probably bought in Italy by the 5th Earl, and
arguably identifiable in the 1688 inventory, p.
10, in the "Lower Gallery, The North End
Chamb or 7th Roome" as "2 pictures of ffruite &
flowers over the doores done by . . .". Recorded
at Burghley House in a manuscript inventory of
1793, partly in the hand of the 9th Earl, as "two
pieces of fruit and flowers by Michael Angelo
Bonorota" (i.e., Campidoglio?). Again recorded
at Burghley House in 1815, p. 59, as by M. Ang.
Campidoglio, and in 1847, p. 203, nos. 156, 158,
as by Ang. Battaglio; 1878, p. 18, nos. 102, 112,
as by N. Boschaert; 1954, nos. 102, 112, also as
by N. Boschaert.

Giovanni Battista Ruoppolo was one of
only two Neapolitan still life painters to be
the subject of a separate chapter in De
Dominici's *Vite dei Pittori Napoletani* of
1742. According to John Spike, the only
dated painting by the artist is a *Still Life
with Fruit and Bread* of 1661, in the
Pinacoteca Comunale, Faenza (Spike
1983, p. 87). The present pictures reflect
the influence of Abraham Brueghel, who
moved to Naples from Antwerp in 1675,
and they may therefore date from relative-
ly late in Ruoppolo's career. The 5th Earl,
who was in Naples in the winter of
1683–1684, might easily have bought
them directly from the artist.

45

46

47.

VENTURA SALIMBENI
Siena 1567 – 1613 Siena

The Adoration of the Magi

Oil on copper
30 by 23 cm; 11¾ by 9 in.
B.H. No. 7

Provenance:
Probably bought by the 9th Earl; recorded in
his annotated copy of Orlandi, *Abecedario
Pittorico*, 1704, p. 207, as *"Adoration of the
Magi* by Fr. Vanni, at Burghley"; subsequently
recorded in 1815, p. 28; 1847, p. 185, no. 30;
1878, p. 10, no. 7; 1954, no. 7, all as by F.
Vanni.

Literature:
Cordellier 1986, under no. 33, illus.; Shearman
1965, vol. 1, p. 152.

Acquired as a work by F. Vanni, that
attribution was sustained until 1983
when Philip Pouncey proposed the attri-
bution to Ventura Salimbeni (oral com-
munication). The design is based on a
composition attributed to Andrea del
Sarto, which is known from two draw-
ings: one in the Louvre (inv. 1688; fig.
1), which was formerly in the Jabach col-
lection (see Cordellier 1986, no. 33,
illus.); the other in the Uffizi, Florence
(inv. 634E; fig. 2) (see Shearman 1965,
p. 152, pl. 93). The precise status of the
two drawings has been a matter of dis-
pute, but their connection with a lost
design by Andrea del Sarto is widely
accepted. Salimbeni, who was active in
many parts of Italy besides his native
Siena, including Rome, Lucca, Pisa and
Florence, where he would have known
del Sarto's work, may have been working
from a lost painting rather than directly
from the drawings. He invested the
design with his own very individual and
vivid sense of colour and a distinctive
technique of high finish.

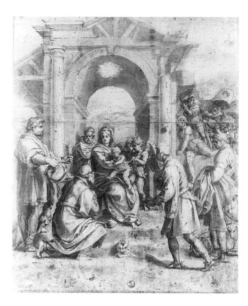

Figure 2
Andrea del Sarto
The Adoration of the Magi
Gabinetto Stampe e Disegnie,
Uffizi, Florence

Figure 1
Andrea del Sarto
The Adoration of the Magi
Musée du Louvre, Paris

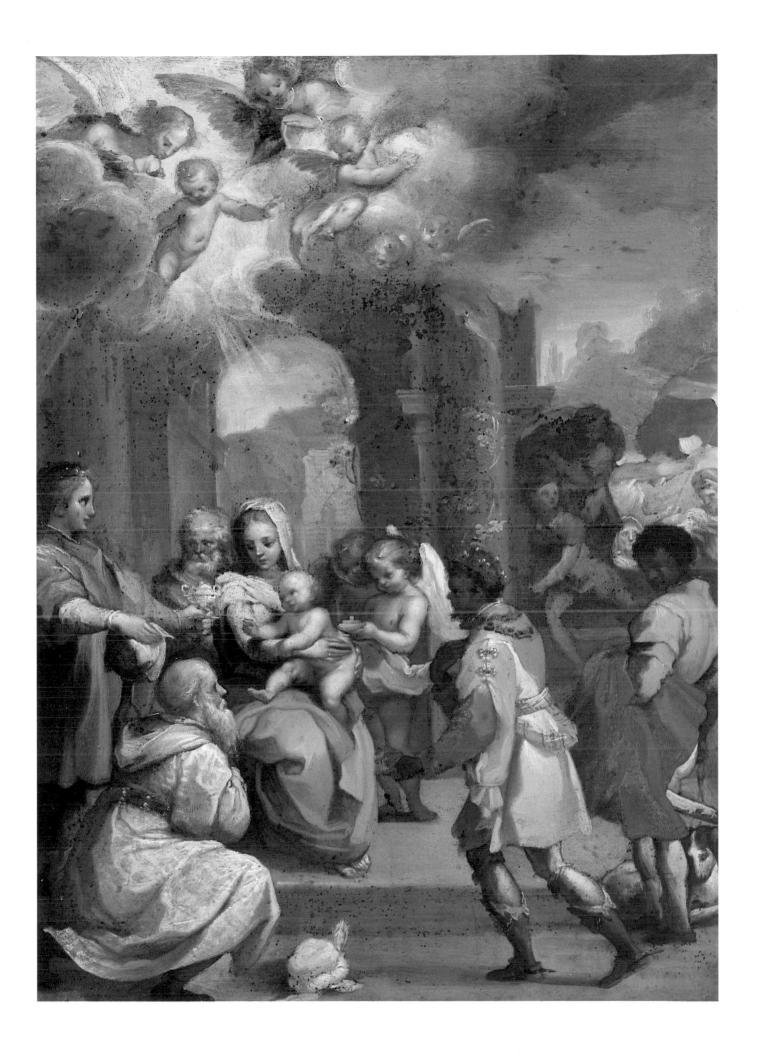

48.

CARLO SARACENI
Venice 1579 – 1620 Venice

St Gregory the Great Writing his Gospel

Oil on canvas
166.5 by 127 cm; 65½ by 50 in.
B.H. No. 313

Provenance:
Presumably painted for the Soranzo family.
Probably acquired in Italy by the 9th Earl;
recorded in his annotated copy of Orlandi,
Abecedario Pittorico, 1704, p. 57, as "Portrait
of Gregory ye Great, by And: Sacchi at
Burghley"; first recorded at Burghley House in
1797, p. 150; 1815, p. 89; 1847, p. 229, no.
328; 1878, p. 35, no. 313; 1954, no. 313, all as
by Sacchi.

Literature:
Waagen 1854, p. 403, as by Sacchi; Gregori
1968, pp. 414–415, as by Carlo Saraceni;
Ottani 1968, p. 97, fig. 103; Sutherland Harris
1977, p. 108, no. R.4, as by Saraceni.

This painting of St Gregory is almost
certainly a late work, dating from circa
1619–1620, when Carlo Saraceni was in
Venice immediately before his death.
The picture, with its warm palette and
soft painterly technique, is distinct in
style from Saraceni's earlier and more
intensely intimate and realistic picture of
St Gregory in the Galleria Nazionale
d'Arte Antica, Rome, which reflects
Caravaggesque influences (Ottani 1968,
no. 59, fig. 89).

The coat of arms on the table is that
of the Soranzo family, Venice.

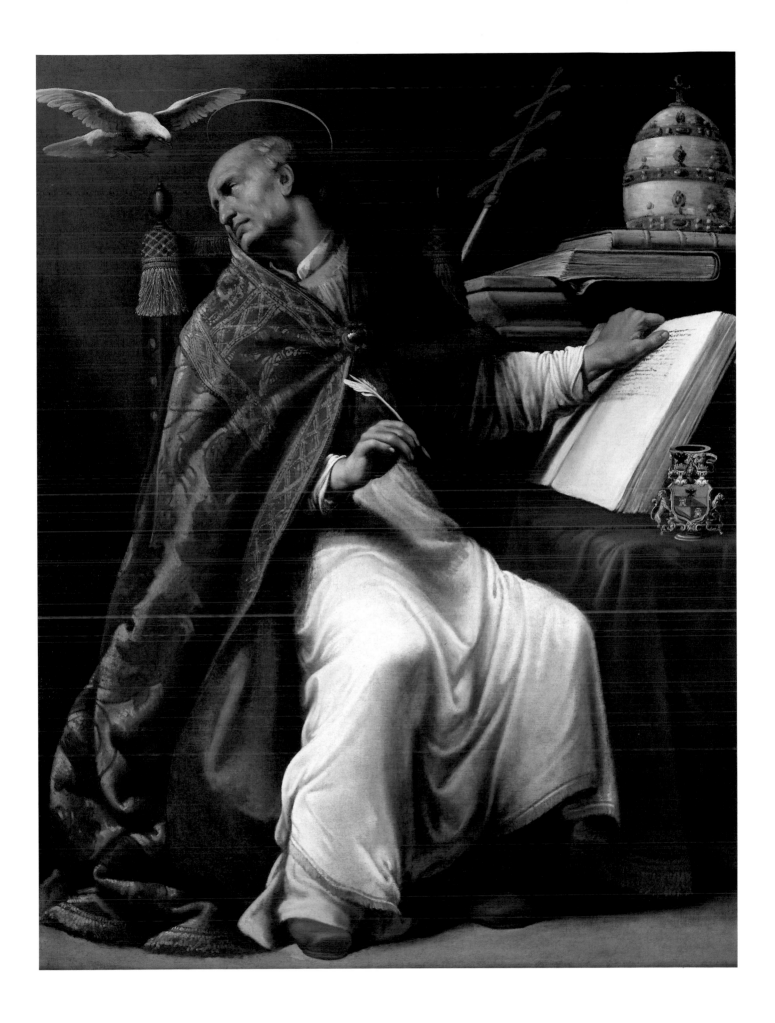

GIOVANNI BATTISTA SALVI, CALLED IL SASSOFERRATO
Sassoferrato 1609 – 1685 Rome

Madonna and Child

Oil on canvas, unlined
43 by 34.5 cm; 17 by 13½ in.
B.H. No. 277

Provenance:
Bought for the 9th Earl through the agent
James Byres, in Rome, 1769, for £20 (receipt
date Rome 16 May 1769). Subsequently
recorded at Burghley House in 1815, p. 49;
1847, p. 196, no. 104; 1878, p. 30, no. 277;
1954, no. 277, all as by Sassoferrato.

Literature:
Blunt and Cooke 1960, p. 103, under no. 873;
Tomory 1976, p. 143, no. 150.

Acquired as a copy from Raphael by Il
Sassoferrato, the picture is based on
Raphael's *Mackintosh Madonna* in the
National Gallery, London. Further vari-
ant copies from the Raphael prototype
are in the Borghese Gallery, Rome,
attributed to Sassoferrato (see della
Pergola 1955, vol. 2, p. 124) and in the
Brera, Milan (Zuccari 1992, pp. 233–
234, no. 96). A preparatory drawing by
Sassoferrato of the curtain in the back-
ground of the design is at Windsor
Castle (see Blunt and Cooke, no. 373).
One version of this picture, close in
every respect to the present painting but
without the building in the landscape,
appears in the background of
Sassoferrato's magnificent *Portrait of
Cardinal Rapaccioli* (fig. 1) (De Lépinay
1990, p. 92, no. 34). The Cardinal
might well have been the original owner
of either the Burghley House picture or
more probably some other version of
Sassoferrato's *Madonna and Child.*
Cardinal Rapaccioli, who died in 1657,
was also noted for his Spanish affilia-
tions and his patronage of Michelangelo
Cerquozzi (see Haskell 1980, p. 137).

Figure 1
Il Sassoferrato
Portrait of Cardinal Rapaccioli
The John and Mable Ringling
Museum of Art, Sarasota, Florida

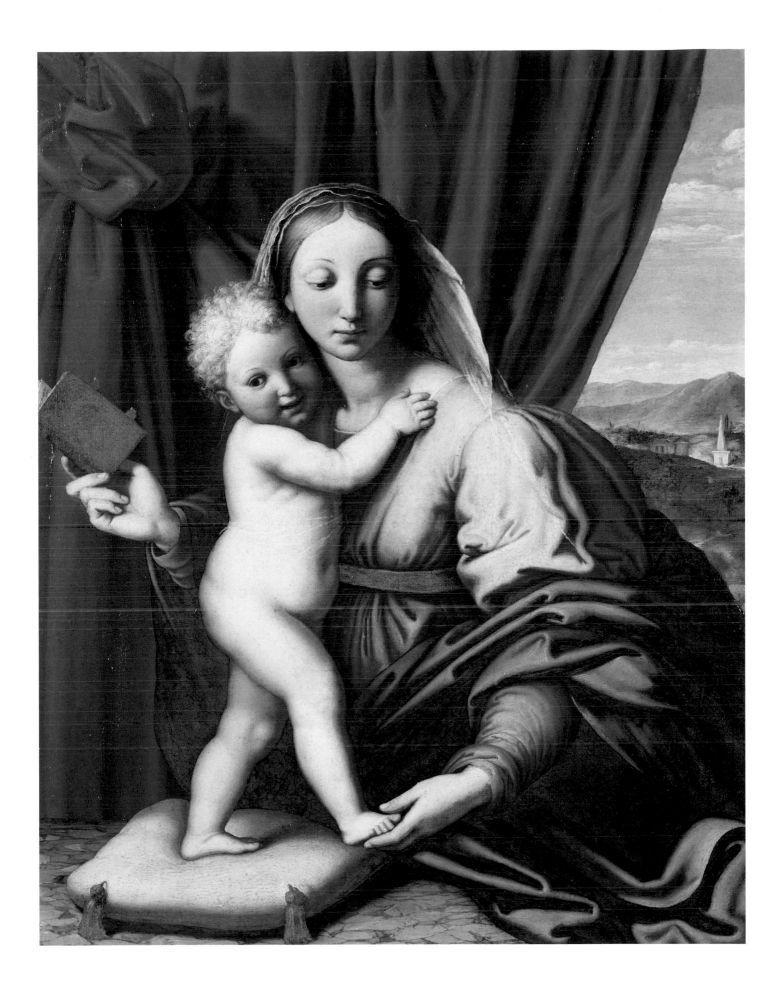

50.

IPOLLITO SCARSELLA, CALLED LO SCARSELLINO
Ferrara c. 1550 – 1620 Ferrara

The Madonna and Child with the Infant St John the Baptist

Oil on canvas
25 by 22 cm; 9¾ by 8⅝ in.
B.H. No. 28

Provenance:
Probably acquired by the 9th Earl and first
recorded at Burghley House by the 9th Earl in
his annotated copy of Orlandi, *Abecedario
Pittorico*, 1704, p. 331, as by Scarsillino [*sic*].
Also recorded in 1815, p. 29, and 1847, p. 185,
no. 53, as by Surcelo Farara [*sic*]; 1878, p. 11,
no. 28, and 1954, no. 28, in both as by
Ipollito Scarsella.

Exhibited:
Washington, D.C., National Gallery of Art, *The
Treasure Houses of Britain*, 1985–1986, no.
266.

Literature:
Novelli 1964, no. 179, fig. 7, as an early work;
Berenson 1968, vol. 1, p. 388.

Acquired as by Lo Scarsellino, this
Madonna and Child is generally consid-
ered to be an early work. A variant of
the design, with the added figure of
Joseph, is in the Hermitage, St
Petersburg, Russia. Lo Scarsellino's ear-
ly style reflects the influence of Venetian
mannerist artists, including Schiavone,
Jacopo Bassano and Tintoretto. The last
of the great Ferrarese painters of the
Renaissance, Scarsellino combined free-
dom of technique with a romantic and
poetic spirit.

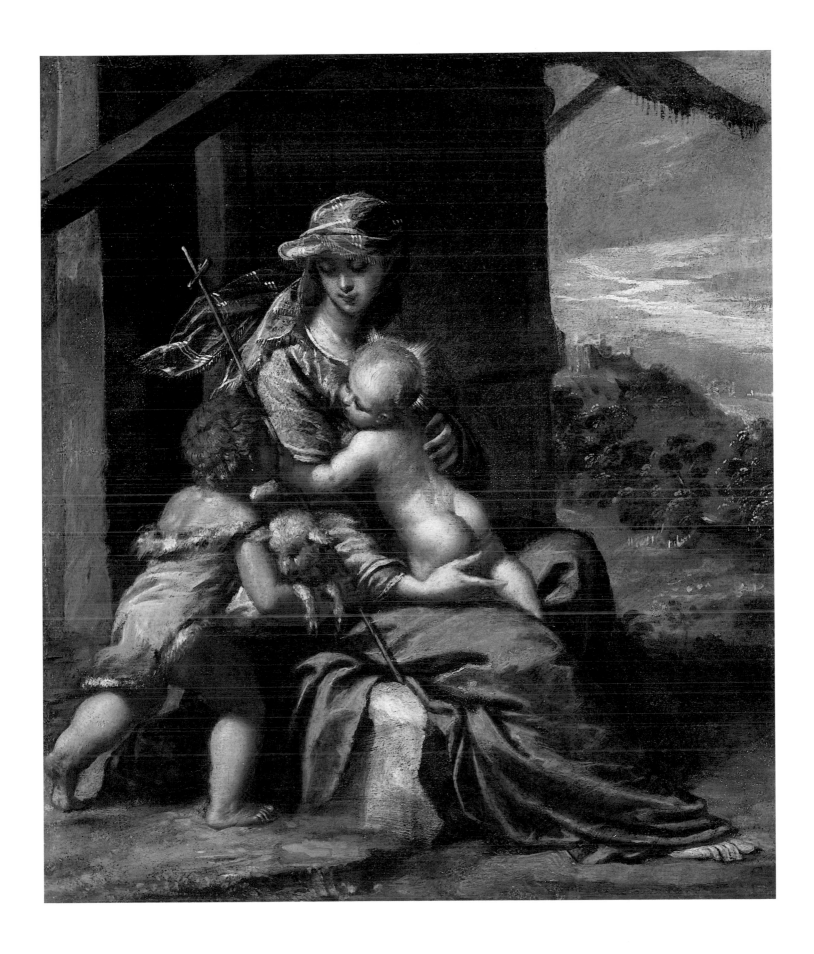

51.

DANIEL SEITER
Vienna 1649 – 1705 Turin

Venus, Cupid, Ceres and Bacchus

Oil on canvas
168 by 145 cm; 66 by 57 in.
Signed, lower right: Daniel. Seuter
B.H. No. 296

Provenance:
Purchased in Rome by the 5th Earl in 1684, as recorded in *An Account of wt I have expended since Naples*, p. 5, under the title "The account of ye charge of pictures at Rome / To Daniel - 060 - 0", and further on, "pd Earnest to Daniell crowns / 20.0"; in the 1688 inventory, described as hanging in the "North Drawing Roome" and as "2 pictures over the Doores / a Satyr & Venus sleeping & / a Venus & Bacchus / done by Daniel of Rome"; 1738, p. 78, "over the other Door, A Satyr; Venus / and Bacchus pouring out Wine, Cupid / at her feet"; 1815, p. 89, as by D Rutter; 1847, p. 228, no. 315, as by N. de Ruyter; 1878, p. 35, no. 296; 1882, p. 44, no. 296; 1954, no. 296.

Literature:
Varriano 1988, pp. 31–47, pl. 15.

Figure 1
Daniel Seiter?
Venus, Cupid, Ceres and Bacchus
Kunstmuseum Düsseldorf im Ehrenhof, Düsseldorf

A *Sleeping Venus*, the pendant to this *Venus, Cupid, Ceres and Bacchus* and which is still at Burghley (B.H. No. 300), is identical in size. It too is signed but is dated 1684. A version of *Venus, Cupid, Ceres and Bacchus* (also oil on canvas, measuring 190 by 165 cm [75 by 65 in.] and with traces of a signature) is in a private French collection. The owner of that painting has drawn attention to a drawing related to the composition in the Louvre (R.F627) attributed to

Maratta. In it the central figures of Venus and Cupid are virtually identical, but the figure of Bacchus is reversed and Ceres is placed closer to Venus. The Louvre drawing, however, is said by Schaar and Sutherland Harris (1967, p. 177 under no. 606) to be a copy of a drawing also given to Maratta at Düsseldorf. In that drawing (fig.1), the figure of Ceres is yet again different, this time facing in profile to the left.

Though he was born in Vienna, studied in Bavaria, and then moved to Venice, Daniel Seiter, as Voss remarked (1924, p. 590), "revealed few specifically German traits" and he has come to be regarded as an Italian artist. Seiter had arrived in Rome from his twelve-year study in Venice by Easter of 1682. Varriano (1988, p. 32) examined Seiter's early Roman works, into which the Burghley pair can be securely placed since both are dated 1684. By 1686 Seiter's *Martyrdom of St Lawrence* and *Martyrdom of St Catherine* had joined Carlo Maratta's altarpiece of *The Immaculate Conception* in the Cybo chapel of Santa Maria del Popolo in Rome (see Titi 1686, pp. 359, 433). Prior to his arrival in Rome, the 5th Earl had made contact with Seiter's master, Carl Loth (cat. nos. 31, 32), and Maratta himself would probably have led the Earl towards Seiter as well. Quite what the working arrangement was between Maratta and Seiter is unclear but interesting, particularly in the light of the drawing at Düsseldorf (fig.1.) and if that drawing is indeed by Maratta. Varriano says, "Seiter's artistic relationship with Maratta . . ., seems to have been more complex. . . . Maratta evidently played some pedagogical role in Seiter's development. . . . It is entirely possible that Maratta was even instrumental in securing the commission (The Cybo Martyrdoms) for the younger artist

who may never the less have felt ambivalent about following his stylistic example" (Varriano 1988, p. 36). In his early Roman period Seiter's works became increasingly Marattesque as he quickly assimilated the current grand manner of the late Roman baroque and in particular Maratta's calm atmospheres and idealized forms. Even if Maratta and not Seiter is the author of the Düsseldorf drawing, then the newly arrived artist must have been working closely with Rome's pre-eminent painter and had access to such drawings.

Another drawing at Düsseldorf but this time connected with the Cybo chapel's *Martyrdom of St Lawrence* was recognized as being by Seiter as early as 1930 (Budde 1930, no. 973, pl. 234). Philip Pouncey wrote, "Furthermore, when compared with the final composition, it shows the nice balance of similarity and difference that one so often finds in a preparatory drawing . . . but however it . . . does not provide a very satisfactory basis for further attribution" (Pouncey 1967, pp. 286–288). If indeed the Düsseldorf drawing (fig. 1) is by Seiter and is connected to the Burghley painting, it would be one of his finest works in that medium, revealing grandeur of conception and a fluency and elegance in execution not seen in his generally more sombre, laboured, and heavy compositions.

On page 14 of the Burghley inventory of 1738 another painting attributed to Seiter is mentioned - "St Thomas thrusting his Hand into our Saviour's Side done by Daniel Shutter" - but this is no longer in the house. Perhaps it was a version of *The Incredulity of St Thomas*, formerly at Schleissheim and now deposited in the Alte Pinakothek at Munich, and which Varriano (1988, p. 39) also dates to the artist's early years in Rome.

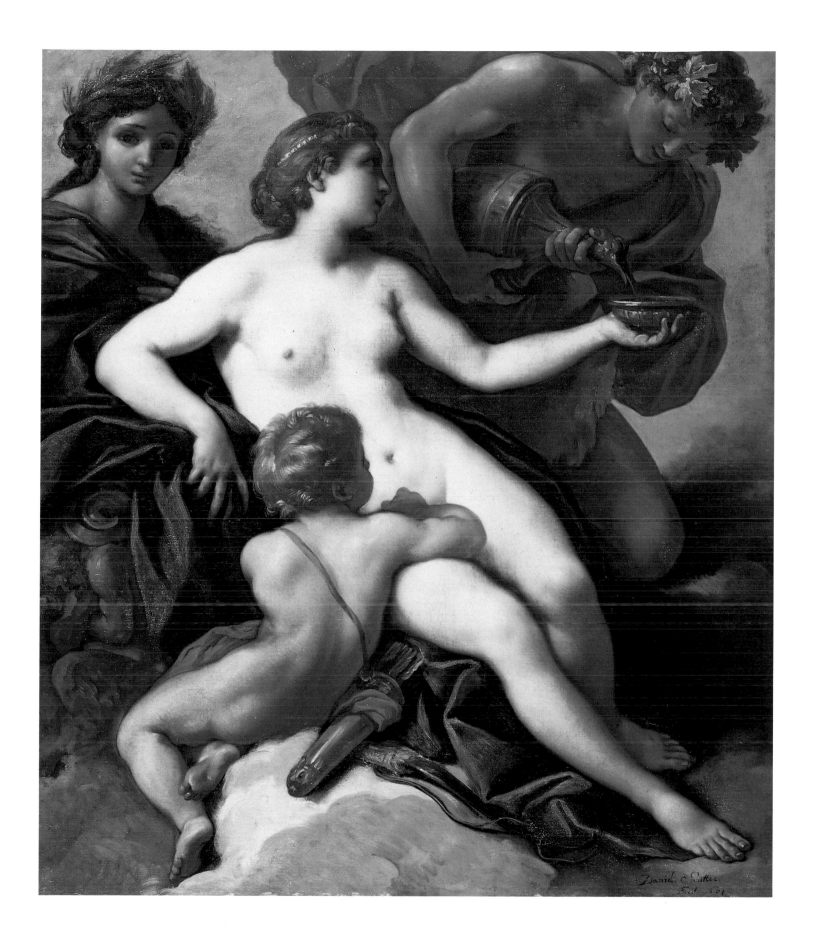

52.

ELISABETTA SIRANI
Bologna 1638 – 1665 Bologna

Judith with the Head of Holofernes

Oil on canvas
236.5 by 183 cm; 93 by 72 in.
Signed and dated, lower right: ELISAB^{TA}
SIRANI F. 1658
B.H. No. 304

Provenance:
Probably the picture of this subject painted by Sirani for Signor Cattalani and recorded in the artist's list of her own works published by Malvasia (1678) as follows: 1598 "Una Giuditta mostrante la testa di Oloferne al Popolo de Bettuglia di notte tempo, con la nutrice, e due paggetti con torci accesi che fanno lume, figure del naturale per il sig. Cattalani⁹"; probably the same picture recorded in the Palazzo Monti, Bologna, in July 1752 by Sir Joshua Reynolds as follows: "Judith going to take Holofernes' head to show it to the army: she is on a scaffold in the foreground. By Eliz Sirani" (see Leslie and Taylor 1865, vol. 1, p. 478) Probably acquired by the 9th Earl and noted by him in his annotated copy of Orlandi, *Abecedario Pittorico*, 1704, p. 153; first recorded at Burghley House in 1815, p. 90; 1847, p. 229, no. 336; 1878, p. 35, no. 304; 1954, no. 304, all as by E. Sirani.

Literature:
Malvasia 1678, 1841 ed., vol. 2, p. 394; Leslie and Taylor 1865, vol. 1, p. 478; Kurz 1955, p. 134, under nos. 493, 494; Frisoni 1978, p. 7, tavola II; Cera 1982, illus. (unpaginated); Posner 1986, p. 534.

The subject is taken from the Book of Judith 13:7–8. Two preparatory drawings for the picture are at Windsor Castle (see Kurz 1955). One (no. 493) is a compositional study and includes all four of the principal figures in the final painting (fig. 1); the other (no. 494) is a study of the boy with a torch on the right (fig. 2).

Elisabetta Sirani worked in Bologna and is often described as a late follower of Guido Reni. The present picture, by far the largest and most important of her works to have found its way to Britain, is notable for its dramatic use of

nocturnal light and an almost baroque sense of movement and drama. It serves to remind us of the extent to which Elisabetta Sirani emancipated herself from the classical influence of Guido and of her own father, Giovanni Andrea Sirani, prior to her untimely death at the age of only twenty-seven.

Elisabetta Sirani appears to have favoured subject matter depicting women in heroic roles. In addition to this scene of Judith holding the head of Holofernes, she also painted *Timoclea Casts Alexander's Captain into a Well* (fig. 3), which may, according to Anne Sutherland Harris, have been conceived as its companion (see Sutherland Harris and Nochlin 1978, p. 155); and *Porcia Wounding her Thigh* as taken from Plutarch (see Sutherland Harris and Nochlin 1978, p. 150, no. 31).

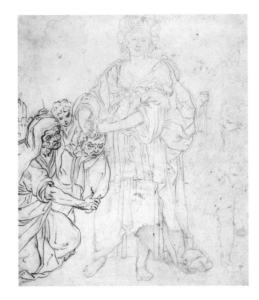

Figure 1
Elisabetta Sirani
Judith Handing the Head of Holofernes to her Nurse
The Royal Collection, Her Majesty Queen Elizabeth II

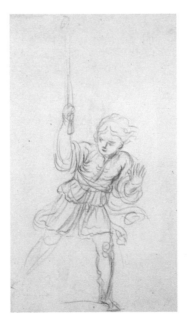

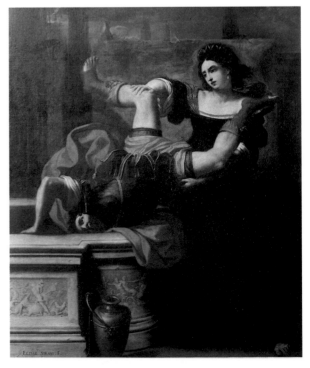

Figure 2
Elisabetta Sirani
A Boy Carrying a Torch
The Royal Collection, Her Majesty Queen Elizabeth II

Figure 3
Elisabetta Sirani
Timoclea Casts Alexander's Captain into a Well
Capodimonte, Naples

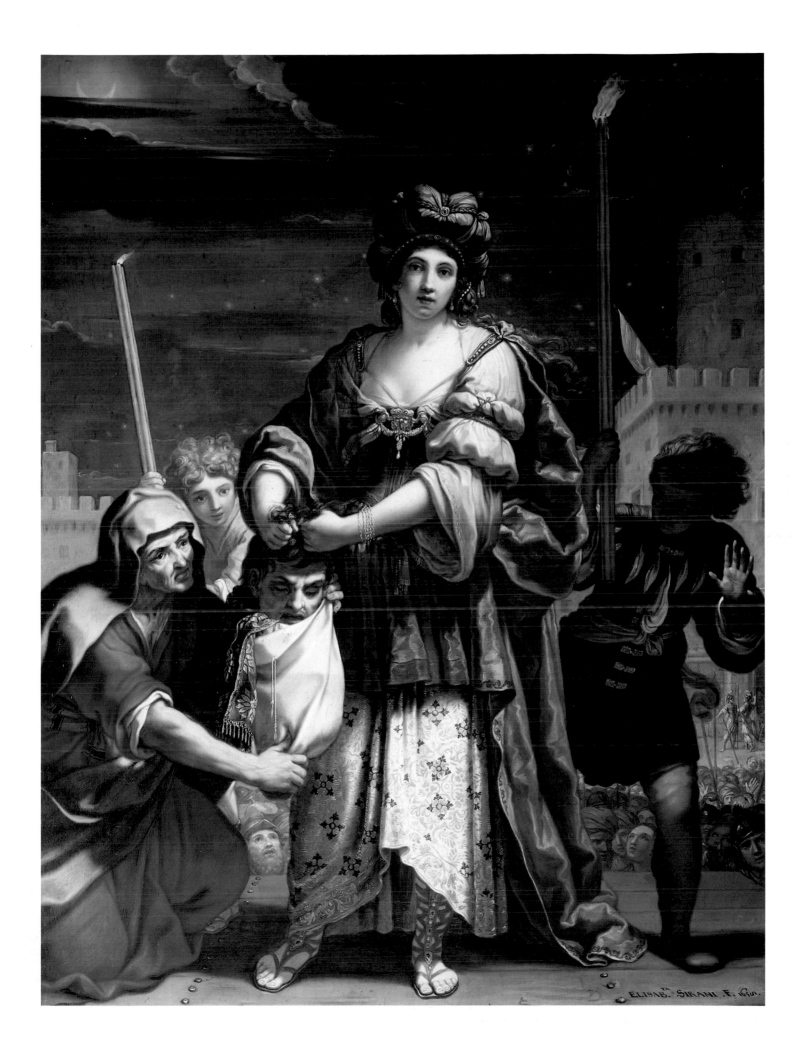

53.

JEAN TASSEL
Langres 1608 – 1667 Langres

The Virgin and Child

Oil on canvas
98 by 74 cm; 38½ by 29⅛ in.
B.H. No. 60

Provenance:
Presumably bought by the 5th Earl, possibly while travelling through France *en route* to Italy. First recorded in the 9th Earl's annotated copy of Orlandi, *Abecedario Pittorico*, 1704, p. 377, as follows: "Virgin and Child, colouring good, drawing detestable by M. Ang. da Caravaggio at Burghley"; otherwise first recorded at Burghley House in 1797, p. 76; 1815, p. 60; 1847, p. 205, no. 183; 1878, p. 12, no. 60; 1954, no. 60, all as by Caravaggio.

Exhibited:
Leicester, Leicestershire Museum and Art Gallery, *Masterpieces of Reality. French 17th Century Painting*, 1985–1986, no. 8, as by Jean Tassel.

Literature:
Ronot 1990, pp. 260–261, no. 61, pl. XV, as by Jean Tassel.

While this painting traditionally has been attributed to Caravaggio, the attribution to Jean Tassel has been endorsed by numerous scholars, including Dr Federico Zeri, Professor Anthony Blunt, Christopher Wright (see under Exhibited) and Henry Ronot (1990). Although Tassel visited Italy, he was active mainly in Langres and Dijon. His distinctive and refined figure style is matched by a delicate use of light and shade, qualities that set him apart from other more robust French Caravaggesque artists of the Manfredi circle.

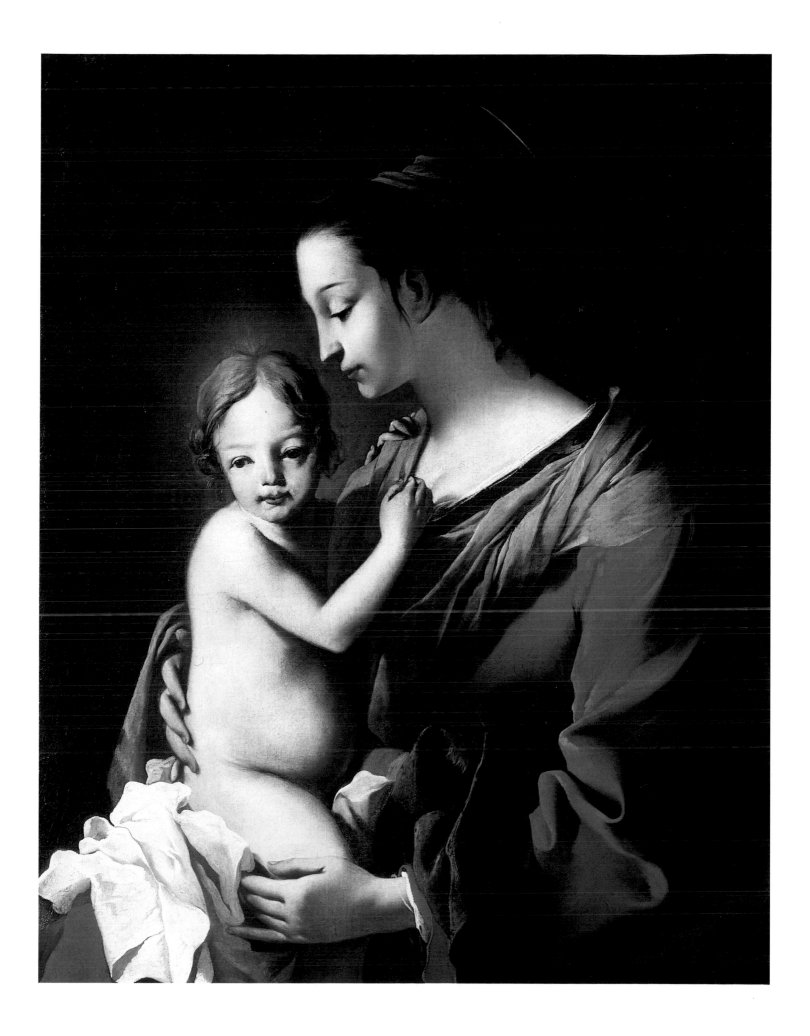

54.

FRANCESCO TREVISANI
Capodistria 1656 – 1746 Rome

The Mocking of Christ

Oil on canvas
85 by 109 cm; 33½ by 43 in.
Signed, on dog's collar: F.T.
B.H. No. 302

Provenance:
Presumably bought by the 5th Earl during his final visit to Rome; first recorded at Burghley House in the 1738 inventory, pp. 56–57, in The Dressing Room, as follows: "Our Saviour scourging and crowned with Thorns, the Guards about him, One that is crowning him is in Armour, an old Man looking at him with a Pair of Spectacles, another deriding him, a Dog seems barking"; 1815, p. 30; 1847, p. 229, no. 339; 1878, p. 35, no. 302; 1954, no. 302, all as by Trevisani.

Literature:
Gaynor and Toesca 1963, p. 113; Di Federico 1971, p. 53; Di Federico 1977, p. 44, no. 21.

Figure 1
Francesco Trevisani
The Flagellation
Burghley House

This picture, together with *The Flagellation* (also at Burghley House, fig. 1), relates to Francesco Trevisani's work on the Crucifixion chapel in the Church of S. Silvestro, Rome, which was completed in 1696. Trevisani's early training had been in Venice, under Antonio Zanchi (cat. no. 60), and he then went to Rome in 1678. There he was employed by Cardinal Flavio Chigi on various pro-

jects outside Rome, most notably two altarpieces for the cathedral in Siena, *Christ between St James and St Philip* and *The Martyrdom of the Four Crowned Saints*, which dates from 1688. (A connected sketch for, or more probably after, this altarpiece by Trevisani is also at Burghley.) As Di Federico (1971, pp. 52-53) has observed, however, it is the paintings in S. Silvestro, Rome, which reflect the crucial moment of Trevisani's artistic maturation.

Relying on Caravaggio and other early seicento Roman-Bolognese masters, Trevisani moderated an earlier Venetian *seicento* tenebristic manner and brought it into line with the Roman Baroque-Classical tradition. At the same time, contacts with contemporary Roman painting stimulated an awareness, until then dormant in Trevisani, of the potential in the art of Veronese and the Venetian *cinquecento* as a way through the current, dominating academic manner of Carlo Maratti.

The chapel comprised an altarpiece of *The Crucifixion*, with *The Flagellation* (fig. 3) on the left wall below a lunette of *Christ Crowned with Thorns* (fig. 2), and on the right *Christ Falling beneath the Cross*, below a lunette of *The Agony in the Garden*. Friezes on the ceiling show *Angels with the Cross* and *Putti with Instruments of the Passion*.

Numerous oil sketches are connected with this important commission, some of which, including a *Flagellation* in the Accademia di San Luca, may have been preparatory studies, while others, including the present picture, may have been made as records. As Di Federico (1971) has noted, in the preparatory sketches "evidence of a fluid and loaded brush remain on the forms which have been

Figures 2, 3
Francesco Trevisani
Christ Crowned with Thorns
The Flagellation
S. Silvestro, Rome

very quickly blocked out and highlighted". On the other hand, in the *ricordi*, such as the present picture, "paint is applied with a great deal more deliberation and light has been projected on the forms with a subtlety and sophistication which, comparatively, creates more sculpturally and plastically modelled entities" (Di Federico 1971, p. 53, n. 4). Although almost certainly painted after the picture in S. Silvestro, the present picture differs from it in several respects. The change from the format of a lunette to a rectangular shape has created the need for a more elaborate architectural background in the Burghley picture. The figure entering from behind, second from the right, has also been reconsidered.

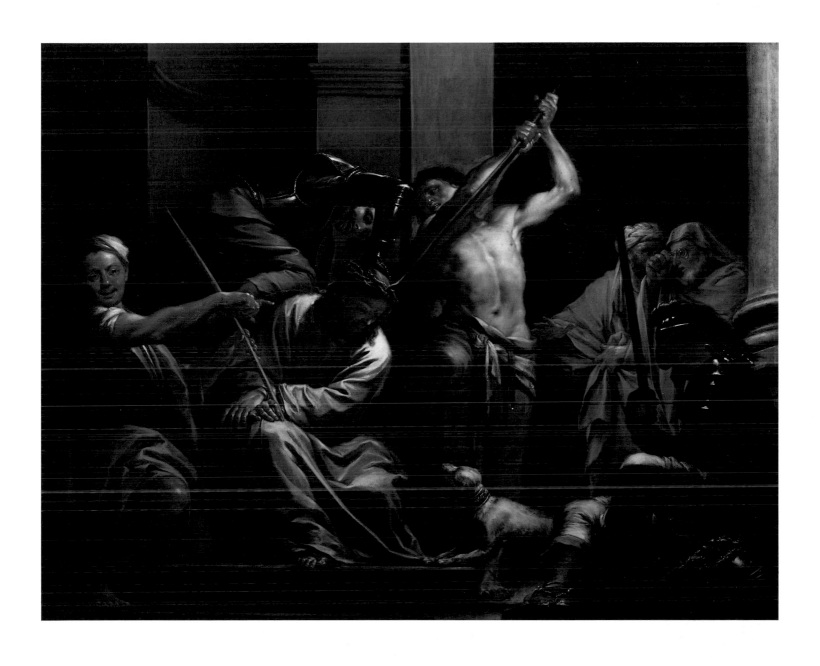

55.

FRANCESCO TREVISANI
Capodistria 1656 – 1746 Rome

Noli Me Tangere

Oil on canvas
97.8 by 72.4 cm; 38½ by 28½ in.
B.H. No. 417

Provenance:
Acquired by the 5th Earl, probably before
1688; probably in the 1688 inventory, p. 27,
without attribution, as one of two overdoors;
also recorded in the 1738 inventory, p. 55, as
in the Dressing Room: "Noli me tangere 3
1\6 Foot wide," without an artist's name; also
recorded in a manuscript inventory of 1793,
partly in the hand of the 9th Earl, as by Carlo
Maratta; 1815, p. 115; 1847, p. 251, no. 414;
1878, p. 52, no. 417; 1954, no. 417, all as by
Maratta.

Literature:
Di Federico 1977, p. 48, no. 34, pl. 28.

The attribution to Francesco Trevisani
was proposed first by Sir Ellis
Waterhouse and is accepted by Frank Di
Federico, who suggests a date circa 1710.
There is, however, a *prima facie* case for
supposing that this picture was either
commissioned or bought by the 5th Earl
of Exeter, who died in 1700. It may
even be an early work by the artist dat-
ing from before 1688 (see provenance).
In any event, it is most unlikely that the
picture would have been acquired for
Burghley House in the immediate after-
math of the 5th Earl's death in 1700,
unless for some reason the artist was
much delayed in fulfilling the commis-
sion.

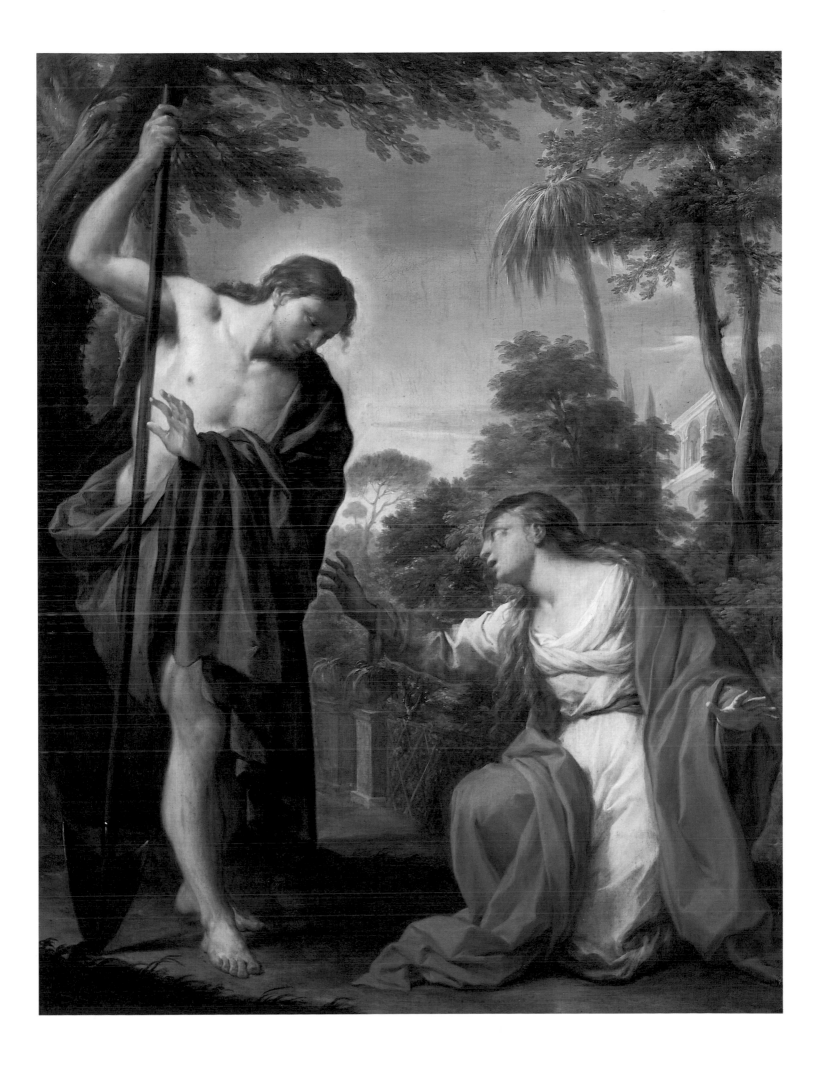

56.

GIROLAMO DA TREVISO
Treviso 1497 – 1544 Bologna

The Mystic Marriage of St Catherine

Oil on panel
107 by 126 cm; 42⅛ by 49½ in.
B.H. No. 410

Provenance:
Acquired by the 9th Earl, and recorded in a list
made in the 9th Earl's hand, *Extracts from an
old catalogue of ye furniture at Burghley*, as
"marriage of St. Cat on wood by Schiavoni"
and also said to be from the Barberini collec-
tion, Rome. Not identifiable in the Barberini
inventories (published by Lavin 1975).
Recorded in 1815, p. 115; 1847, p. 251, no.
421; 1878, p. 52, no. 410; 1954, no. 410, all as
by Schiavone.

Literature:
Waagen 1854, p. 404, as by Schiavone;
Pouncey 1961, p. 209, tavola 85b; Byam Shaw
1967, no. 88, pp. 72–73, pls. 71,72.

This painting was acquired as by
Schiavone, to whose etchings it shows
some stylistic affinity. Pouncey (1961, p.
209) has identified it as a work of
Girolamo da Treviso, who was active in
Bologna. He compares the pose of the
Madonna in the present picture with
that of a seated St Joseph in an
Adoration of the Shepherds at Christ
Church, Oxford, England, which
Berenson considered to be a late work
(Berenson 1957, p. 90; also Byam Shaw
1967, no. 88, pp. 72–73, pls. 71, 72).

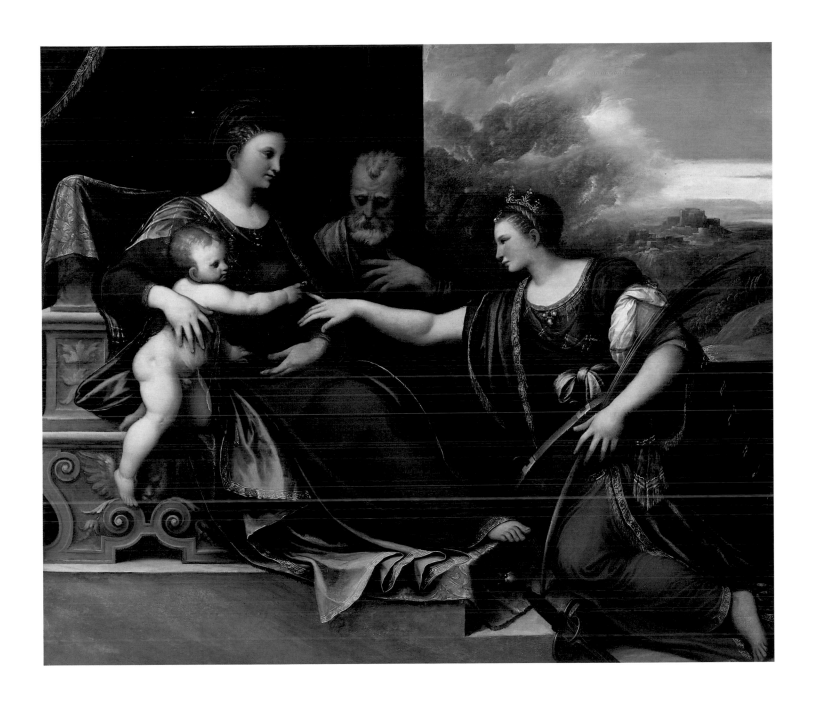

57.

PIETRO DELLA VECCHIA
Venice 1603 – 1678 Venice

Envy Plucking the Wings of Youth

Oil on canvas
91.3 by 121.2 cm; 36 by 47¾ in.
B.H. No. 328

Provenance:
Perhaps acquired by the 9th Earl and recorded
at Burghley House for the first time in the
1797 inventory, p. 73; also recorded in the 9th
Earl's annotated copy of Orlandi, *Abecedario
Pittorico*, 1704, p. 420, as *"Envy pulling
feathers from the wings of youth*, by Pietro
della Vecchia in ye col[n] at Burghley"; 1815,
p. 93; 1847, p. 232, no. 346; 1878, p. 38, no.
328; 1954, no. 328, all as by Pietro della
Vecchia.

Exhibited:
London, National Gallery, *Venetian 17th
Century Paintings*, 1979, no. 34.

Literature:
Aikema 1990, p. 139, no. 155; Potterton 1979,
no. 34, as *An Allegory* (?) by Pietro della
Vecchia.

The picture is described by the 9th Earl
as "Envy pulling feathers from the wings
of youth". Homan Potterton (1979) has
questioned the traditional description of
the subject and raised the possibility
that it may represent some episode from
literature involving a conflict or contrast
between old age and youth. Aikema
(1990) describes it simply as "An old
Woman and a Winged Girl" and suggests
a date circa 1640–1660.

Pietro della Vecchia was a pupil of
Padovanino. This relationship inspired
his devotion to Venetian painting of the
early *cinquecento*, which he celebrated
with imitations and pastiches. At their
best, as in the present picture, his works
amount to baroque reinterpretations of
a Renaissance style.

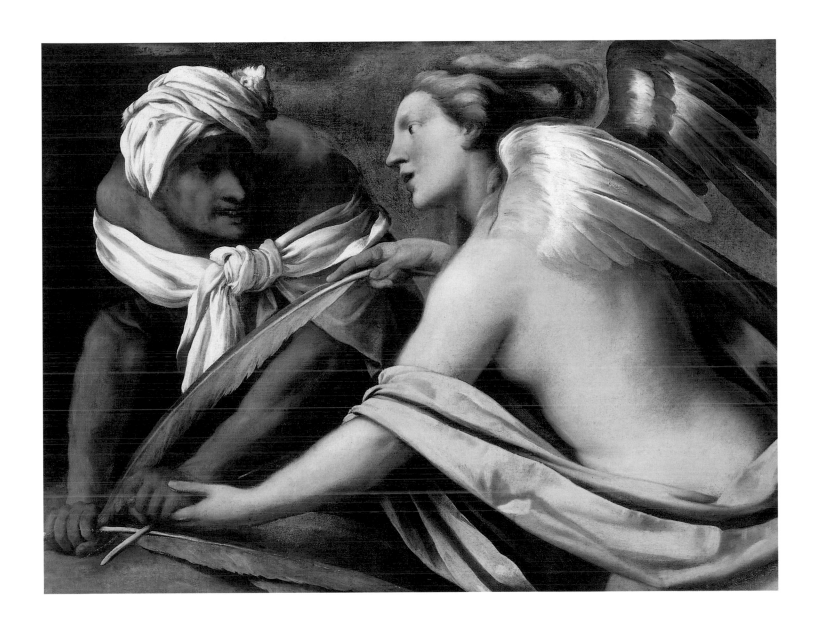

58, 59.

PAOLO VERONESE
Verona 1528 – 1588 Venice

St James

St Augustine

A pair
Oil on canvas
Each 200 by 85 cm; 78¾ by 33½ in.
B.H. Nos. 345, 351

Provenance:
Originally painted for the Church of San
Jacopo, Murano, Venice; bought in Venice by
the 9th Earl, June 1769 (information recorded
in the 9th Earl's annotated copy of Ridolfi
1648, p. 316); first recorded at Burghley House
in a list made out in the 9th Earl's hand,
*Extracts from an old catalogue of ye furniture
at Burghley*, as "St James / St Augustine by P.
Veronese from the church of St James in the
Island of Murano near Venice"; also recorded
in 1815, pp. 93–94; 1847, p. 233, nos. 361, 368;
1878, p. 38, nos. 345, 351; 1954, nos. 345,
351, all as by Veronese.

Exhibited:
Washington, D.C., National Gallery of Art, *The
Art of Paolo Veronese*, 1989, nos. 44, 45.

Literature:
Ridolfi 1648, 1914 ed., vol. 1, p. 330; Boschini
1674, p. 36; Zanetti 1733, p. 456; Cochin
1756, vol. 3, pp. 129–130; Caliari 1888, p. 75;
Ingersoll-Smouse 1924, pp. 96–100; Osmond
1927, pp. 30–31; Venturi 1929, vol. 9, part 4,
p. 951; Fiocco 1928, p. 122; Nicolson 1949,
pp. 333–334; Marini 1968, nos. 124 and 125,
as by Paolo Veronese and workshop; Crosato
Larcher 1968, p. 223, as by Benedetto Caliari;
Crosato Larcher 1969, p. 125, as by Benedetto
Caliari; Pignatti 1976, nos. A.290 and A.291,
as by Paolo Veronese and workshop; Rearick
1989, pp. 93–94, nos. 44 and 45, as by Paolo
Veronese.

These two paintings formed the wings of
an organ complex in the church of San
Jacopo, Murano, Venice, which was
described by Ridolfi (1648), Boschini
(1674) and Zanetti (1733). The present
pictures would have been visible when
the organ was open, with St James on
the left and St Augustine on the right.
When the complex was closed, the
reverse side of the two wings together
showed a picture of *The Mystic Marriage
of St Catherine*, which was last noted at
Christie's, 14 February 1778, lot 98.

These pictures formed part of an
impressive group of paintings by Paolo
Veronese in the church, but they were
subsequently dispersed and sold to
English collectors and travellers visiting
Venice in the eighteenth century. The
9th Earl of Exeter, in 1769, acquired not
only these two organ wings but also the
principal altarpiece representing *God
The Father in Glory*, with *Christ Blessing
the Sons of Zebedee* (illustrated on p.
21). Lord Clive, in 1771, acquired from
Sir James Wright *The Mystic Marriage of
St Catherine* from the organ complex, as
well as a side altarpiece of *The
Visitation*, now in the collection of the
Barber Institute, Birmingham, England;
and the Earl of Lonsdale acquired anoth-
er side altarpiece of *The Resurrection*,
which is in the chapel of Westminster
Hospital, London.

The present pictures, which may origi-
nally have measured nearly 216 by 106
cm (85 by 42 in.) (see Rearick 1989, pp.
93–94, nos. 44 and 45), have lost part of
their architectural settings. Some recent
writers, most notably Crosato Larcher,
have questioned their traditional attribu-
tion to Paolo Veronese, which dates back
to the seventeenth century with Ridolfi
and Boschini, and have proposed

instead an attribution to Paolo's work-
shop and in particular his brother
Benedetto. There seems, however, no
good reason to doubt Paolo's personal
involvement in the execution of the pre-
sent pictures. As Rearick (1989) has
written:

It is a mistake to see the simplicity of
these saints as a sign of shop execu-
tion, and in particular that of
Benedetto, whose hand is detectable,
if at all, only in peripheral passages
such as the architecture. It is, instead,
Paolo's hand in a subtly understated
vein. Augustine is solemnly patriar-
chal and immobile, but his deep emo-
tion suggests a pathos new to Paolo's
expressive range, and the tonal mas-
tery with which the cast shadow on
the book establishes space and atmos-
phere is expertly controlled.

Cocke has made the convincing sug-
gestion (letter, 1 September 1994 and
forthcoming Veronese monograph) that
Veronese's paintings from S. Giacomo
may all date from circa 1578 (see further
R. Cocke in *Veronese Drawings,
Catalogue Raisonné*, 1984, pp. 189–190,
under no. 80). Rearick (1989, p. 91,
under no. 43) had earlier suggested a
date for all these paintings circa 1568–
1569, but this appears to have been
based on what seems from Cocke's evi-
dence to be an erroneous belief that a
Mystic Marriage of St Catherine in the
Musée des Beaux Arts, Brussels, and a
drawing in the Museum Boymans-van
Beuningen, Rotterdam, which is datable
1568–1569, are connected with the S.
Giacomo commission.

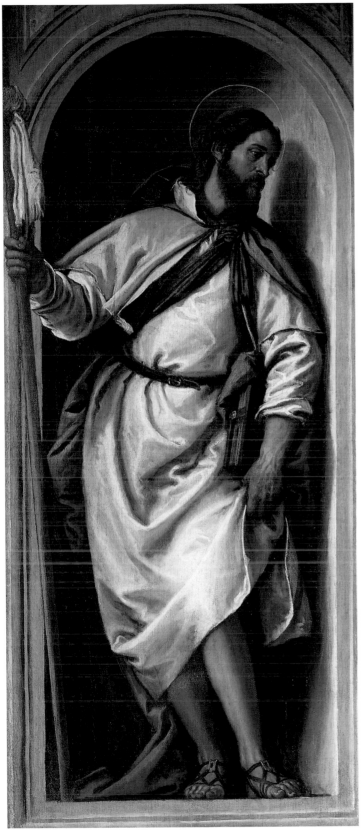

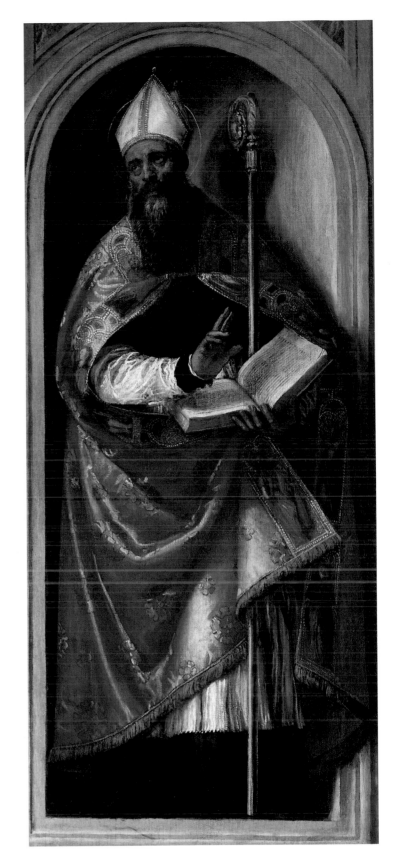

58

59

60.

ANTONIO ZANCHI
Este 1631 – 1722 Venice

Jephtha's Vow

Oil on canvas
229 by 274 cm; 90⅛ by 107¾ in.
Signed, lower left: Ant. Zanchi . . .
B.H. No. 073

Provenance:
Bought in Italy by the 5th Earl and first recorded in the 1688 inventory, p. 14, as being in the "Plaster Dineing Roome & Closett", as follows: "1 peice of Jeptha and his Daughter by ye Same hand (i.e. Zanchi)"; also recorded at Burghley in 1797, p. 118, as by "Jordano"; also 1815, p. 32; 1847, p. 186, no. 64; 1878, p. 12, no. 73; 1954, no. 73, all as by Giordano and as in the chapel.

Literature:
Ferrari and Scavizzi 1966, vol. 2, p. 122, as traditionally but incorrectly attributed to Giordano and proposing an attribution to Allessandro Gherardini; Potterton 1979, p. 30, as by Zanchi.

Although acquired as by Antonio Zanchi, before 1688, and signed by the artist, the attribution was already lost by the eighteenth century. Another painting by Zanchi at Burghley, *Saul and the Witch of Endor* (fig. 1), was probably acquired at the same time, since it immediately precedes the present picture in the 1688 inventory and is of exactly the same dimensions. Originally they were hung together in the "Plaster Dineing Room and Clossett" before they were moved to the chapel. A further

pair of paintings by Johann Carl Loth, also of the same size and representing *The Idolatry of Solomon* and *The Finding of Moses* (cat. no. 32), now hang with the two Zanchi paintings in the chapel. They appear to have been acquired independently (see cat. no. 32).

Zanchi transformed Giordano's vigorous baroque manner into a lighter, more decorative style, characterized by intense vivid colouring and reminiscent of Veronese.

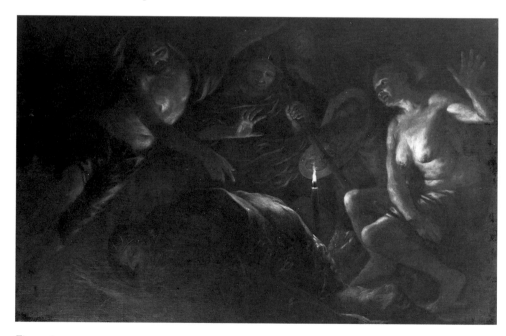

Figure 1
Antonio Zanchi
Saul and the Witch of Endor
Burghley House

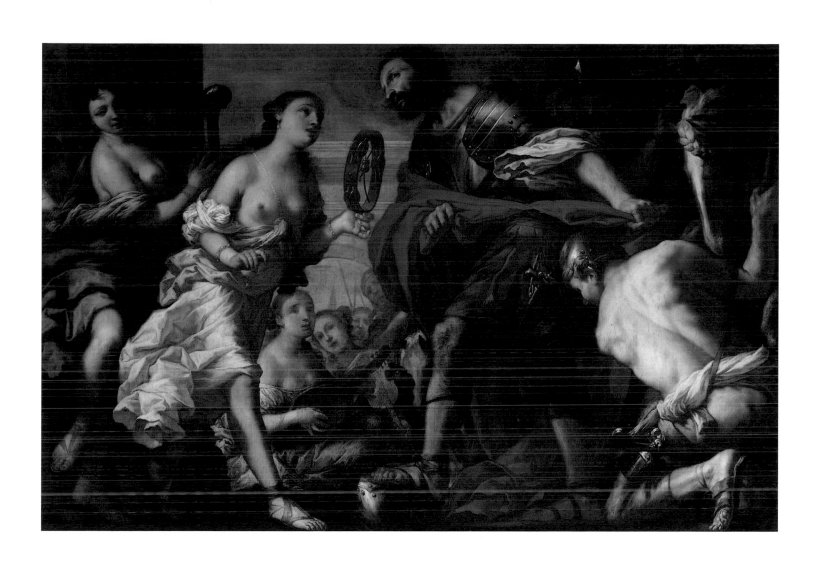

Endnotes

1. There are several extant originals of Christ, including a half figure of Christ blessing the bread.

2. A spacious painting of two half figures, including Orpheus, lyre in hand; he is playing and the animals have gathered around to listen to him (and around him are a ram, a dog, a parrot, and two other small birds, listening to him). This work was for Lord Exeter, mentioned above.

3. A painting with a Venus with a sketch of no. 8. Small putti by the hand of Jacinto, a student of Pietro da Cortona, measuring 2 by 3 palms, bought in Rome from Mr Abbe.

4. As if the work had been painted on a canvas on which another composition had already been sketched out.

5. Only generally from the circle of Giordano, probably by one of his students.

6. They appear curiously incomplete, particularly *The Death of Seneca*, where the arm of the crouching figure, left, and the entire upper part are barely sketched out.

7. He went on to do no small number of portraits of English gentlemen who came to Rome, obtaining most liberal compensation for them. These portraits included Lord Sunderland, standing in a most noble posture on a marble base, and Lord Roscomen, also standing, pointing with a commanding hand. Both are devised in a vague manner, in what they call picturesque clothing "all'antica" [in the ancient style]. He did the portrait of Count Exeter, and another of Sir Thomas Isham, seated, holding a miniature portrait of a woman. He drew Mr Charles Fox and Mr George Herbest [*sic*], a most eager admirer of painting who, being charmed by Carlo's style, wanted two half figures by him, the two Penitents, as well as his portrait: Mary Magdalene in the desert, contemplating the cross being shown to her by the angels, and the Samaritan woman at the well before our Lord.

8. On 10 May 1684 - George Davies paid 66 ducats, on an account of 100 ducats, to Giuseppe Recco in the name of and on behalf of the Count of Exeter, as a deposit on the price of two paintings of flowers that were to be delivered to the Count, measuring 10 by 8 palms; they agreed on a price of 400 ducats for the two paintings, and because one of the two that had been started had yet to be completed, Recco was required to complete it during that month of May. When word came that it was completed as well as the other one, it would be up to the Count to choose both or either painting, whichever he pleased. If he chose both, he would have to pay the remaining 300 ducats; if only one, the remaining 100 ducats. That was the agreement between them.

9. A Judith showing the head of Holofernes to the people of Bettuglia at night, with the nurse and two pages holding lighted torches, life size figures for Mr Cattalani.

Translations provided by William H. Skinner for the publisher

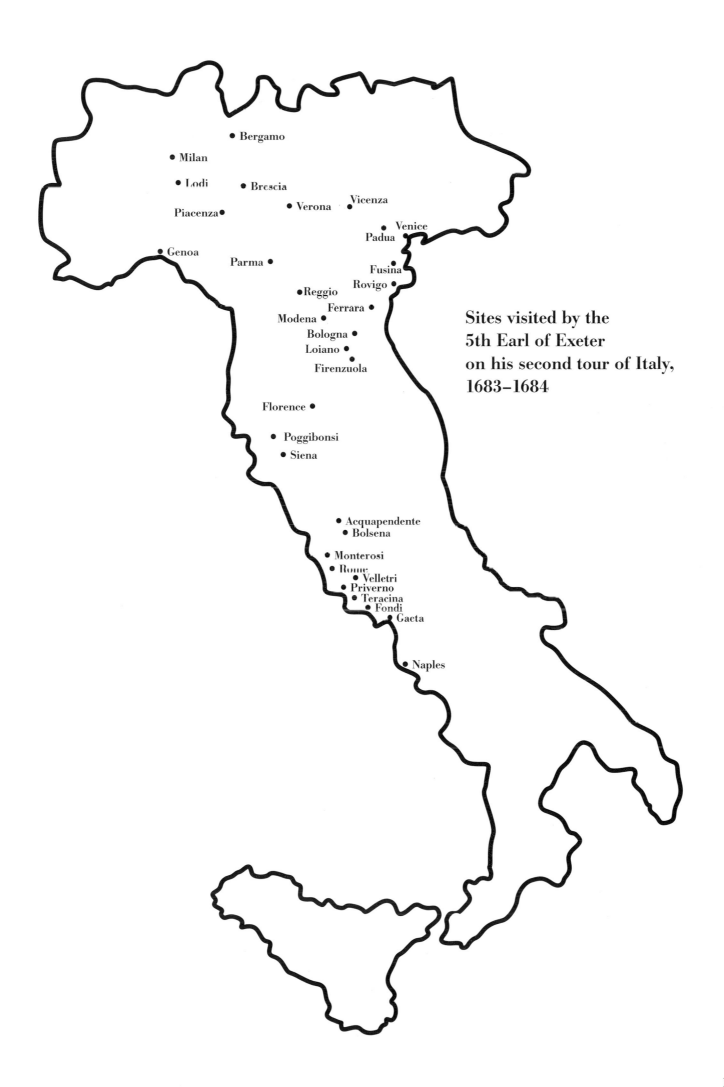

Bergamo

Milan

Lodi Brescia

Piacenza Verona Vicenza

Venice

Padua

Genoa

Parma Fusina

Rovigo

Reggio

Ferrara

Modena

Bologna

Loiano

Firenzuola

Florence

Poggibonsi

Siena

Sites visited by the
5th Earl of Exeter
on his second tour of Italy,
1683–1684

Acquapendente

Bolsena

Monterosi

Rome

Velletri

Priverno

Teracina

Fondi

Gaeta

Naples

The Cecils of Burghley

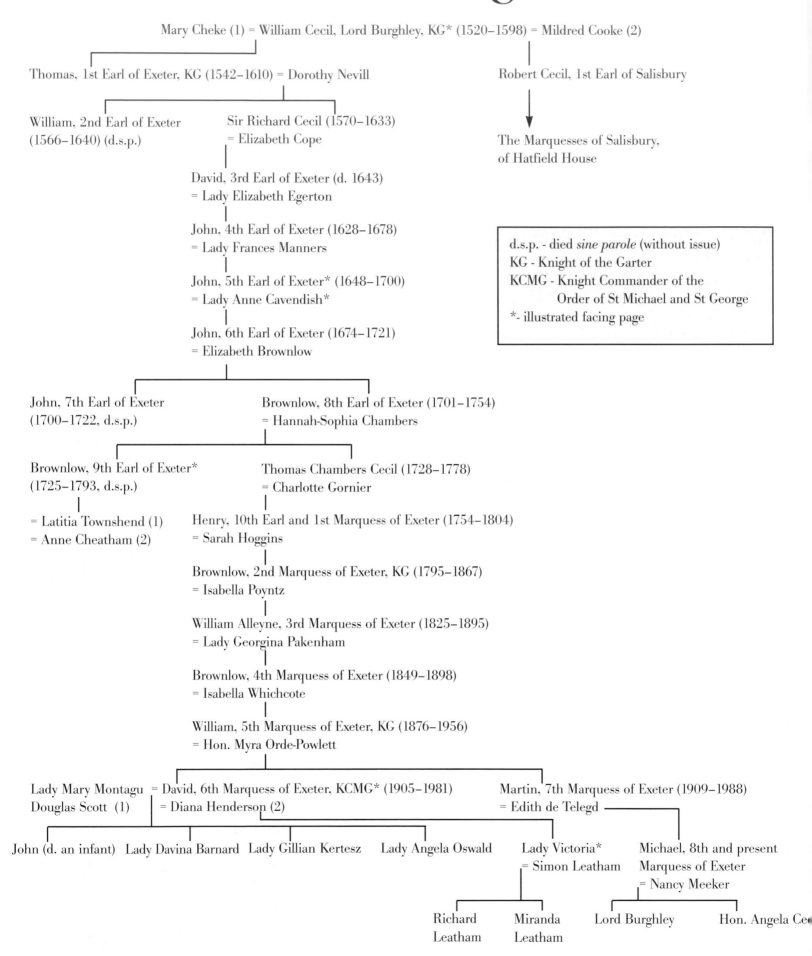

Mary Cheke (1) = William Cecil, Lord Burghley, KG* (1520–1598) = Mildred Cooke (2)

Thomas, 1st Earl of Exeter, KG (1542–1610) = Dorothy Nevill

Robert Cecil, 1st Earl of Salisbury

William, 2nd Earl of Exeter (1566–1640) (d.s.p.)

Sir Richard Cecil (1570–1633) = Elizabeth Cope

The Marquesses of Salisbury, of Hatfield House

David, 3rd Earl of Exeter (d. 1643) = Lady Elizabeth Egerton

John, 4th Earl of Exeter (1628–1678) = Lady Frances Manners

John, 5th Earl of Exeter* (1648–1700) = Lady Anne Cavendish*

John, 6th Earl of Exeter (1674–1721) = Elizabeth Brownlow

> d.s.p. - died *sine parole* (without issue)
> KG - Knight of the Garter
> KCMG - Knight Commander of the
> Order of St Michael and St George
> *- illustrated facing page

John, 7th Earl of Exeter (1700–1722, d.s.p.)

Brownlow, 8th Earl of Exeter (1701–1754) = Hannah-Sophia Chambers

Brownlow, 9th Earl of Exeter* (1725–1793, d.s.p.)

= Latitia Townshend (1)
= Anne Cheatham (2)

Thomas Chambers Cecil (1728–1778) = Charlotte Gornier

Henry, 10th Earl and 1st Marquess of Exeter (1754–1804) = Sarah Hoggins

Brownlow, 2nd Marquess of Exeter, KG (1795–1867) = Isabella Poyntz

William Alleyne, 3rd Marquess of Exeter (1825–1895) = Lady Georgina Pakenham

Brownlow, 4th Marquess of Exeter (1849–1898) = Isabella Whichcote

William, 5th Marquess of Exeter, KG (1876–1956) = Hon. Myra Orde-Powlett

Lady Mary Montagu Douglas Scott (1) = David, 6th Marquess of Exeter, KCMG* (1905–1981) = Diana Henderson (2)

Martin, 7th Marquess of Exeter (1909–1988) = Edith de Telegd

John (d. an infant) Lady Davina Barnard Lady Gillian Kertesz Lady Angela Oswald

Lady Victoria* = Simon Leatham

Michael, 8th and present Marquess of Exeter = Nancy Meeker

Richard Leatham Miranda Leatham

Lord Burghley Hon. Angela Ce

156

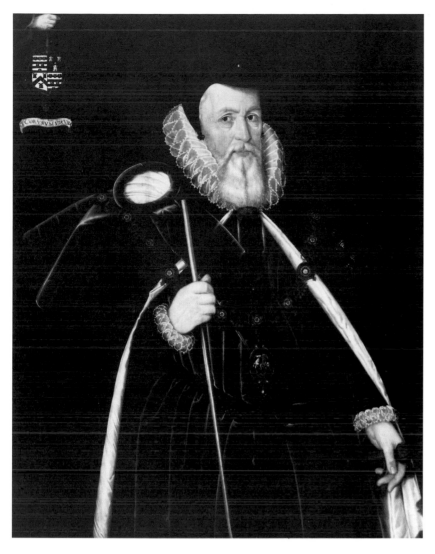

William Cecil, Lord Burghley

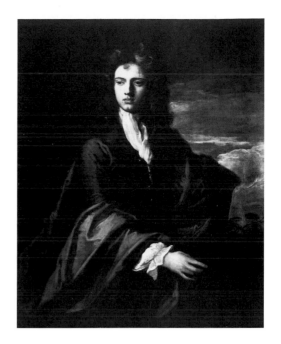

John Cecil, 5th Earl of Exeter

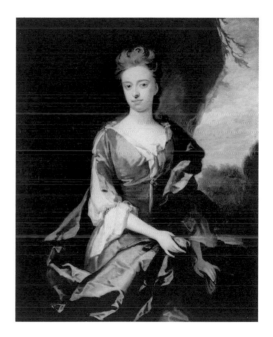

Anne Cavendish, Countess of Exeter

Lady Victoria Leatham

David Cecil, 6th Marquess of Exeter

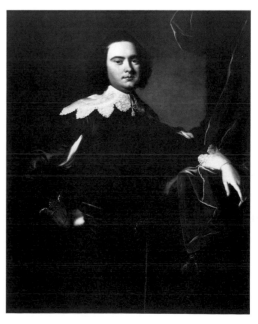

Brownlow Cecil, 9th Earl of Exeter

An Inventory of the Goods
in Burghley House belonging to
the Right Honble John Earle of
Exeter and Ann Countesse of
Exeter Taken August 21th
1688

Upper Gallery	
South End 1st Roome	1 Bedstead, 1 feather bed, 1 Boulster.
	2 Pillowes, 2 Blanketts, 1 Silke quilt
	1 Stript Sattin bed Lin'd with Sastnet, Guilt feet &
	6 Sattin Chaires to ye Bed, 1 old holland quilt
	1 Table, & yellow Silke Carpett
	1 old walnut tree Stand
	1 pr Brasse Andirons, & 1 pr Brasse Doggs
	1 fire shovell & Tongs Brasse knobs
	1 pr of Bellowes, 1 Iron Back & Grate,
	4 peices of ye Boyes Tapestry hangings } Brussells
	2 peices of Landskip Tapestry hangings }
	1 old Cloth Stoole 1 Close Stoole box
	2 old Callico Dimity window Curtains, & Rod
Pictures	{ 1 Picture hunting peice over the Chimney } by wyke
	{ of mr wyke's painting ———— }
2d Roome	1 Bedstead, 1 feather bed, 1 Boulster, 1 Pillow
	4 Blanketts
	1 Red cloth Bedd Laced silk & Silver ffringe and
	2 old Chaires, 2 old Stooles, { 1 Counterpoint to it
	1 Table & Tushywork Carpett,
	2 purple Serge window Curtains, & Rod
	2 peices of Landskip Tapestry hangings

An Annotated Listing of Pictures Mentioned in the 1688 Inventory

Compiled by John Somerville

In 1688, John Cecil, the 5th Earl of Exeter, conducted an inventory of his vast collections (see opposite page). The handwritten notations describe in detail the appearance and placement of hundreds of objects, from furniture and tapestries, to statuary, paintings, and Japanese porcelain. The handwriting is that of Culpepper Tanner, the Earl's steward. Tanner left numerous blanks in the sections that concern paintings, as if awaiting the Earl's confirmation of an artist's name.

The following transcriptions merely show the entries for paintings and indicate the page on which they appear in the 1688 inventory. The original spelling and punctuation have been retained. Where pictures can be positively identified, the current attribution, Burghley House collection number, and subject or sitter are also given.

Manuscript Page	Inventory Listing	Pictures still at Burghley House
2 Pictures	Upper Gallery South End 1st Roome { 1 Picture hunting piece over the Chimney of Mr Wykes painting- - - - - - - - - - - -by Wyke	
3 Pictures	Upper Gallery Roomes Continued 3rd Roome 1 Picture over ye Chimney, paesage & Beasts 1 of painting	
3 Pictures	Midle or 4th Roome 1 Landskip picture over ye Chimney of} by with a Guilt fframe————}	
4 Pictures	Upper Gallery Continued 5th Roome { 1 Picture Landskip over ye Chimney of	
4 Pictures	7th Roome or ye North End Roome { 1 Picture Landskip over the Chimney old	
7 Pictures	The Lower Gallery Roomes 2nd Roome next the South 2 Pic Pictures over the Doores, ye Brasen Serpent and ye Isarelites Mana done by } vandercable 1 Satyr & Venus in a Guilt fframe, by Sgr Libery 1 Satyr and Boyes in a Guilt fframe, by Pioli 1 Susanna & ye 2 Elders in a Guilt fframe by,	Liberi, no. 473: "Venus and Satyr"

Manuscript Page	Inventory Listing	Pictures still at Burghley House
8	Lower Gallery Continued South Bed Chamb or 3rd Roome Mr William Cecils picture over ye Chimney, by Wissing 2 peices of fruite over the Doores, by Vandercable	Wissing, no. 514: "The Hon^ble William Cecil"
8 Pictures	Midle or 4th Roome and ye 2 Clossetts 2 peices of Moses & ye Isarelites} over the Doores done by————} Vandercable 2 peices of Birds & Beasts over ye} Doores done by————————}David of Rome 2 Large ffish peices done by Recco of Naples 1 Large peice of Noahs Ark in a fframe done by————————} by Castillione	de Koninck, no. 111: "Cockerels Fighting"* no. 120: "A Spaniel and Eagle Surprising Duck"
9 Pictures	Lower Gallery Continues North Bedchamber or 5th Roome Ld Burghley picture over the Chimney by, Wissing 2 picture, fowle & flowers over the Doores done by—} mon Louis att Thurin	Vagnier, no. 515: "Fruit and Flowers" no. 352: "Flower Piece"
9 Pictures	6th Roome 3 pictures over the Doores of Birds and beasts done by——Jacomo di Castello 1 Andromeda in a Guilt fframe} 1 Dana in a Guilt fframe——} by Pignione 1 Mars & Venus in a Guilt fframe, by Jordanus	Giacomo da Castello, no. 145: "Battle of Birds and Beasts" no. 168: "Aesop's Fable" no. 513: "Animals in the Garden of Eden" Giordano, no. 297: "Venus and Satyr" (This or a similar picture is described on page 26.)
10 Pictures	Lower Gallery Continued The North End Chamb or 7th Roome 2 pictures of ffruite & flowers over} the doores done by————}	Ruoppolo, no. 102: "A Still Life of Fruit with Pomegranates"* no. 112: "A Still Life of Fruit with a Melon"*
10 Pictures	The Clossett att ye North End of ye Gallery Roomes 1 picture over the Chimney of Birds} and Beasts done by————} Jacomo di Castello 1 picture of Noahs Ark} done by Vandercable over yr Doore } 1 picture of ye Great Dutchess of florence over the Doore done by————} by 1 picture, of Susanna & the Elders} in a Guilt fframe done by } Francesco di Maria 1 picture of birds and beasts in a Guilt frame done by } Petro di fiori 1 little picture of Acteon & Dianah} in a Carvd Guilt frame done by }	Giacomo da Castello, no. 525: "Birds and Beasts"
11 Pictures	The Bedd Chamb next ye Gallery Roomes 2 Pictures over the Doores being} by Augustine the Storyes of } Scilla, Rome } 1 Picture over the Chimney} by Carlo Loti the story of Ovid & Julia }	Agostino Scilla, no. 135: "Ariadne abandoned by Theseus"

12 Pictures	The North Drawing Roome 1 Picture over the Chimney } a herrodiet(??) done by——} Francesco di Maria 2 pictures over the Doores} a Satyr & Venus Sleeping &} a Venus & Bacchus done } by Daniel of Rome 2 pictures over ye Clossett doores The Storys of David & Bathsheba} & Sollomon & ye Queen of Sheba } by Carlo Loti	Seiter, no. 300: "Sleeping Venus" no. 296: "Venus, Cupid, Ceres and Bacchus" Loth, no. 368: "Solomon's Idolatry"
13 Old in all 20 Pictures	The North Dineing Roome Ld Treasurer Burghley's picture in a frame, 2 Pictures { pictures of my late Ld Exeter & his Lady together, one a frame ye other none, late Lady Exeters picture in Guilt frame, Lds picture a Guilt frame La Scudameres picture a Guilt frame, Mrs Wise picture in a frame 7 womens pictures halfe lengths in Guilt frames of Relacons Sir Walter Rawleighs picture in frame, Judgement of Paris no frame, 2 Landskips, & one Sea Storme in frames; Queen Elizabeth in a Guilt frame done by——} Piolo My Lords picture on horse back no frame, by monsr D'agar a Sibill in a Guilt frame done by, Piolo 2 peices of Aurora & a Night done by Jacinto Brandi 2 peices of Coriolanus, & Rape of Helen} by Zanchi 2 peices of Hero and Leandow} done by——————} by 2 peices of Dido & Aeneas} done by——————} by Sigr Celestie 1 peice of Endimion & Diana } 1 peice of the Child Achilles} by Piolo delivered to a Centaur } 1 Night peice ye Nativity done by Sgr Liberi	Marcus Gheerhaerts the Younger, no. 196: "The Lord Treasurer Burghley" Jacob Huysmans, no. 394: "Frances, Countess of Exeter, wife of the 4th Earl" Manner of Marcus Gheerhaerts, no. 353: "Sir Walter Raleigh his son" H. Rottenhammer, no. 259: "The Judgement of Paris" Marcus Gheerhaerts the Younger, no. 197: "Queen Elizabeth" Liberi, no. 70: "Adoration of the Shepherds"
14 8 old pictures	The Plaster Dineing Roome & Clossett 1 old Landskip wt fframe, & 6 litle head in fframes 1 old Turkish Story in a Guilt frame 1 peice of Samson & ye philistines} 1 peice of Sam Son & Dalilah } by Ferrar te 1 peice of ye Israelites done } 1 peice of old Time done by-Fra:Mattheus Knt of Malta 2 litle peices of hagar and Ismaell} & a Sheppherd & Sheppard ess—} by Sigr Romigio 1 peice of Susanna & ye Elders } 1 peice of Joseph & potifers wife} by 1 peice of Saul & ye witch of Endor, by} Zanchi of Venice	 Preti, no. 379: "The Triumph of Time"* Valerio Castello, no. 232: "Joseph and Potiphar's Wife"* Zanchi, no. 69: "Saul and the Witch of Endor"

1 peice of Jeptha & his Daughter, by } ye Same hand Pictures Zanchi, no. 73: "Jephtha's Vow"*
6 Landskip perspective peices Ruines} by Antonio
in Guilt fframes from Gennoua } di Cestri
5 Sea peices in Guilt frames}
from Gennoua done by———} Marrini
1 Larger Landskip & water peice}
with ffishes in a Guilt frame—} by
4 litle peices of flower potts in}
Guilt fframes————————} by
1 picture over ye Chimney without a } by
frame of Argus & Io turnd into a bull} Francesco di Maria
1 litle Madona in a Carvd wallnutt}
tree fframe————————} by
The Stair Cases Pictures}
1 peice of Polyphemus & acis by Sigr Romigio
1 peice of flowers done by——

15

Chappell Chamber

1 picture of Ld Montague an old picture

Ld Burghley's picture of ye Chimney in a Guilt Kneller, no. 519: "Lord Burghley"
fframe by Kneller
Major Willoughbys Picture drawn by Bombello
Mr Barnard Sistons Picture drawne by, Fr:di Maria
1 peice
1 peice Judith & holiphernes in a black frame by
1 peice of St John no frame by
4 peices, a venus & adonis, judgement of Paris}
An Acteon & a Dianah & her Nimphs no frames} by
Stephano Gerardi
4 peices of ye Seasons represented by}
fruite & flowers in figures no frames} by Pore
3 peices of flowers done no frames } by
1 peice of Birds & a hare dead no frame by
1 litle peice, Moses Striking ye Rock in frame by
2 peices of Landskips no frame by Stephano Gerardi
1 Sea Storme piece no frame by
1 peice Ruines & Landskip by
1 peice of paesage & Landskip by
1 Night peice of Shipps Repaireing by
1 peice of Lazarus in ye Tomb by
1 peice of Diana Bathing, all no frames by
1 peice, a Gallatea no frame by Stephano Gerardi
1 peice hippomeus & Attalanta by

16

Pictures

My Lords Clossett

1 picture of Ld Burghley Mr Cecil Mr Charles in
a Guilt frame done by Signor Verrio
1 peice of Still Life in a Guilt frame by Io Stratton Roestraeten, no. 380: "Still Life"
4 Landskips on pannels done by
1 peice of fruite over ye Doore by
1 peice Love no frame, by
1 flower pott of tapistry, in Ebony frame, by monsr Jans
2 peices of paesage & Landskip over}
the Leads Doore in black frames, } by
2 litle Round Landskips no frame, by
3 schetches in water Coullers of Diana}
& Europa in black frames } by
1 litle peice of Moses & ye Israelites
in black frame by
2 flower peices in black frames, by
2 little peices, of Asses & horses,black frames,by

	1 litle peice of a Turkey Cock pigeons no frame	
	1 litle Landskip by ye Leads doore no frame by	
	1 litle peice of flowers in water Coullers}	
	a Glass and Guilt frame } by	
	1 litle Madona round in Ebony frame}	
	water Coullers }	
	13 Drawings & 1 print of ye nativity	

17	My Lords Dark Bed Chamb	
Pictures	1 picture over ye Bedchambr Chimney}	
	of fowle & a Monkey————} by Barlo	
	1 picture of Endimion over the}	
	Clossett Chimney————} by Mr D'agar	
	1 Picture on Cloth in a Black fframe}	
	and Glasse before itt a Venus——}	
	over ye Chambr Doore————} by	

18	Mr Noels Chambr	
Pictures	1 Baccanell over the Chimney} by	
	1 from Back my Lords Crest }	

20	The Old Wardrobe And Outward Roome	
	1 old picture	
	1 old Landskip picture in a black & Guilt fframe	

23	Tile Room	
Pictures	a venus & Satir over ye Chimney done by, Sigr Librei Librie	
	2 peices of Boyes in Guilt frames & over ye Doores, by Pioli	
	2 peices of boyes no frames over ye Clossetts, by	
	1 peice of perspective Guilt frame————by	
	a Cate tearing his bowells Guilt frame by	
	a Spaniard playing on ye lute Guilt frame by	Valentin, attributed to, no. 530: "Man with a Guitar"
	an old peice of Landskip Guilt frame by Salvitor Rosa	
	a Magdalen with a Deths head no frame by	
	a Magdalen with a book no frame by	
	a peice of litle boyes offering to an}	
	Idoll } by	
	ye destruction of Troy no frame }	
	The Rape of ye Sabines no frame } by	

24	My Lords Dressing Room	
Old picture	Ld Treasurer Burghley's picture in a Guilt fframe	
	a peice of Birds & beasts over ye Chimney by	
Picture	2 peices of ffishes over ye Doores——by	
	1 peice of fruite & flowers in flower potts}	
	with black & Guilt frames————} by Reccus	

25	My Lords Clossett	
Pictures	1 Picture over the Doore, Salamatius and }	
	Hormophriditus————} by	
	1 picture over ye book Case }	
	{ } by	
	1 peice of Birds & fruite in Stone Ebbony frame by	
	1 peice painted upon Stone in Ebbony frame by	
	4 peices in Guilt frames, ye Judgement of Paris, a}	

baccanell, a Musick peice, Jupiter & Juno—} by
A Nessus in an Ebony frame———by Carlo Dolci
a Gallotea, in an Ebbony frame———by
a Jupiter & venus, Ebony frame sketch by phillippa Laura
2 peices of small horse men Guilt frames by
1 litle Landskip Guilt frames————by
1 Dutch piper with a Rennish wine Glass Guilt frame by
a Lyda in an Ebony frame & Glasse———by
a Cobler in a black frame————by
a Jael in a black frame
a peice of Goates, Asses, & Cowes black frame by
a peice of Boyes & a Goate black frame by
a St John & on Copper Ebony frame by
2 peices a Lyda, a Ixion no frames by———by
2 peices a polliiphemus, a sheppard no frames by
a Christs head, a Madona's head no frames by
a Daphne & Appollo, without a frame} by Carlo
a Diana Bathing alone no frame } Mauratto
a Susanna on a boarde no frame———by
a Diana, Acteon & one nymph, no frame-by
a Drown'd Leander, no frame———by
a venus Sleeping, no frames———by
2 litle peices a Sleeping venus & Satir and}
a Cupid & Sheppard, no frames———} by
a Catt & birds litle picture no frame———by
2 Sketches, a St John & a by

Maratta, no. 239: "Leda and Swan"*
 no. 238: "Ixion embracing the Cloud"*

 no. 244: "Jupiter and Semele"*
 no. 245: "Danae and the Shower of Gold"*

de Koninck, no. 474: "Cat and Dead Game"

26	My Lords Bedd Chamb	
Pictures	1 picture of Susanna over ye Chimney by 2 pictures over the Doores a Lott and } his 2 Daughters, Joseph & Pottiphers wife} by Francesco Maria	After Orazio Gentileschi, no. 482: "Lot and his Daughters"
26	My Lords Anty Roome	
Pictures	1 peice of Cleopatra over ye Chimney by Carlo Loti 2 peices over ye Doores, a Noli me tangere} & our Saviour & Thomas————} by 4 peices in Guilt frames, a Mars & Venus} a Europa, a Dana, & Naked Venus———}by Jordanus 2 old pictures Earle Thomas, & his Lady 2 pictures in frames by	Giordano, no. 297: "Venus and Satyr" This or a similar picture is described on page 9).
27	My Ladyes Anty Roome & Clossett	
5 old pictures	Earle David, Ld Bridgewaters, Ld Rutland } in Guilt frames 2 Lady Exeters Guilt frames} a Daphne & Appollo over ye Chimney –by 2 peices over the Doores, a Magdalen } & our Saviour, & ye Sepulcher———} by an Isaac on his Deth bed } a Tobitt in 2 Guilt frames} by Jordanus a Sleeping Cupid painted upon Cloth } Ebony fframe & Glass before itt—} by a Baskett of flowers Needle worke } in Ebony frame & Glass before it }	Trevisani, no. 417: "Noli Me Tangere"* Chiari, no. 412: "The Virgin and Mary Magdalen Mourning over the Dead Christ"*

28	My Ladyes Bed Chamb	
	Mr Charles Cecills picture over ye Chimney by Wissing	Wissing, no. 306: "Hon Charles Cecil"
	2 peices over the Doores, Abram & hagar} and Rachell and Benjamin——— } by Celestie	Celesti, no. 484: "Abraham dismissing Hagar and Ishmael" no. 483: "Death of Rachel"
29 Pictures	My Ladyes Dressing Roome	
	3 pictures over the Doores, Ld Burghley } pulling fortune, prudence & fortune and } one Embracing fortune———————— } by Sigr 1 picture over the Chimney a painter } Librei or Carver giving his figure he made } to fortune——————————— }	Liberi, no. 248: "Lord Burghley pulling Fortune by the Hair" no. 139: "Logic Between Vice and Virtue"* no. 586: "Virtue and Truth Kissing"
	1 peice of David & Bathsheba in a } Large Guilt fframe———————— } by 1 peice of ye woman taken in Adultery} Jordanus in a large Guilt frame——————— }	Giordano, no. 217: "David and Bathsheba" no. 152: "Woman taken in Adultery"
30 Pictures	My Lady's Clossett	
	a Magdalen Sleeping over ye Chimney} by Pasinellus a peice of Bathing over ye Doore } a peice of Diana & over ye bookcase} by a flower pott & fruit of Needle worke } in Ebony fframe & a Glasse————} by 6 pictures in Ebony fframes (viz) the } by adoration, a St Sebastian, a young Christ's} Carlo	Pasinelli, no. 418: "Magdalene" Dolci, no. 400: "Adoration of the Magi" no. 11: "St. Sebastian" no. 262: "The Infant Christ with Flowers"
	=head, St Johns head in a Charger———} Dolci 1 St Lucy in an Ebony fframe——by Carlo Dolci a picture of La: when dead} in an Ebbony frame————} by a peice of a young Christ whole length} in Ebbony frame————————} by 4 pictures on Copper in Ebbony frames } (viz) a St Stephen, a St Lawrence, and }	no. 263: "Head of St John the Baptist" no. 453: "St Lucy" Lauri, no. 51: "The Stoning of St Stephen" no. 47: "Martyrdom of St Lawrence"
	Appollo & Midas, Appollo fleying a Satir} by phillipo Laura	no. 25: "The Judgement of Midas" no. 26: "Apollo flaying Marsyas"
	3 larger peices in Ebbony frames } (viz) a Venus & Adonis, a venus & Satir} by	no. 477: "Venus and Adonis" no. 481: "A Satyr brought before Venus" no. 476: "Apollo in his Chariot"
	& a Phaeton, all on cloth——————} a Magdalen Reading in Ebony frame, by a Madona, needleworke in a Guilt frame, by a Dead Christ on Copper, Ebony frame by Sigr Romigio a virgin Mary in litle with our Saviour in } her Armes Ebony frame——————} by a Christ taking from ye Crosse in water } Coulers, Ebony frame & Glasse before itt} by 4 litle pictures painted upon lapis } Lazoli in Ebbony frames————} by	Giulio Clovio, no. 714: "The Descent from the Cross"

31	2 litle peices painted upon bloud stones	
	with Guilt and wrought brasse frames }	
	(viz) a Joseph & Mary, ye flight into Egypt} by	
	a St without a frame by	
	a noli me tangere without a frame by	
	a Christ taken from ye Crosse, no frame by	
	3 pictures in litle (viz) late Ld Exeter }	
	Ld Roosse, Lady Ruttland, Ebony frames } by	
	a picture in Gold Case of Ld	
	a picture in Gold Case blue enamel of ye }	
	late Ld Devonshire————————} by	
	a picture of late Lady Exeter in Gold } by Mr	
	Case and Christall—————————} Cooper	
	a picture of my Lord in Gold Case &, by Mr Cooper	
	another picture of my Lord in a }	
	Gold Case & Christall————} by Mr Crosse	

32	The Best Bedd Chambr	
	1 peice over ye Chimney, pollyphemus & Aeis} by Livio Magius	
	Pictures 1 peice of Simeon & our Saviour a child} by Guerchine	
	1 peice over ye other Doore, our Saviour & St John by Genaro	Gennari, no. 396: "The Virgin, Child, Baptist and St Anne"

33	2 pictures over ye Doores a Magdalen	Maratta, no. 426: "The Penitent Magdalen with an Angel"*
	praying, & our Saviour & ye Samaritan wo:} by Carlo Marattus	no. 408: "Christ and the Woman of Samaria at the well"*
	1 picture over the Chimney Tapistry}	
	ye french king & Queene att a Ball } by Mr Jans	
	4 very Large pictures in Guilt fframes	
	(viz) a Seneca, a Europa, St John decollating}	Giordano, no. 406: "The Death of Seneca"
		no. 397: "The Rape of Europa"
	and an a Diana & Acteon————by Jordanus	no. 113: "Diana and Actaeon"

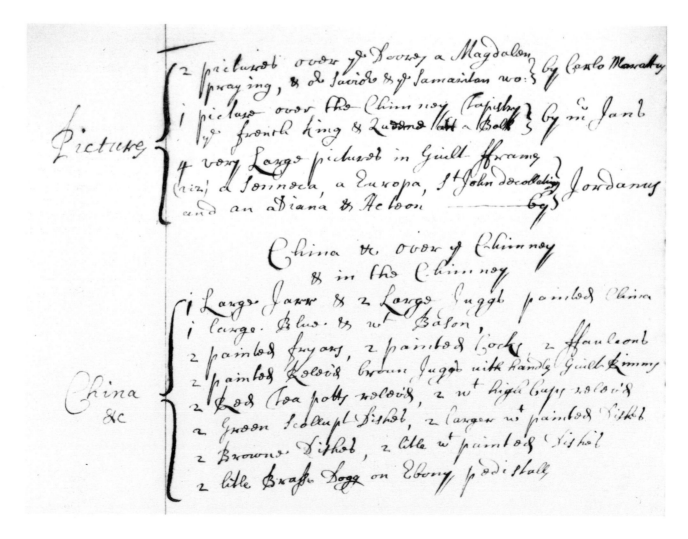

34	The Marble Salloon Roome	Lely, no. 391: "John, 5th Earl of Exeter"
		no. 390: "Anne, Countess of Exeter, Wife of the 5th Earl"
	2 My Lords picture my Ladys picture, by Sr Peter Lilly	
		D'Agar, no. 388: "John 6th Earl of Exeter, the Honble
	1 Ld Burghley Mr Will Cecil La Anns picture, by monsr Dagar	Charles Cecil, & Lady Elizabeth Cecil"
		no. 389: "John, Lord Burghley, afterwards 5th Earl of
	1 picture of my Lord when a child in & David}	Exeter; the Honble David Cecil, & Lady Frances Cecil"
	Cecil & Lady Scudamore in a peice } by	Huysmans, no. 394: "Frances, Countess of Exeter, wife of
	2 late Ld Exeters picture, his Ladys picture, by Mr Dagar	the 4th Earl"
	2 late Ld Devonshires picture, his Ladys picture	Kneller, no. 382: "1st Duke of Devonshire"
	1 picture of ye now Ld Devonshire—by Mr Kneller	
	1 picture of ye prince of Tuscany by	
	1 picture over the Chimney of }	
	Euridice in flames———— } by Genaro	Gennari, no. 467: "Euridice in flames"
	2 pictures of Orpheus, & Pluto }	no. 393: "Pluto, Orpheus, and Euridice"
	and Orpheus playing over ye Doores}	no. 219: "Orpheus Playing his Lyre"*
35	The Dineing Roome	
	2 pictures over the Doores, a St peter }	
	Denying Christ, & a Tobi blind } by Carlo Loti	
	1 picture over the Chimney being ye}	
	story of Enchanting a Sword } by	
	2 large peices in Guilt frames (viz) }	Loth, no. 368: "The Idolatry of Solomon"
	Soloman's Idolatry, Moses in ye Rushes} by Carlo Loti	no. 107: "The Finding of Moses"*
	2 other peices in large Guilt frames }	
	being a Hercules & } by Radgio and a }	
36	The Tea Roome	
	1 picture over the Chimney of Elisha }	Brandi, no. 107: "Elijah and the Widow"
	and the widdow of Sarepta————} by	
	2 pictures over the Doores, one with ye Dogg in	
	itt by Petro di fiori	
	the other with the hare in itt by Jacamo di Castello	Giacomo da Castello, no. 367: "Dead Game"
	1 picture of Noahs Ark in a Guilt frame, by	
	1 picture of a Batle in Small figures guilt frame	Adam van der Meulen, no. 500A: "A Cavalry Engagement"
	by vandermuler	
	1 picture, of Drinking, fidling & Guilt Frame, by	
	Io Straten	
	4 pictures of the Ellements Guilt frames, by	Studio of Jan Brueghel, no. 114: "The Elements: Earth"
	2 litle pictures in black frames (viz) }	no. 115: "The Elements: Air"
		no. 118: "The Elements: Fire"
		no. 119: "The Elements: Water"
	a Curtius, & a } by Jordanus	Giordano, no. 403: "Marcus Curtius leaping into the Chasm"
		no. 478: "Nessus and Deineira"
	1 litle picture of Cocks Peacock &c blak frame, by	de Koninck, no. 379: "Birds and Rabbits in a Park"
	1 picture of fflorinda,Guinnea piggs & blak frame,	no. 490: "A Spaniel, Parrot and Guinea Pigs"
	by	
	upon thes pictures 32 black knotts of Ribbon	
37	The Passage Under Ye Great Stairs & Clossetts	
	1 peice of ye Late Earle of Exeter, Guilt frame, by	
	1 peice of Guilt frame, by	
	1 peice of my Lord when a Child and }	
	Mr David Cecil Guilt frame } by,	
	1 peice of St John in a large Guilt frame, by,	
	1 picture of my Lord no frame, by Bombelli	
	1 picture of this present Duke of Tuscany, by	
	1 picture of Effugenia & Agamemmnon no frame, by	
	1 picture of a Magdalen no frame, by,	
	1 large picture, The overthrow of the }	
	Giants, or their fight against Jupiter no frame} by fra: di Maria	

	1 picture, a Dutch kitchin no frame, by 2 litle pictures of ffishes, black frames, by 1 pictures of Palermo no frame, by 1 Egyptian Madona draune upon Silke by 5 prints of Alexanders Triumphs in } black fframes designs of———— } Mr le Brun 4 prints of ye Seasons in fframes black—by 3 prints of Churches black frames, by 1 print of an Altar black frame, by 2 pictures over the Doors, a Diana, } and an Orpheus ——————— } by ffra: 1 picture over the Chimney a Prometheus } di Maria	
38	The Passage by ye Hall Stairs 2 pictures over ye Doors no fframes (viz) } ye Centaur & a Baccanell————}by Sigr Dandini 1 peice of ye Marriage ffeast in Cana, by 2 peices of Alexanders Sickness & Darius his wife, by Sig Romigio 2 peices of Boyes—————————by 1 peice of Jacob & ye Angell wrestling, by 1 peice of wo: stabing her Selfe by, 1 peice of Masinella's insurrection, by, 1 peice of the prodigall Son,————by 1 peice of Beasts & fowls killd——by 1 peice of Doggs & wild Catts————by all no fframes	Cozza, no. 23: "The Prodigal Son as a Swineherd" de Koninck, no. 374: "Hounds and Game"* no. 361: "Hunting Wild Cats"
38	The Smoaking Roome 1 litle picture over the Doore, Naked Woman} no frame————————————} by 1 picture over the Chimney, a Tarquin & Lucretia, by Carlo Loti 1 picture a killed by a wild bore } without a fframe——————————} by	
39	The Great Hall & Staire Cases by itt. 1 picture of Joseph on his Deth bed——by 1 picture, a Christ Taking from ye Crosse } 1 picture, a Magdalen & Our Saviour}by Sigr Librei 1 old peice of a landskipp all no frames	Liberi, no. 74: "Christ appearing to Mary Magdalene"
43	The Stewards Parlor 1 peice of Adam & Eve in a large wt frame, by Celestie 1 peice of Juda & Thamer no fframe, by 1 peice of Gipsies no fframe, by ffra: di Maria 1 peice of } 1 peice of no frame } by 1 peice of Curtius no frame, by Jordanus 1 peice of Silvius & Dorinda no frame, by 1 peice of a Madona no frame, by	Celesti, no. 489: "Adam and Eve Mourning over the Dead Abel" Giordano, no. 117: "Marcus Curtius leaping into the Chasm" Chiari, no. 161: "Doris wounded by Silvio"

43	Little Hall & Portico	
	1 picture of a Sheppard in a Bed Capp & Sheepe} by	

53	Severall Pictures Bought and brought in to Burghley house Since the foregoeing Inventory	
	1 picture of a Christ Consecrating the} Bread and Wine no frame————} by Carlo Dolci	Dolci, no. 265: "Christ Consecrating the Elements"*
	1 picture of Elisha feeding by Raven	
	1 picture of La: Bridgett Noel in a } an Ovall Guilt & Carv'd frame————} by Sigr Verrio	
	1 picture of La: Ruttland in Crayons } in a Small Guilt frame————}by Mr: Gibbons	
	1 picture of La in Crayons } Same bigness Guilt fframe by }	
	1 picture of Mr Cha:Mr:Edw and } Lady Betty in an Ovall Guilt fframe} by Sigr Verrio	
	1 picture of Captn ffitzwilliam no frame}	
	1 picture of Captn flide no fframe }	
	1 picture of Mr Palmer————}by Bombelly	
	1 picture of Sigr Verrio no fframe}	Kneller, no. 80: "Portrait of Verrio"
	1 picture of Mr Kneller no fframe } by Kneller	no. 78: "Self Portrait"
	1 picture of Mr Bapt Noel }	Closterman, no. 535: "The 3rd Earl
	1 picture of Mr Jno Noel }no fframes by Sigr Verrio	of Gainsborough"
	1 picture of Mr Dormier }	
	1 picture of Jno Derbyshire}	
	1 peice being a Designe}	
	in an ovall Guilt frame} by Sigr Verrio	
	9 other peices being all Designe no frames } by him also	
	1 picture of the Dutchesse of Mazareen in litle} Ebony frame————} by	
	2 Silver Pictures in Small Ebony fframes &	
	1 picture of a woman in a wrought Silver fframe	

54	Pictures not in ye former Inventory	
	2 litle peices in Stone Couller no fframes &, by	
	1 Christ head with Crown of thorns	
	1 Madona both in Water Coullers and } by Ebbony fframes————}	
	1 paire painted on both sides one being } a Satyr & a Cupid water Coull Ebbony fframes } by	
	1 picture of a head in a Box to } Screw being orks } by	
	7 Drawings more than before by Severall hands	
	4 pictures Cutt outt upon Pastbourds	

* - Painting is included in this exhibition

A List of Pictures Mentioned in the 1690 Schedule

The following is a schedule of chattels of all kinds, including pictures, which came into the collection at Burghley when Lady Anne Cavendish, wife of the 5th Earl, inherited them from her mother, the Countess of Devonshire (died 19 November 1689), who was herself a Cecil but of Hatfield (see Family Tree, page 156). The attribution, Burghley House collection number, and title of those works that can still be identified at Burghley are provided below the respective entry in the schedule.

Oyle Colour pictures

A Picture of six figures in a Guilt fframe by Andrea del Corta

A Picture of a Magdalen in a Guilt fframe by Mr: Smith

A Picture of two Naked Boyes in a black Ebony fframe after old palm

A Picture of our Saviour and the three Kings in a Black fframe

A Picture of my Lady Barring (?) in a Guilt fframe

A picture of Latona six ffigures on Copper in Ebony fframe
> (Follower of Adam Elsheimer, no. 14: "Latona and the Peasants")

A Landskipp with sheep on Copper in an Ebony fframe } by Pollingbrooke

Two pictures in Guilt fframes by fferguson one with his owne picture and severall other ffigures, The other with a Tomb in it

A litlle picture A Madona ffour figures in a Guilt fframe after Coradgio - being the Marriage of our Saviour and Saint Katherine

A Night piece of our Saviour in the mount of ffour figures in a Guilt fframe by Bassan
> (Jacopo Bassano, no. 173: "The Agony in the Garden")

A Picture of our Saviour and three other ffigures in a Guilt fframe after Raphael

A Picture of Diana and her Nymphs } by Elsam after

Another of Charity and two children } Rotten Hammond in black fframes

A Picture of ffour ffigures (or lamb) in it in a Guilt fframe after old Palma

A Picture of our Saviour and the Samaritan Woman in a Guilt fframe after old Palma
> (Venetian School, c. 1600, no. 494: "Christ and the Woman of Samaria")

A picture of Two boyes in a Guilt fframe after parmasan

A picture of the Queen of Bohemia & ffamily in a Black fframe after Pollinbrooke
> (After Honthorst and Poelenburch, no. 737: "The Seven Eldest Children of the Winter Queen")

A Coppy in Little after the said six ffigures of Andrea del Corta, in a Guilt fframe

A Picture of our Saviour at his last Supper in a Guilt fframe after Tissian

A Picture of hagar in the wood with a White Rabbit after Coradgio

A Picture of our Saviour in the Mount in a White garment in a, Guilt fframe after - Coradgio

Another picture of our Saviour in the Mount in a Red garment in a Guilt fframe after Coradgio

A Landskipp with Staggs in it in a Black fframe by R: Savery
> (Roelandt Savery, no. 4: "Animals in a Rocky Landscape")

A picture of our saviour on the Crosse in a Black fframe after Vandike
> (Follower of Van Dyck, no. 557: "The Crucifixion")

A picture of a head in a square Capp in a Black fframe by Tintarett

A Picture of Saint Margarett in a Guilt fframe after Raphael

An old woman's head in a Black fframe

A picture of the Marriage of our Saviour and Saint Katherine in A Guilt fframe - by Coradgio
> (After Correggio, no. 264: "The Mystic Marriage of St Catherine")

A Picture of the Children of King Charles ye:ffirst in a White fframe after Vandike
> (Studio of Van Dyck, no. 187: "The Children of Charles I")

A Picture of Susanna and the two Elders in a Narrow Guilt fframe by Mr:Lilly
> (Peter Lely, no. 223: "Susanna and the Elders")

A Picture of a Woman Leaneing on her hand in a Cedar fframe after Corredgio

A Night piece Landskipp in a Guilt fframe small

A picture of the Nativity in a Black fframe small

A picture of a dead partridge and ffruite in a Black fframe

A picture of Will Earle of Devonshire ffather to the present Countess of Exeter

A picture of the present Earle of Devonshire when a Child by Mr:Lilly in a Guilt fframe naked

A Picture of Venus and Adonis in a Garden by fferguson Little

A picture of the Countess of Bedford in a Guilt fframe
 (After Van Dyck, no. 177: "Ann Carr, Countess of Bedford")

A picture of the late Earle of pembroke in a Guilt fframe
 (Peter Lely, no. 205: "Philip Herbert, 4th Earl of Pembroke")

A picture of Mary Queen to Charles the ffirst in a White fframe
 (After Van Dyck, no. 181: "Henrietta Maria")

A picture of the princess Royall in a Guilt fframe daughter of King Charles the ffirst

A picture of Lady Stanhope in A narrow Guilt fframe

A picture of the late Earl of Salisbury in a Carv,d fframe
 (Peter Lely, no. 212: "William Cecil, 2nd Earl of Salisbury")

A picture of his Lady in the like fframe
 (Studio of Peter Lely, no. 95: "Catherine Howard, Countess of Salisbury")

A Picture of the late Countess of Northumberland in A Carved fframe
 (After Van Dyck, no. 200: "Lady Ann Cecil, Countess of Northumberland")

A picture of the Lady Lisse (?) in a Narrow Guilt fframe

A picture of the late Earle of Devonshire in a Carv,d fframe
 (Peter Lely, no. 85: "William, 3rd Earl of Devonshire")

A picture of his Countess in the like fframe-
 (Studio of Van Dyck, no. 87: "Lady Elizabeth Cecil, Countess of Devonshire")

A picture of the Dutchesse of Cleaveland and one of her sons togeather

A picture of the present Earle of Exeter a Carv,d fframe
 (Godfrey Kneller, no. 77: "John, 5th Earl of Exeter")

A picture of the present Countess of Exeter in the like fframe
 (Godfrey Kneller, no. 76: "Anne Cavendish, Countess of Exeter")

A picture of Cleopatra with two dead ffigures, in the like fframe

A picture of an Old Mans head by Tissian a Black fframe

A perspective picture of the Inside of a Dutch Church in a black fframe

A picture of Mr Charles Cavendish in a Guilt fframe by Rommee

A Night piece if our Saviour our Lady and St Joseph in a black fframe by Bassan

A picture of a paesage = __ = __ = with Cows in it on Board in a black fframe by Bollromb

Collonell Cavendish his picture in a Carv,d fframe

A Little picture of Lady Oxford in A Guilt frame

A Little picture of ffour ffigures in a white fframe by Giaves

A picture of Danras with a boy upon an Eagle

The Nine Muses being the Roofe of a Closestt with ffour long narrow pieces to it by Giaves

A picture of the Children of both ffamilyes by Wissing

A Landskip of a broken pillar in a Narrow Guilt fframe

Select Bibliography

Aikema 1990
Aikema, B. *Pietro della Vecchia and the Heritage of the Renaissance in Venice*. Florence, 1990.

Anderson 1972
Anderson, W.E.K. *The Journal of Sir Walter Scott*. Oxford, England, 1972.

Arslan 1960
Arslan, E. *I Bassano*. Milan, 1960.

Baldinucci 1845
Baldinucci, F. *Notizie de' professori del disegno*. 6 vols. Florence, 1681–1728. Reprint, 5 vols., Florence, 1845–1847.

Bagni 1986
Bagni, P. *Benedetto Gennari e La Bottega Del Guercino*. Padua, 1986.

Bellori 1732
Bellori, G.P. *Vita del Maratta*. Rome, 1732.

Berenson 1910
Berenson, B. *North Italian Painters of the Renaissance*. 1907. Reprint, London, 1910.

Berenson 1957
Berenson, B. *Italian Pictures of the Renaissance*. Vol. 1, *Venetian School*. London, 1957.

Berenson 1968
Berenson, B. *Italian Pictures of the Renaissance. Central Italian and North Italian Schools*. London, 1968.

Blunt 1958
Blunt, A. *Poussin Studies VII*, "Poussins in Neapolitan and Sicilian Collections". *Burlington Magazine*, vol. 100 (March 1958).

Blunt and Cooke 1960
Blunt, A., and H. Cooke. *Roman Drawings of the XVII and XVIII Centuries in the Collection of Her Majesty the Queen at Windsor Castle*. London, 1960.

Boschini 1674
Boschini, M. *Le Ricche Minere della Pittura Veneziana*. Venice, 1674.

Brigstocke 1990
Brigstocke, H. "Pier Francesco Mola" (exhibition review). *Burlington Magazine*, vol. 132 (January 1990).

Brigstocke 1993
Brigstocke, H. *Italian and Spanish Paintings in the National Gallery of Scotland*. Edinburgh, 1978. Revised edition, Edinburgh, 1993.

Budde 1930
Budde, I. *Beschreibender Katalog der Handzeichnungen in der Staatlichen Kunstakademie Düsseldorf*. Düsseldorf, 1930.

Burdon 1960
Burdon, G. "Sir Thomas Isham. An English Collector in Rome in 1677–1678". *Italian Studies*, vol. 15 (1960).

Byam Shaw 1967
Byam Shaw, J. *Paintings by Old Masters at Christ Church, Oxford*. London, 1967.

Caliari 1888
Caliari, P. *Paolo Veronese*. Rome, 1888.

Carr 1993
Carr, D. "Ecstasy in the Wilderness: Pier Francesco Mola's *The Vision of Saint Bruno*". *Getty Museum Journal*, vol. 19 (1991).

Cera 1982
Cera, A. *La Pittura Emiliana del '600*. Milan, 1982.

Cochin 1756
Cochin, C.N. *Voyage d'Italie ou Recucil de notes sur les ouvrages d'Architecture, de Peinture et de Sculpture qui l'en voit dans les principales villes d'Italie (1749–1751)*. Paris, 1756.

Cocke 1972
Cocke, R. *Pier Francesco Mola*. Oxford, England, 1972.

Contini 1991
Contini, R. In *Artemisia*. Exhibition catalogue, Casa Buonarroti, Florence, 1991.

Cordellier 1986
Cordellier, D. *Hommage à Andrea del Sarto*. Exhibition catalogue, Musée du Louvre, Paris, 1986–1987.

Cortese 1967
Cortese, G. di Domenico. "Percorso de Giacinto Gimignani". *Commentari*, vol. 18, nos. 2–3 (April-September 1967).

Crinò and Nicolson 1961
Crinò, A.M., and B. Nicolson. "Further Documents relating to Orazio Gentileschi". *Burlington Magazine*, vol. 103 (April 1961).

Crosato Larcher 1968
Crosato Larcher, L. "L'Opera Completa del Veronese" (review). *Arte Veneta*, vol. 22 (1968).

Crosato Larcher 1969
Crosato Larcher, L. "Note su Benedetto Caliari". *Arte Veneta*, vol. 23 (1969).

Crowe and Cavalcaselle 1912
Crowe, J.A., and G.B. Cavalcaselle. *A History of Painting in North Italy*. Edited by T. Borenius. London, 1912.

D'Addosio 1913
D'Addosio, G. "Documenti Inediti di Artisti Napoletani del XVI e XVII secolo". *Archivio Storico per le province Napoletane*, Anno 38. Societa di Storia Patria, Naples D'Addosio, 1913.

Daniels 1976A
Daniels, J. *Sebastiano Ricci*. Bath, 1976.

Daniels 1976B
Daniels, J. *L'Opera Completa di Sebastiano Ricci*. Milan, 1976.

De Lépinay 1990
De Lépinay, F.M. *Giovanni Battista Salvi "Il Sassoferrato"*. Exhibition catalogue, Sassoferrato, Italy, 1990.

della Pergola 1955
della Pergola, P. *Galleria Borghese. I Dipinti*. Rome, 1955.

Di Federico 1971
Di Federico, F. "Francesco Trevisani and the Decoration of the Crucifixion Chapel in San Silvestro in Capite". *Art Bulletin*, vol. 53 (March 1971).

Di Federico 1977
Di Federico, F. *Francesco Trevisani, Eighteenth-Century Painter in Rome: A Catalogue Raisonné*. Washington, D.C., 1977.

Divitiis 1982

Divitiis, G. Pagano de. "I due Recco de Burghley House. Osservazioni sul collezionismo inglese e sul mercato delle opere d'arte nella Napoli del Seicento". *Prospettive Settanta*, nos. 3–4 (1982).

Donzelli and Pilo 1967

Donzelli, G., and G.M. Pilo. *I Pittori del Seicento Veneto*. Florence, 1967.

Dreyer 1971

Dreyer, P. "Notizien zum malerischen und zeichnerischen Oeuvre der Maratta - Schule. Giuseppe Chiari - Pietro de'Pietri - Agostino Masucci". *Zeitschrift für Kunstgeschichte*, vol. 34 (1971).

Dreyer 1977

Dreyer, P. *Stiftung Ratjen Italienische Zeichnungen*. Exhibition catalogue, Staatliche Graphische Sammlung, Munich, 1977.

Dussieux 1856

Dussieux, L. *Les Artistes Français à l'etranger*. Paris, 1856.

Earlom 1777

Earlom, R. *Liber Veritatis*. 1777. Reprint, London, 1872.

Enggass 1964

Enggass, R. *The Paintings of Baciccio, Giovanni Battista Gaulli 1639–1709*. University Park, Pennsylvania, 1964.

Enggass 1967A

Enggass, R. "Exhibition Review of Baciccio at Oberlin". *Burlington Magazine*, vol. 109 (March 1967).

Enggass 1967B

Enggass, R. "Letter". *Burlington Magazine*, vol. 109 (August 1967).

Ewald 1965

Ewald, G. *Johann Carl Loth*. Amsterdam, 1965.

Ferrari and Scavizzi 1966

Ferrari, O., and G. Scavizzi. *Luca Giordano. L'Opera Completa*. Naples, 1966.

Ferrari and Scavizzi 1992

Ferrari, O., and G. Scavizzi. *Luca Giordano. L'Opera Completa*. Revised edition, Naples, 1992.

Fiocco 1928

Fiocco, G. *Paolo Veronese*. Bologna, 1928.

Fischer 1973

Fischer, U.V. "Giacinto Gimignani". Ph.D. diss., University of Freiburg, Germany, 1973.

Friedman 1988

Friedman, T. "Lord Harrold in Italy 1715–16: four frustrated commissions to Leoni, Juvarra, Chiari and Soldani". *Burlington Magazine*, vol. 130 (November 1988).

Frisoni 1978

Frisoni, F. "La Vera Sirani." *Paragone*, no. 335 (January 1978).

Garrard 1989

Garrard, M. *Artemisia Gentileschi, The Image of the Female Hero in Italian Baroque Art*. Princeton, New Jersey, 1989.

Gaynor and Toesca 1963

Gaynor, J.S., and I. Toesca. *S. Silvestro in Capite*. Rome, 1963.

Gerola 1909

Gerola, G. "Un Nuovo Libro sull'arte dei Bassano". *Bolletino del Museo Civico di Bassano*, vol. 5 (1909).

Graf 1973

Graf, D. *Master Drawings of the Roman Baroque from the Kunstmuseum, Düsseldorf*. Exhibition catalogue, Victoria and Albert Museum, London, and Scottish Arts Council, Edinburgh, 1973.

Graf 1976

Graf, D. *Die Handzeichnungen von Guglielmo Cortese and Giovanni Battista Gaulli*. 2 vols. Düsseldorf, 1976.

Graf 1986

Graf, D. *Die Handzeichnungen von Giacinto Calandrucci*. Exhibition catalogue, Kunstmuseum Düsseldorf, Düsseldorf, 1986.

Gregori 1968

Gregori, M. "Su Due Quadri Caravaggeschi a Burghley House". *Festschrift Ulrich Middeldorf*. 2 vols. Berlin, 1968.

Haskell 1980

Haskell, F. *Patron and Painters*. New edition. New Haven and London, 1980.

Hazlitt 1930

Hazlitt, W. *The Complete Works*. 21 vols. London, 1930–1934.

Ingersoll-Smouse 1924

Ingersoll-Smouse, F. "Quatre Veronese retrouvés en Angleterre". *Gazette des Beaux Arts*, 5th period, vol. 9 (February 1924), 744e livraison.

Kerber 1968

Kerber, B. "Giuseppe Bartolomeo Chiari". *Art Bulletin*, vol. 50 (March 1968).

Kitson 1978

Kitson, M. *Claude Lorrain: Liber Veritatis*. London, 1978.

Kurz 1955

Kurz, O. *Bolognese Drawings of the XVII and XVIII Centuries in the Collection of Her Majesty The Queen*. London, 1955.

Laureati 1989

Laureati, L. *Pier Francesco Mola*. Exhibition catalogue, Museo Cantonale, Lugano, Switzerland, 1989.

Lavin 1975

Lavin, M. *Seventeenth Century Barberini Documents and Inventories of Art*. New York, 1975.

Leslie and Taylor 1865

Leslie, C., and R. Taylor. *Life and Times of Sir J. Reynolds*. Vol. 1: Age 1–49 (1723–1772). London, 1865.

Levey 1964

Levey, M. *The Later Italian Pictures in the Collection of Her Majesty The Queen*. London, 1964.

Longhi 1948

Longhi, R. "Calepino Veneziano. Suggerimenti per Jacopo Bassano". *Arte Veneta*, nos. 5–8 (1948).

Macandrew and Graf 1972

Macandrew, H., and D. Graf. "Baciccio's Later Drawings: A Rediscovered Group Acquired by the Ashmolean Museum". *Master Drawings*, vol. 10 (Autumn 1972).

Malvasia 1678

Malvasia, C. *Felsna Pittrice. Vite de' Pittori Bolognesi*. 1678. Revised edition, vol. 2, Bologna, 1841.

Mancigotti 1975

Mancigotti, M. *Simone Cantarini il Pasarese*. Milan, 1975.

Mannocci 1988

Mannocci, L. *The Etchings of Claude Lorrain*. New York, 1988.

Manzitti 1972
 Manzitti, C. *Valerio Castello*. Genoa, 1972.
Marcora 1976
 Marcora, G. *Marco d'Oggiono*. Oggiono, Italy, 1976.
Marini 1968
 Marini, R. *L'Opera Completa del Veronese*. Milan, 1968.
McCorquodale 1979
 McCorquodale, C. *Painting in Florence, 1600–1700*.
 Exhibition catalogue, Royal Academy of Arts, London, 1979.
Middione 1982
 Middione, R. *Painting in Naples 1606–1705. From Caravaggio
 to Giordano*. Exhibition catalogue, Royal Academy of Arts,
 London, 1982.
Middione and Daprà 1987
 Middione, R., and B. Daprà. *Realtà e Fantasia nella Pittura
 Napoletana XVII–XIX Secolo*. Exhibition catalogue, Institut
 culturel italien, Paris, and Musée des Beaux Arts, Lyons, 1987.
Miller 1983
 Miller, D. "Benedetto Gennari's Career at the Courts of
 Charles II and James II, and a newly discovered portrait of
 James II". *Apollo*, no. 117 (January 1983).
Muraro 1992
 Muraro, M., ed. *Il Libro Secondo di Francesco e Jacopo del
 Ponte*. Bassano, 1992.
Newcome 1978
 Newcome, M. "Valerio Castello, A Genoese Master of the
 Seicento". *Apollo*, vol. 108 (November 1978).
Nicolson 1949
 Nicolson, B. "The Resurrection by Paolo Veronese".
 Burlington Magazine, vol. 91, (December 1949).
Nicolson 1960
 Nicolson, B. "Some little known pictures at the Royal
 Academy". *Burlington Magazine*, vol. 102 (February 1960).
Nicolson 1974
 Nicolson, B. "Current and Forthcoming Exhibitions."
 Burlington Magazine, vol. 116 (July 1974).
Novelli 1964
 Novelli, M.A. *Lo Scarsellino*. Milan, 1964.
Oertel 1990
 Oertel, R. "England und die Italienische Kunst".
 Kunstchronik, vol. 13 (April 1960).
Old Master Drawings 1990
 Old Master Drawings from the Galleria dell'Academia, Venice.
 Exhibition catalogue, Italian Ministry for Cultural Heritage,
 London; Talbot Rice Gallery, Edinburgh; and Courtauld
 Institute Galleries, London, 1990–1991.
Osmond 1927
 Osmond, P. *Paolo Veronese*. London, 1927.
Ottani 1968
 Ottani, A. *Carlo Saraceni*. Vicenza, 1968.
Pampalone 1972
 Pampalone, A. In *Dizionario Enciclopedico Bolaffi dei Pittori e
 degli Incisori Italiani*, vol. 5. Turin, 1972.
Pascoli 1730
 Pascoli, L. *Vite de' pittori, scultori ed architetti moderni*.
 Rome, 1730–1736.
Peck 1732
 Peck, F. *Desiderata Curiosa*, vol. 1, chap. 22, London, 1732.
Perez Sanchez 1965
 Perez Sanchez, A. E. *Pintura Italiana del S.XVII en Espana*.
 Madrid, 1965.

Pignatti 1976
 Pignatti, T. *Veronese*. Venice, 1976.
Posner 1986
 Posner, D. *The Age of Correggio and the Carracci*. Exhibition
 catalogue, National Gallery of Art, Washington, D.C., 1986.
Potterton 1979
 Potterton, H. *Venetian Seventeenth Century Painting, a loan
 exhibition from collections in Britain and Ireland*. Exhibition
 catalogue, National Gallery, London, 1979.
Pouncey 1961
 Pouncey, P. "Aggiunte a Girolamo da Treviso". *Arte Antica e
 Moderna*, vols. 13–16 (1961).
Pouncey 1967
 Pouncey, P. "Two Studies by Daniel Seiter for Ceiling
 Paintings in Turin". *Master Drawings*, vol. 5 (1967).
Rearick 1958
 Rearick, W.R. "The Burghley House 'Adoration' of Jacopo
 Bassano". *Arte Veneta*, vol. 12 (1958).
Rearick 1989
 Rearick, W.R. *The Art of Paolo Veronese*. Exhibition catalogue,
 National Gallery of Art, Washington, D.C., 1989.
Rearick 1993
 Rearick, W.R. *Jacopo Bassano, c. 1510–1592*. Exhibition cata-
 logue, Bassano 1992/Kimbell Art Museum 1993 (American edi-
 tion), 1993.
Riccio 1959
 Riccio, B. "Vita di Filippo Lauri di F.S. Baldinucci".
 Commentarii, vol. 10 (January-March 1959).
Ridolfi 1648
 Ridolfi, C. *Le Maraviglie dell'Arte. Le Vite degli Illustri Pittori
 Veneti e dello Stato*. Venice, 1648. New edition edited by D.F.
 von Hadeln. Berlin, 1914.
Ronot 1990
 Ronot, H. *Richard et Jean Tassel, Peintres à Langres au XVIII
 Siécle*. Paris, 1990.
Röthlisberger 1961
 Röthlisberger, M. *Claude Lorrain, The Paintings*. London,
 1961.
Röthlisberger 1968
 Röthlisberger, M. *Claude Lorrain, The Drawings*. Berkeley
 and Los Angeles, 1968.
Rudolph 1977
 Rudolph, S. "La Prima Opera Pubblica del Maratti".
 Paragone, no. 28 (July 1977).
Rudolph 1983
 Rudolph, S. *La Pittura del 700 a Roma*. Rome, 1983.
Russell 1982
 Russell, H.D. *Claude Lorrain*. Exhibition catalogue, National
 Gallery of Art, Washington, D.C., 1982.
Salerno 1984
 Salerno, L. *Still Life Painting in Italy*. Rome, 1984.
Salerno 1988
 Salerno, L. *Dipinti del Guernico*. Rome, 1988.
Schaar and Sutherland Harris 1967
 Schaar, E., and A. Sutherland Harris. *Die Handzeichnungen
 von Andrea Sacchi und Carlo Maratta*. Kunstmuseum
 Düsseldorf, Düsseldorf, 1967.
Sedini 1989
 Sedini, D. *Marco D'Oggiono*. Milan, 1989.
Shearman 1965
 Shearman, J. *Andrea del Sarto*. Oxford, England, 1965.

Spear 1966

Spear, R. "Baciccio's Pendant Paintings of Venus and Adonis". *Allen Memorial Art Bulletin*, vol. 23 (Spring 1966).

Spear 1968

Spear, R. "Baciccio's Venus and Adonis: A Postscript". *Burlington Magazine*, vol. 110 (January 1968).

Spike 1983

Spike, J. *Italian Still Life Paintings from Three Centuries*. Exhibition catalogue, National Academy of Design, New York, 1983.

Spike 1991

Spike, J. "Review of 'Nuovi studi su la natura morta italiana/New Studies on Italian Still Life Painting' by L. Salerno, Rome 1989". *Burlington Magazine*, vol. 133 (October 1991).

Spinosa 1984

Spinosa, N. *La pittura napoletana del '600*. Milan, 1984.

Standring 1988

Standring, T. "Some pictures by Poussin in the Dal Pozzo Collection: Three new inventories". *Burlington Magazine*, vol. 130 (August 1988).

Stechow 1967

Stechow, W. *Catalogue of European and American Paintings and Sculpture in the Allen Memorial Art Museum*. Oberlin, Ohio, 1967.

Suida 1929

Suida, W. *Leonardo und sein kreis*. Munich, 1929.

Sutherland Harris 1977

Sutherland Harris, A. *Andrea Sacchi*. Oxford, England, 1977.

Sutherland Harris and Nochlin 1976

Sutherland Harris, A., and L. Nochlin. *Women Artists 1550–1950*. Exhibition catalogue, Los Angeles County Museum of Art, Los Angeles, 1976.

Thieme-Becker 1913

Thieme, U., and F. Becker. *Allgemeines Lexikon der Bildenden Kunstler*. 37 vols. Leipzig, 1907–1950. Vol. 13, 1913.

Till 1988

Till, E. *The Travelling Earl*. Exhibition catalogue, Burghley House, Stamford, England, 1988.

Till 1990

Till, E. *A Family Affair. Stamford and the Cecils, 1650–1900*. Northampton, England, 1990.

Titi 1686

Titi, F. *Ammaestramento di pittura, scultura et architettura nelle chiese di Roma*. Rome, 1686.

Tomory 1976

Tomory, P. *Catalogue of the Italian Paintings before 1850*. The John and Mable Ringling Museum of Art, Sarasota, Florida, 1976.

Treasure Houses of Britain

Treasure Houses of Britain. Exhibition catalogue, National Gallery of Art, Washington, D.C., 1985.

Varriano 1988

Varriano, J. "The First Roman Sojourn of Daniel Seiter, 1682–1688". *Paragone*, vol. 39, no. 12(465) (November 1988).

Venturi 1929

Venturi, A. *Storia dell'Arte Italiana*. 25 vols. Milan, 1901–1940. Vol. 9, part 4, 1929.

Voss 1924

Voss, H. *Die Malerei des Barock in Rom*. Berlin, 1924.

Waagen 1854

Waagen, G.F. *Treasures of Art in Great Britain*. Vol. 3. London, 1854.

Ward Bissell 1968

Ward Bissell, R. "Artemisia Gentileschi - A New Documented Chronology". *Art Bulletin*, vol. 50, no. 2 (June 1968).

Ward Bissell 1981

Ward Bissell, R. *Orazio Gentileschi and the Poetic Tradition in Caravaggesque Painting*. University Park, Pennsylvania, 1981.

Waterhouse 1960A

Waterhouse, E.K. "A note on British collecting of Italian pictures in the later seventeenth century". *Burlington Magazine*, vol. 102 (February 1960).

Waterhouse 1960B

Waterhouse, E.K. *Italian Art and Britain*. Exhibition catalogue, Royal Academy of Arts, London, 1960.

Waterhouse 1962

Waterhouse, E.K. *Italian Baroque Painting*. London, 1962. Second edition, London, 1969.

Waterhouse 1965

Waterhouse, E. Review of R. Enggass, "The Painting of Baciccio". *Burlington Magazine*, vol. 107 (October 1965).

Westin 1975

Westin, J.K. *Carlo Maratta and his Contemporaries, Figurative Drawings from the Roman Baroque*. Exhibition catalogue, Pennsylvania State University, University Park, Pennsylvania, 1975.

Zampetti 1957

Zampetti, P. *Jacopo Bassano*. Exhibition catalogue, Palazzo Ducale, Venice, 1957.

Zanetti 1733

Zanetti, A.M. *Descrizione di tutte le pubbliche pitture della Citta di Venezia*. Venice, 1733.

Zeri 1989

Zeri, F. *La natura morta in Italia*. 2 vols. Milan, 1989.

Zuccari 1992

Zuccari, F. *Pinacoteca di Brera. Scuola dell'Italia centrale e meridionale*. Milan, 1992.

Photography credits

Jörg P. Anders, Berlin: cat. no. 8, fig. 3

Courtesy of the Art Institute of Chicago: cat. no. 8, fig. 1; cat. no. 10, fig. 2

Katrin Bellinger, Munich: cat. no. 8, fig. 2

Sue Bond, London: p. 157 (Lady Victoria)

Courtauld Institute of Art, Photographic Survey of Private Collections, London: cat. no. 10, fig. 3; cat. no. 19, fig. 1; cat. no. 22, fig. 1; cat. no. 27, fig. 1; cat. no. 28, fig. 1; cat. no. 30, figs. 1–3; cat. no. 32, fig. 1; cat. nos. 35–38, fig. 4; cat. no. 54, fig. 1; cat. no. 60, fig. 1

English Life Publications Ltd: p. 10; pp. 15–28, figs. 2–12; p. 28, fig. 1

Financial Times, London: p. 157 (6th Marquess)

Gabinetto Fotografico, Soprintendenza Beni Artistici e Storici, Florence: cat. no. 5, fig. 2; cat. no. 47, fig. 2

Istituto Centrale per il Catalogo e la Documentazione, Rome: cat. no. 54, figs. 2, 3

Kuntsmuseum Düsseldorf im Ehrenhof: cat. no. 17, figs. 2–5; cat. no. 18, figs. 3, 5; cat. nos. 35–38, figs. 1, 2; cat. no. 51, fig. 1

The Metropolitan Museum of Art, New York: p. 36, fig. 9

Photo R.M.N., Paris: cat. no. 4, fig. 1; cat. no. 47, fig. 1

Royal Collection Enterprises, London: cat. no. 52, figs. 1, 2

Soprintendenza alle Gallerie, Naples: cat. no. 52, fig. 3

All other photographs are courtesy of Sotheby's, London.